Minoan
and
Mycenaean
Art

Minoan and Mycenaean Art

Reynold Higgins

Revised Edition

New York and Toronto
OXFORD UNIVERSITY PRESS
1981

Author's Note on the Second Edition

In this edition the text has been brought up to date in the light of research and discoveries since 1967, and a few changes have been made to the illustrations. In particular space has been created for two colour photographs of the newly discovered frescoes from Thera (*Ills. 110* and *111*).

© 1967 and 1981 Thames and Hudson Ltd, London
All Rights Reserved

Library of Congress Cataloging in Publication Data
Higgins, Reynold Alleyne.
 Minoan and Mycenaean art.

 (World of art)
 Bibliography: p.
 Includes index.
 1. Art, Cretan. 2. Art, Minoan. 3. Art, Mycenean. I. Title. II. Series.
N5660.H5 1981 790'.38 80–26722
ISBN 0–19–520256–2
ISBN 0–19–520257–0 (pbk.)

Printed and bound in Great Britain by
Jarrold and Sons Ltd, Norwich

Contents

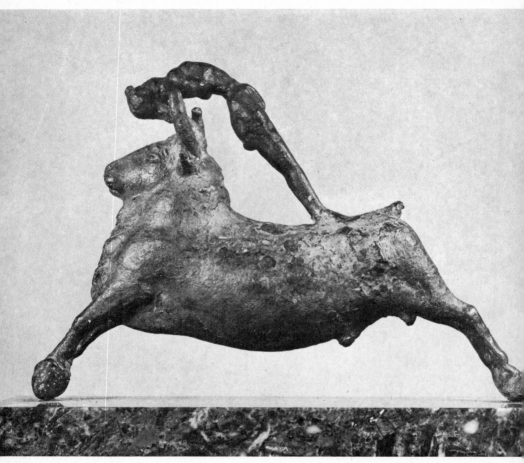

Frontispiece. The finest extant Cretan bronze represents an incident in the ceremonial bull-sports. Made about the sixteenth century BC, it is believed to have been found at Rethymnon. It is of solid bronze cast by the *cire perdue* method, and has the rough surface typical of Cretan bronzes. The representation of violent movement, both of the animal and the acrobat, is unequalled in ancient art. The technical feat of showing an acrobat virtually in mid-air has been achieved by making his long hair actually touch the bull's forehead. The legs from mid-thigh to the ankles are modern restorations

Introduction

When Heinrich Schliemann claimed in 1876 to have discovered a new world for archaeology, he was stating no less than the truth. The occasion for this claim was his historic discovery of the Royal Shaft-Graves at Mycenae, which opened the door to the study of Bronze Age Greece.

It is a surprising fact that although Classical Greece has been familiar to us, after a fashion, since the Renaissance, the rich Bronze Age culture of the Aegean area was completely unknown as recently as a century ago. Indeed, so unfamiliar were the treasures from the Shaft-Graves that they were variously interpreted by experts (who should have known better) as Celtic, Carian, Scythian, Byzantine, Gothic, and even Indian. The principal reason for this amazing ignorance is that whereas the Classical period has bequeathed us a wealth of literary sources, the Bronze Age has left us precious little on which to build but the evidence which archaeology can supply.

The lack of contemporary documentation has not, however, been all loss, for the student of prehistoric art in the Aegean area is forced to assess the surviving material on its merits alone, unhampered by the often confusing judgments of ancient art-critics.

This book is concerned with the three principal civilizations of the Aegean in the Bronze Age: those of Crete, the Cycladic islands, and Mainland Greece. The title is therefore convenient rather than strictly accurate, for our scope is somewhat wider than it would suggest. Yet the fact remains that of the cultures to be considered, the Minoan and Mycenaean are by far the most important.

The tale begins shortly after 3000 BC, with the gradual replacement of stone for tools and weapons by copper, and later by bronze, an alloy of copper and tin. It ends round about 1100 BC with the destruction of the Bronze Age sites, the arrival of the Dorian branch

of the Greek family, and the replacement, for many purposes, of bronze by iron.

It may be objected that the starting-point of this survey is too arbitrary, since art of a kind existed in the Neolithic period, which preceded the Bronze Age; but it seems on balance sensible to start at the point where European civilization as we know it may reasonably be said to begin.

HISTORY OF SCHOLARSHIP

The Greeks of the Classical period had hazy memories of what they regarded as an age of heroes. They possessed the Homeric poems and other legends set in Mycenae and Thebes, and they knew that a great king called Minos once lived in a palace called the Labyrinth at Knossos in Crete and ruled over most of the Aegean with his fleet.

In addition, certain monuments from the Bronze Age had never been lost to sight, as for example the Cyclopean Walls and the Lion Gate at Mycenae (*Ill. 1*), and the Treasury of Atreus near by; and there is a growing body of evidence that many Mycenaean tombs were venerated from the eighth century BC onwards as the resting-places of heroes.

These reminders of former greatness retained their significance for the Romans, but after the official adoption of Christianity in the fourth century of our era, interest in the Heroic Age was almost extinguished, to be altered out of all recognition in the Middle Ages, when the tale of Troy was reshaped to fit the feudal mould. With the Renaissance and the rediscovery of ancient literature, the stories regained their Classical form, but until the mid-nineteenth century there were few indeed who regarded them as better than fairy tales. It remained for Heinrich Schliemann to reveal something very near the truth. Convinced that the Homeric poems were basically historical documents, he set out to excavate those sites with which they were principally concerned, and was triumphantly successful.

In 1870 he identified the site of Troy, in spite of the consensus of scholarly opinion that the city (if it existed at all) was elsewhere. Here he dug intermittently for some twenty years, his most dramatic

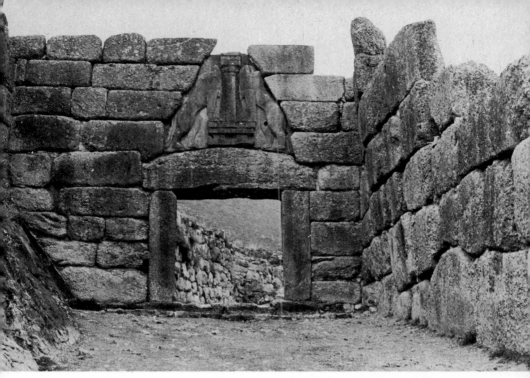

1 One of the most impressive monuments of Mycenaean Greece is the Lion Gate at Mycenae, built *c.* 1250 BC. For the main part of the circuit wall, rough 'Cyclopean' masonry (visible through the gate) was used, but to give a more imposing appearance to the main entrance, smooth squared ashlar work was used (cf. *Ill. 100*)

discovery being the gold treasure from the Second City, which (mistakenly, but pardonably) he identified with Homeric Troy.

In 1876 he turned his attention to Mycenae. Taking his cue from Pausanias (a traveller of the second century AD), he searched inside the walls for the royal burials, and found the richest tombs ever to be excavated in Greek lands. He later dug at Tiryns, Orchomenos, Ithaca and other sites, and would have excavated at Knossos in Crete, but was prevented by circumstances beyond his control.

In all strictness, Schliemann was not the first to discover antiquities belonging to the Greek Bronze Age. In the early nineteenth century Lord Elgin had visited the Treasury of Atreus at Mycenae and had brought to London reliefs and sculptures found in that

9

tomb. Either he or a contemporary also brought back Mycenaean vases, and several European collections acquired similar vases about the same time, all of which were consigned to store-rooms and forgotten.

In 1866 Late Minoan vases were found on the island of Thera beneath volcanic material, and two years later the first consignment of Mycenaean antiquities from Ialysus in Rhodes reached the British Museum.

Then came Schliemann's discoveries, which have already been mentioned. He was in a fair way to understanding the significance of his discoveries, but it was left to C. T. Newton of the British Museum as early as 1877 to gather together all these separate threads and to make of them a coherent story.[1]

By identifying a scarab of Pharaoh Amenophis III (c. 1417–1379 BC) among the finds from Ialysus, and by spotting parallels to Schliemann's discoveries in Egyptian tomb-paintings of the Eighteenth Dynasty, he was able to reach a very good estimate of the correct age of this civilization, to which the generic name Mycenaean inevitably attached itself.

Meanwhile, work continued in the study and in the field. In 1886 Adolf Furtwängler published a masterly study of Mycenaean pottery, and in 1890–1 Flinders Petrie improved somewhat on Newton's chronology by further correlating Mycenaean finds in Egypt and Egyptian imports at Mycenae. He also correctly identified as coming from the Aegean area some hitherto unknown varieties of pottery from Twelfth Dynasty tombs: we know it today as Middle Minoan.

It was now the turn of the Cycladic islands. In the 1890s the Greek archaeologist Christos Tsountas turned from excavating Mycenaean sites in Greece to the Cyclades, where he excavated some hundreds of tombs on Amorgos, Paros, Syros and Siphnos. This culture, which proved to be different from the Mycenaean, he called Cycladic. He was followed by a British venture on Melos in 1896–9, at the prehistoric settlement known by its modern name of Phylakopi.

The next major step forward was taken by (Sir) Arthur Evans, who succeeded in 1899, where Schliemann had failed, in initiating an excavation at Knossos in Crete. The greater part of the palace was

laid bare in the first few years; but the excavation continued, with the exception of the war years, till 1932, and Knossos was to occupy Evans continuously until his death in 1941. His great work, *The Palace of Minos at Knossos*, was completed in 1935.

His greatest achievements, apart from the excavation of the palace, were first, to establish the principal origins of the Mycenaean culture as lying in the far older civilization of Crete; second, to work out a relative chronology for the Bronze Age in Crete. This civilization he called Minoan, after Minos the legendary King of Knossos. It is a matter for regret that this fanciful name has become established (it has been observed that it is about as logical as calling the entire post-Conquest history of England the Victorian period), but it is too late now to change.

It remained to trace the Mainland Greek antecedents of the great Mycenaean age. This was first achieved by Blegen in the 1920s at sites near Corinth. He was able to work out a complete chronology for Bronze Age Greece, parallel to the Minoan chronology of Crete, which he called Helladic, after Hellas, the name by which the Greeks, ancient and modern, have always known their country.

It would be tedious to enumerate all the good work which has been done since, and is still in progress, but some recent achievements are worthy of special mention.

In 1941, the Swedish scholar Arne Furumark produced a monumental study, in two volumes, of Mycenaean pottery. This attempt to bring order out of a rapidly growing chaos was in many ways successful. He has been criticized, as are all systematists, for a too rigid approach, but he has not been upset in his essential conclusions, and there are few excavations and fewer Mycenaean scholars who could dispense with these two books.

After the last war, work was resumed at Mycenae. Wace uncovered three large houses outside the Citadel, and Papademetriou and Mylonas excavated a second grave-circle. More recently, Caskey has dug at Lerna in the Argolid and has worked out an improved historical sequence for the Early Helladic period based on this, and on a reassessment of earlier excavations. The same scholar later excavated a settlement on the Cycladic island of Keos.

Blegen and Marinatos have excavated at Pylos; exciting finds have been made by Greek archaeologists at Thebes; Marinatos has excavated at Marathon and with Doumas on Thera; and the British have returned to Melos and Sparta.

In Crete, a fourth royal palace has been discovered and excavated at Zakro by Platon, and two intact royal burials have been excavated at Archanes near Knossos.

Finally, in one of the greatest intellectual achievements of our generation, in 1952 the late Michael Ventris deciphered the so-called Linear B script of Knossos and Mycenaean Greece, and found it to be Greek.

CHRONOLOGY

The relative chronology of the Aegean area is as follows: The Early Bronze Age comprises Early Minoan (EM), Early Cycladic (EC), and Early Helladic (EH), all roughly contemporary. The Middle Bronze Age comprises Middle Minoan (MM), Middle Cycladic (MC), and Middle Helladic (MH), all roughly contemporary. The Late Bronze Age comprises Late Minoan (LM), Late Cycladic (LC) and Late Helladic (LH) or Mycenaean (the terms are synonymous), also roughly contemporary. Each period is generally subdivided into three phases, and each phase has been further subdivided where necessary. Thus we get such references as EH II, MM IA, etc. which tend to mystify and exasperate the layman. This system, although it has stood the test of time fairly well, is becoming increasingly cumbersome even to scholars, and where an absolute dating is assured, it is always preferable to use it. Another disadvantage of this kind of dating is that it is based ultimately on pottery styles, some of which have proved to be not consecutive but concurrent, with the consequent telescoping of dates. Therefore, when used at all, this system should be applied only to a period of time, never to a particular pottery style. It is advisable, too, to bear in mind Pendlebury's remark: 'It is not reported that Minos declared, "I'm tired of Middle Minoan III, let Late Minoan I begin!"' [2]

Absolute chronology (that is to say, dates in years BC) is clearly the ultimate answer to this problem, and there are two methods of

Chronological table of the Aegean Bronze Age

BC	CRETE	CYCLADES	GREECE	EGYPT	DYNASTY
3000					
2800	E M I	E C I	E H I	ARCHAIC	I I
2600					III
2500				OLD	IV
2400	E M II	E C II	E H II	KINGDOM	V
2300					VI
2200					
2100	E M III	E C III	E H III	1st INTER	VII-X
2000					XI
1900	M M I	M C I		MIDDLE KINGDOM	XII
1800	M M II	M C II	M H		
1700				2nd INTER	XIII-XVII
1600	M M III	M C III			
1500	L M I A / L M I B		L H I / L H II		
1400	L M II / L M IIIA		L H IIIA	NEW KINGDOM	XVIII
1300	L M IIIB		L H IIIB		
1200	L M IIIC		L H IIIC		XIX-XX
1100	DARK AGES			LATE PERIOD	XXI
1000					
900					

2 Chronological table of the Aegean Bronze Age. *N.B.* In Crete MMII is found only at Knossos and Phaestos, LMII is found only at Knossos. In the Cyclades the subdivisions of the Late Cycladic period are seldom used; the LM and LH systems are used instead. In Greece MH is not yet susceptible of division into phases. The terms LH and 'Mycenaean' are synonymous. In Egypt, Inter=Intermediate

obtaining it. The first is that inaugurated by Newton: correlations with the better-established chronologies of Egypt and the Near East. These chronologies rest ultimately upon Egyptian astronomical fixes, which, coupled with king-lists, give certainty as far back as 2000 BC, and a high degree of probability to 3000 BC.

A second system, not yet perfected, is well on the way to providing an absolute date for any organic object (wood, bone, etc) which may be recovered from an excavation. It is based on the fact that in certain substances containing carbon there is a predictable proportion of radioactive carbon, or Carbon 14, as it is called. In life, animal and vegetable forms maintain a constant proportion of Carbon 14, but after death it gradually decays at a known rate. It is thus in theory possible, by measuring the amount of Carbon 14 in a bone or in a piece of wood, to date the death of the creature or the tree. There are difficulties, but some eminently reasonable dates are being obtained, and are proving particularly useful for fixing the chronology of the Early Bronze Age, where good results have been obtained at Lerna and Eutresis.

The diagram (*Ill. 2*) attempts to set out the chronology, relative and absolute, of the Bronze Age in the Aegean. It should, however, be noted that here, and in this book generally, all dates are approximate; in the Early Bronze Age the margin of error may extend to several centuries.

HISTORICAL BACKGROUND

The historical background is, very briefly, as follows. Bronze Age civilization came to Greece from the more advanced East about 3000 BC, and for a thousand years ran an approximately parallel course in Crete, the Cyclades, and Mainland Greece. About 2000 BC the continuity was broken. In Crete civilization rose to new heights; the Cyclades came under Cretan influence; and Mainland Greece suffered a severe setback.

Then, about 1550 BC the Greek Mainland adopted Cretan culture, which continued to flourish in its homeland. About 1450 BC the hegemony passed from Crete to Mainland Greece under the leadership of Mycenae. The fourteenth and thirteenth centuries are

known as the Mycenaean Empire. Political power was henceforth vested in the Mainland, but the art of the Empire was essentially Cretan.

About 1200 BC mass destructions brought the Empire to its knees. A brief artistic renaissance followed in some areas, but the Bronze Age finally came to an end about 1100 BC, to be followed by some two centuries of poverty and near-barbarism.

For the sake of convenience, the arts of Crete, the Cyclades and Greece will be considered separately down to 1550 BC. Thereafter, the whole Aegean area will be taken together.

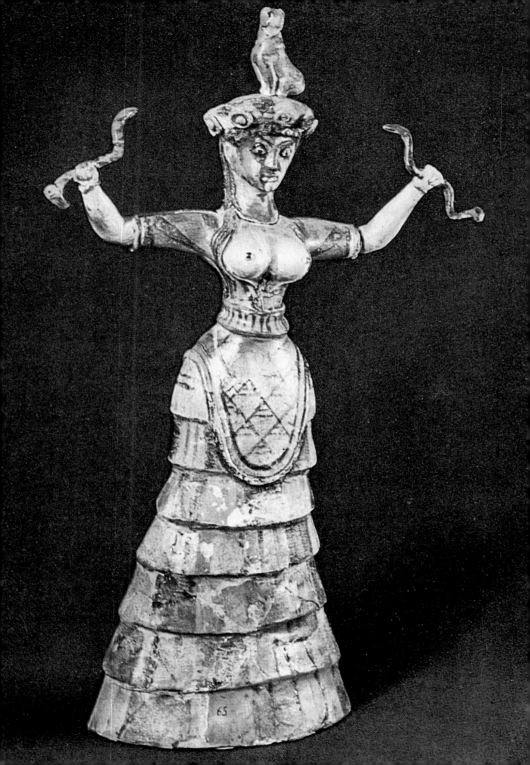

Crete 3000–1550 BC

This chapter is concerned with Cretan art from the beginning of the Bronze Age until (but excluding) the emergence of the Greek Mainland under Mycenae as a rival to Crete.

Civilization was brought to Crete by immigrants from Asia Minor who arrived about 3000 BC and combined with the Neolithic inhabitants. The main centres of civilization were in the east of the island, where many rich settlements have been excavated. Communal tombs in the south, first erected about 2500 BC, also bear witness to a thriving population and possibly to Egyptian or Libyan immigration.

This period is divided by archaeologists, for their convenience, into three phases, but the development was in fact gradual. It ends peacefully, with the shift of power and wealth to the cities of the centre and south.

Here, about 2000 BC, arose an elaborate civilization, based on royal palaces at Knossos, Phaestos, a place whose ancient name is not known (its modern name is Mallia) and probably at Zakro in the east. These palaces and this new civilization clearly owe their origins to intensified contacts with Western Asia and Egypt, but the foreign influences were soon absorbed and transformed by the innate inventiveness of the Cretans into something peculiarly their own.

The destruction by earthquake of the palaces about 1700 BC and their subsequent re-erection on a grander scale scarcely affected the cultural life of the inhabitants. Nor, so far as Crete is concerned, was there any break at 1550 BC, when this chapter ends.

◀ 3 Faience statuette of a Snake Goddess, or perhaps one of her human attendants, made *c.* 1600 BC and found in a stone-lined pit in the palace at Knossos. This figurine could well serve as an exemplar of Cretan art, combining as it does the two dominant characteristics of grace and naturalism

There is evidence for trade with the Cyclades, but not with Mainland Greece (although a Cretan colony was founded on the island of Kythera as early as 2000 BC), with Cyprus, the Levant, the Euphrates valley and Egypt. Crete exported timber, textiles, purple dye, wine and oil, and imported gold, precious stones and ivory.

The peaceful character of this civilization is noticeable even before the Palace period. It was to remain a Cretan peculiarity and contributed to no small extent to the rapid development of her culture.

From the foundation of the palaces about 2000 BC the Cretan civilization was, as is only to be expected, literate. The first form of writing was a hieroglyphic script, found scratched on clay tablets, engraved on stone seals and painted on vases, and derived ultimately from Egyptian models. At some time during the period of the first palaces (2000–1700 BC) a linear script (Linear Script A) evolved from the hieroglyphic and existed side by side with it, much as hieroglyphic and hieratic writing co-existed in Egypt. In the second palaces Linear A was the only script in use, and it flourished down to the destructions of 1450 BC.

ARCHITECTURE

Of the palaces at Knossos, Phaestos, Mallia and (probably) Zakro, which were built about 2000 BC and destroyed by a terrible earthquake about 1700 BC, we know very little. It is, however, safe to say that they must have been like the later palaces but less complicated. The ruins which we see today on these four sites (*Ills. 6–8*) are essentially those of the second palaces, rebuilt on a grander scale after the earthquake, and destroyed (with one exception) by causes unknown about 1450 BC. The exception is the largest and most important of them all, that at Knossos, known as the Labyrinth, or Hall of the Double Axe. It was indeed damaged by the eruption, but was apparently re-occupied and rebuilt by Mycenaeans from the Mainland, to be finally destroyed shortly after 1400 BC.[1]

There is a strong family likeness between all known Cretan palaces, and it is evident that they share a common plan, probably derived from Knossos (*Ills. 4, 5*). By the time the second palaces

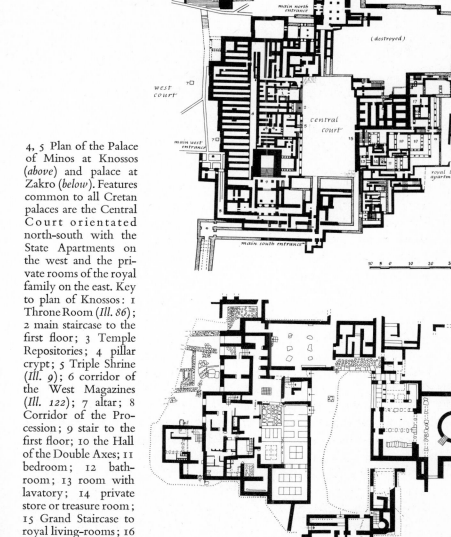

4, 5 Plan of the Palace of Minos at Knossos (*above*) and palace at Zakro (*below*). Features common to all Cretan palaces are the Central Court orientated north-south with the State Apartments on the west and the private rooms of the royal family on the east. Key to plan of Knossos: 1 Throne Room (*Ill. 86*); 2 main staircase to the first floor; 3 Temple Repositories; 4 pillar crypt; 5 Triple Shrine (*Ill. 9*); 6 corridor of the West Magazines (*Ill. 122*); 7 altar; 8 Corridor of the Procession; 9 stair to the first floor; 10 the Hall of the Double Axes; 11 bedroom; 12 bathroom; 13 room with lavatory; 14 private store or treasure room; 15 Grand Staircase to royal living-rooms; 16 Lapidary's Workshop; 17 schoolroom

6–8 The palaces at Knossos (*above*), at Phaestos (*below*) and Mallia (*below, right*) as they are today. A considerable amount of modern reconstruction and restoration has been done at Knossos, but Phaestos and Mallia are much as they were left by the destructions of 1450 BC

were erected the plan had evolved into something peculiarly Cretan, but there is little doubt that the earlier versions owed much to Western Asiatic models.

The heart of a Cretan palace is a rectangular central court, of almost standard size, about 50 yards (45 m.) long by 25 yards (23m.) wide. Many oriental palaces possessed a central court, but as they were built within strong fortification walls they tended to spread inwards from the outside. Cretan palaces, however, with no fortification walls, were able to expand outwards from the court in what might be termed a centrifugal action, almost without restriction.

The one restriction was a standard ornamental façade on the west, facing an outside court. It could hardly be called an entrance court, for the West Façades contained no grand entrance. The entrances were always unobtrusive, and led, usually by devious routes, to the Central Court.

The important buildings faced inwards on to the Central Court. Let us take a closer look at Knossos. If you stood in the Central Court you would see on the west the State Apartments (*Ill. 9*), comprising a basement and two principal storeys, and rising to about 45 feet (14 m.) in height; on the east were the Private Apartments,

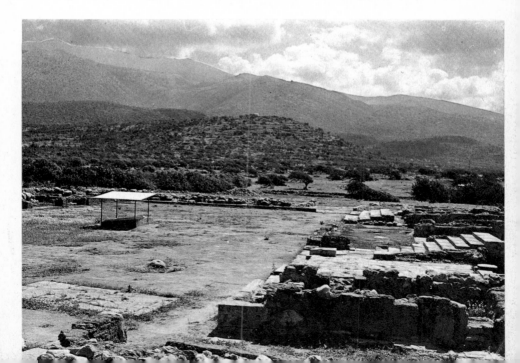

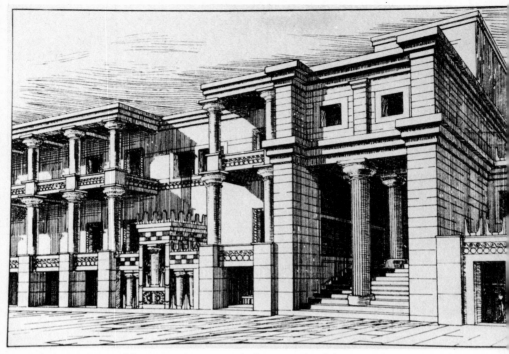

9 Reconstruction of the State Apartments on the west side of the Central Court at Knossos. On the extreme right is the entrance to the Throne Room; next to it is the stepped porch leading up to the Central Hall; and next to this (with the crenellated roof) is the principal shrine of the palace. The reconstruction, although imaginative, is soundly based on archaeological evidence

somewhat similar to the State Apartments, but continuing down the sloping ground, and served by a Grand Staircase which has largely survived. To the north-east were the palace stores and workshops. Farther to the west, on basement level, were the storage magazines. In these were found enormous clay jars which held supplies of oil and foodstuffs, and under the floors were stone treasure-chests.

By means of light-wells (that is to say, small courtyards) it was possible to extend in any direction without sacrificing light or ventilation, and this was done. There is little obvious sense of planning in a Cretan palace, much of gradual and organic growth. It was

no doubt this maze-like effect, still to be observed, which gave rise to the legend of Theseus and the Labyrinth.

Another feature which facilitated this kind of expansion was the use of flat roofs, which make casual extensions a much easier business than when gables are used.

The walls were usually of rubble masonry or mud-brick, framed with horizontal and vertical timbers, and plastered. Dressed blocks of limestone or gypsum were used for special purposes, as for example on the ornamental West Façades. Room-walls were mostly decorated with frescoes, but in exceptional cases were veneered with slabs of gypsum.

The upper floors were regularly supported by wooden columns resting on gypsum bases. They had ornamental capitals, from which they tapered downwards, and were painted in gay colours. Stone pillars were less commonly used, and were evidently considered too unsightly for general use. Ceilings were of wood, plastered and painted, and floors were regularly composed of slabs of gypsum. Courtyards and light-wells were paved with limestone, for gypsum is soluble in water, and cannot be used on unprotected surfaces.

PAINTING AND POTTERY

Wall-paintings certainly existed before 1550 BC but surviving examples are so few that it seems better to postpone discussion of this subject till a later point in this survey (see p. 94).

Pottery of the Early Minoan period was hand-made, but attractive, and often complicated, shapes are nevertheless the rule rather than the exception.

The typical wares of the first phase (3000–2500 BC) comprise two main groups: survivals from the Neolithic period, which may reasonably be ignored, and a new variety, introduced by Asiatic immigrants. The new shapes are round-bottomed jugs with beaked spouts (*Ill. 10*) and bulbous jars with lugs at the side, pierced for suspension. The decoration is in very simple linear patterns in a red or brown semi-lustrous paint.

At its first appearance here, a word about this paint may not be out of place. In almost the same form it was used continuously to

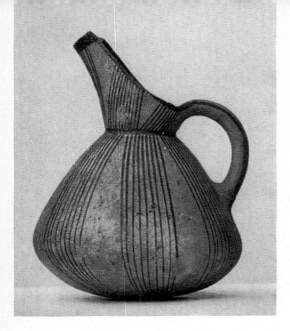

10, 11 Hand-made jug of the Early Minoan period (*left*). The shape is sturdy but dignified, and the pattern, in a red semi-lustrous paint, is well adapted to the shape. The extravagant shape of the Vasiliki Ware 'teapot' (*right*) is clearly indebted to metal originals, but the mottled surface was probably intended to imitate the appearance of contemporary vases in variegated stone (cf. *Ills. 26* and *27*)

decorate pottery in Greek lands from about 3000 BC to about the fourth century AD. It is generally referred to as *paint* by prehistoric archaeologists, but as *glaze* or *gloss* by Classical archaeologists. In this book it will be referred to as a lustrous or semi-lustrous paint, in contrast to the slightly different matt paint, which was used on certain fabrics in the Middle Bronze Age. These terms have deliberately been left vague and unscientific, because it is not always possible to be certain from appearances alone of the composition of a paint, and the systematic analysis of Bronze Age vase-paints has not yet proceeded very far.

This paint, at first semi-lustrous, later fully lustrous, is basically a highly refined clay, rich in iron, which under oxidizing conditions (i.e. in a clear fire) will fire red, but under reducing conditions (i.e. in a smoky fire) will fire black. The great difficulty in this process was to achieve a black paint without also blackening the body of the vase, which was also composed of an iron-rich clay. This difficulty was met by a three-stage firing, at first oxidizing, then reducing, then partially re-oxidizing, the last stage being sufficient to redden the pot but not the more resistant paint. Complete control was still far away,

and throughout the Bronze Age the colour tended to vary between black and brown or red on the same pot. The secret was apparently an invention of Mesopotamian potters in the fourth millennium B C. It reached Mainland Greece in the Late Neolithic period, but was apparently soon discarded and forgotten. It was then re-introduced into Crete from the East about 3000 B C and passed from Crete to the Cyclades and Mainland Greece.

In the second phase of the Early Minoan period, the dark-on-light system of decoration continued, but the characteristic pottery is the so-called Vasiliki Ware, named from the place where it has been most abundantly found (*Ill. 11*). It is decorated with the same paint as was used for the linear patterns, but it is applied over the entire surface of the vase, and the surface is mottled with large black spots. This attractive effect, imitating variegated stone vases, was probably obtained by holding a burning twig against the surface at various points while the vase was still hot from the kiln.

The most popular shapes are a refined form of the earlier beak-spouted jug – it now stands on a firm base – and the so-called teapot (*Ill. 11*), a jar with an enormous horizontal spout. Imitation of metal

originals is betrayed by the angular shapes and by the occasional imitation of rivets. The home of this extravagant vase-shape was in Asia Minor.

The pottery of the third Early Minoan phase (2200–2000 BC) is also best represented at Vasiliki and at other East Cretan sites. Designs in a thick creamy white were drawn at first on a mottled Vasiliki-type ground, later against a black paint, which was evidently found to make a more satisfactory, and a more easily achieved background (*Ill. 12*). The patterns are simple but strangely effective; thick lines, vertical, horizontal, diagonal or slightly curved, with the subsidiary use of spirals. They give the impression of having been squeezed out of a tube rather than applied with a brush.

The teapot is still popular, but the spout is somewhat reduced in size. Jugs, too, are less extravagant in shape; but the characteristic vessel is a drinking-cup resembling a modern tea-cup, but usually without a handle. The so-called hole-mouth jug also makes its first appearance.

The pottery of the time of the first palaces (2000–1700 BC) is best considered as a whole; in the orthodox chronology it covers Middle Minoan I and II. This pottery is normally known as Kamares Ware, from the cave-sanctuary where it was first found. The finest examples were evidently made for palatial use, since they are seldom found outside Knossos and Phaestos. The decoration is an elaboration of the white-on-black of the previous phase (see *Ill. 12*), but the fabric is immeasurably superior, thanks to the introduction, probably from Asia Minor, of the potter's wheel (*Ills. 13, 14, 15*).

The shapes are mostly refinements on earlier forms; bridge-spouted jars, beak-spouted jugs, tea-cups and two-handled cups. The finest pieces are of eggshell thinness. The inspiration of metal vases (few of which have survived), is noticeable. Applied ornament in the shape of flowers or raised knobs is now regrettably popular (*Ill. 16*).

The patterns are drawn in a new pure white and in many brilliant shades of red, orange and yellow, against a black ground. The surface of the black varies considerably. In most examples it is almost matt in appearance, but in the best eggshell-ware it has a definite lustre.

26

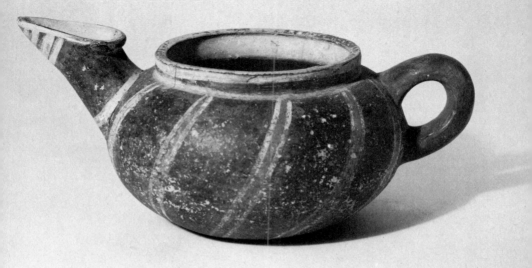

12 Hand-made 'teapot' of Early Minoan date, 2200–2000 BC. When the taste for Vasiliki Ware began to wane, Cretan potters adopted a light-on-dark system of decoration. A thick creamy white was applied, at first on a mottled Vasiliki-type ground, later (and more successfully) on a black ground. The patterns are simple but effective

The motives are infinitely various: curvilinear abstract patterns; natural forms such as marine creatures, frogs, flowers, leaves and petals; and imitations of striped and mottled stones. In the early stages the designs are stiff and geometric in character, and usually consist of individual units placed side by side or arranged in spiral strips. Soon, however, the potentialities of the style are fully realized: the decorative motives are organized into radiating and revolving schemes, throbbing with life. The bright colours and the writhing forms have much the appearance of a rich Paisley pattern, and make one of the most satisfying pottery styles ever to have been developed.

The pottery of the early stages of the second palaces (MM III, 1700–1550 BC), uses much the same means as in the previous period, but with a different effect. It is fashionable to decry this style. It certainly lacks the spontaneity and endless invention of Kamares Ware, but it boasts instead a stately charm and an exact representation of nature. Here we see for the first time that naturalism in which the art of the second palaces was to excel (*Ill. 17*).

13-15 The rise of the palaces in the Middle Minoan period in Crete brought about tremendous advances in civilization, one of which was the introduction of the potter's wheel. The spouted jar (*above*) from Phaestos is of Kamares Ware, as are the two 'tea-cups' (*below*) and the globular spouted jar (*above, right*). This ware, of very fine clay, has thin walls, and the decoration is a development of light-on-dark enriched with vibrant reds and yellows in intricate flowing designs based on natural forms, giving an impression of controlled movement within the graceful contours of the vase

The patterns are in white-on-black; subsidiary reds and yellows are found, but are less common. The motives (palm-trees, lilies, tulips, reeds and grasses), are adapted from the backgrounds of contemporary palace frescoes. It is noticeable that only the backgrounds of the frescoes are used, and the human subjects were ignored; they were doubtless (and possibly rightly) regarded as unsuitable for vase decoration.

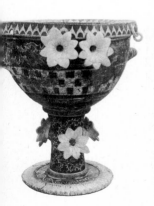

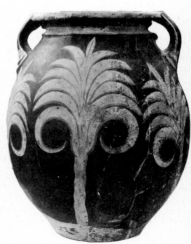

16, 17 The potters who made Kamares Ware had occasional aberrations, an outstanding example of which is a pedestal bowl from Phaestos (*left*) with applied three-dimensional ornament, perhaps the most vulgar object of Minoan workmanship so far known. The large jar (*right*) is of a later date, and is an honourable exception to the rule of general deterioration in pottery that took place towards the end of the Middle Minoan period

Very few Cretan terracottas can be dated earlier than 2000 BC, but between 2000 and 1550 they became very common. Some were found in communal tombs in the south, but by far the largest majority come from sanctuaries on mountain-tops, where they were dedicated by the faithful. They take the form of men, women, animals, and human limbs; the last doubtless thank-offerings for recovery from sickness.

The figurines were gaily coloured, but the colours seldom survive burial in the earth. In accordance with established Egyptian usage, male flesh was coloured red to denote a healthy outdoor tan, while female flesh was white, for a delicately nurtured lady would avoid exposure to the sun.

Let us consider a typical deposit at a mountain-sanctuary at Petsofa in East Crete (*Ills. 18, 19*). The men (*Ill. 19*) stand naked except for a belt, a frontal sheath, and occasionally a dagger. They belong to the lithe, broad-shouldered, narrow-hipped type which was always

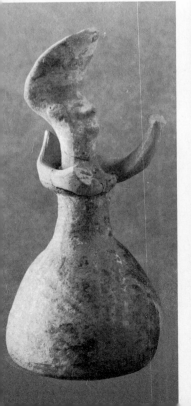
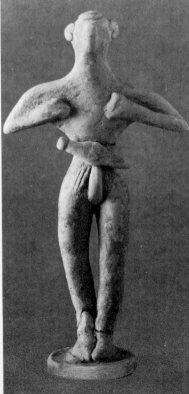

18, 19 Two terracotta votive figurines from a mountain-top sanctuary at Petsofa near Palaikastro in eastern Crete. The lady (*far left*) has a very Victorian appearance with her elaborate hat and flounced skirt. The gentleman (*left*) is more lightly clad, in a belt, a loincloth and a dagger. The modelling is simple and the details were sometimes touched with colour

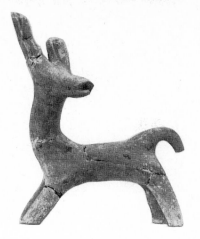

20 A spirited, if crude, rendering in terracotta of a deer from a communal tomb at Porti in the Mesara Plain, dating to 2000–1700 BC

admired in Crete, and still is. The women (*Ill. 18*) have a somewhat Victorian appearance in a long flaring skirt and a very low-cut bodice, with a girdle round the waist. They also occasionally wear elaborate picture-hats. One cannot expect these humble offerings of the poor to be great art, but they cast a valuable gleam of light on an ill-documented period.

From the communal tombs in the south come a spirited rendering of a deer (*Ill. 20*) and a bull with an acrobat.

FAIENCE

The material described in this book as *faience* passes under several names: *Egyptian faience*, or *glazed composition* are recognized alternatives. It consists of a core of quartz grains cemented together, and covered with a true vitreous glaze. The precise method of manufacture is uncertain, but it seems probable that the glaze is formed over the core during the process of firing.

Aptly described as 'man's first conscious essay in the production of a synthetic material',[2] faience was apparently invented in Western Asia at a very early date, but it took root in Egypt as early as the fourth millennium and flourished there in an unbroken sequence till Roman times.

Beads of this material were first made in Crete, under Egyptian influence, in the second Early Minoan phase (2500–2200 BC), but it was not until the eighteenth century BC that a more ambitious use was

31

21 Faience cut-out relief, one of the Town Mosaics and a similar ivory plaque (*far left*), give some idea of the exterior appearance of Minoan private houses, with two or three storeys built in clay bricks with timber tie-beams

made of it. Coloured plaques forming the so-called Town Mosaic were found in the palace at Knossos in a deposit of this date: they may have served as inlays decorating a wooden chest (*Ill. 21*). Some represent town houses; others trees, soldiers, animals, and a ship. The representations of the houses were of great help to Sir Arthur Evans in the reconstruction of parts of the palace at Knossos.

The richest collection of faience objects comes from the stone-lined pits in the palace at Knossos known as the Temple Repositories, which were sealed in by an earthquake which occurred about 1570 BC towards the end of the Middle Minoan period. In this collection are female figurines and appliqué reliefs of animals, marine creatures, flowers and fruit, and female clothing. They are brightly coloured in black and white and shades of blue, green, brown and yellow.

The female figurines comprise the so-called Snake Goddess and her two worshippers. The 'Goddess' (she may in fact be as human as the other two) is about 14 inches (35 cm.) tall, and is shown in *Ill. 22*. She wears a tall hat with a snake coiled round it, the usual tight-waisted, low-cut dress, and over it a short apron. Round her waist is a tight belt. The lower part has been restored from one of the other figures. Her arms are stretched out in front of her, and in each hand she holds a snake. The other two women are similarly dressed. One (*Ill. 3*) is more or less complete; only the lower part of the other survives.

These figures are among the earliest examples in the round of the naturalism which was to be a characteristic feature of the art of the second palaces.

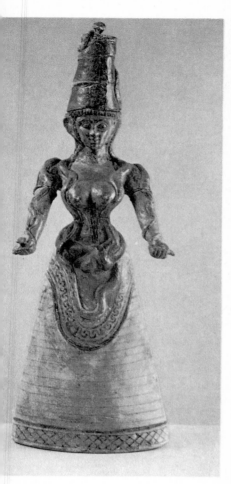

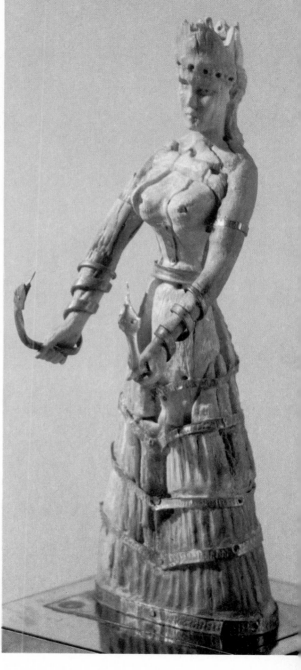

22, 23 Two ritual figurines representing either the Snake Goddess or her attendants. The faience figure (*above*) is a companion to that shown in *Ill. 3*. The authenticity of the ivory and gold figure (*right*) has been questioned, but without good foundation, as the details of costume and feature, the tautness of the pose and the delicacy of the execution all ring absolutely true

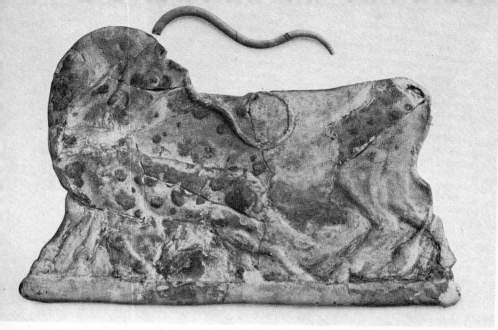

24 Faience plaque of a cow and her calf, from the same deposit at Knossos as the figurines of *Ills. 3* and *22*. For a sympathetic and accurate study from nature this group, which dates *c.* 1600 BC, would be hard to equal in any period

The finest of the appliqué reliefs are a group of a cow with her calf and of a goat with her kid, which are among the most sensitive studies of animals of this period (*Ill. 24*).

IVORIES

Ivory-carving was one of the great arts of the Cretan palaces, but our evidence is scarce and fragmentary, since ivory is subject to decay when buried in damp earth for any length of time. The raw material consisted of tusks of the Syrian elephant, which did not become extinct till the ninth century BC. It was carved in palace workshops, some of which have been identified in the ruins of the second palaces by the presence of ivory-chippings and of whole tusks.

An outstanding example of this art is a gold and ivory statuette in Boston, the so-called Ivory Snake Goddess (*Ill. 23*). Its provenance is uncertain, and its authenticity has in consequence been doubted.

As to the former, there was a strong rumour at the time of its acquisition that it had been removed from the so-called Ivory Deposit in the palace at Knossos which was sealed by the same earthquake of 1570 BC which preserved the Faience Snake Goddess. Such a date, in the late seventeenth or early sixteenth century BC, accords well with the resemblance between this goddess and the faience goddess. As to the question of authenticity, it is accepted by most of those best qualified to judge, and we, too, may accept it.

It has been reconstructed from the splinters into which it had disintegrated. The body was made in two pieces, pegged together, and the arms were also attached with pegs. She wears the same costume as the faience goddess; holes round the top of the head suggest that she also wore a tall headdress. Thin gold bands indicate her bracelets and belt, the flounces on her skirt, and the snakes; and her nipples are marked by gold nails.

Her head is thrown back and her body slightly arched, to give a particularly Cretan impression of tautness and alertness.

Less complete, but better authenticated, is an ivory figure of an acrobat from a bull-jumping group (*Ill. 25*; the bull is unfortunately lost). This comes from the Ivory Deposit at Knossos in which the Boston Goddess is believed to have originated. The same athletic tautness is noticeable here, in spite of the ruinous condition of this figure.

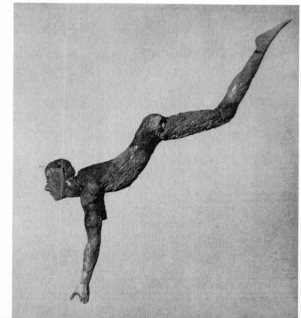

25 Ivory figure of a bull-leaper from the palace at Knossos, dating *c.* 1600 BC. This tense and slender figure probably comes from a group of participants in the bull-sports, in which the acrobat would confront a charging bull, turn a somersault over its horns and leap off its back. Both sexes took part in this dangerous sport, which was probably religious in character

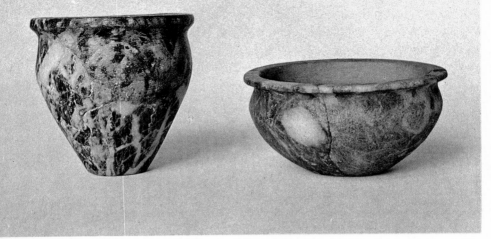

26 Two marble jars from Palaikastro (*left*) and Mochlos (*right*), of 2500–2000 BC. The laborious process of making stone vases was learned in Egypt and practised with great success in Crete from 2500 onwards. The earliest vases are amongst the finest, with graceful shapes and very effective use of the natural colouring of the stone

STONE VASES

Superb stone vases were made in Crete from an early period. As many as 130 were found in tombs at Mochlos of the second and third Early Minoan phase (2500–2000 BC). They were made of brightly coloured variegated stones (limestone, marble, breccia, alabaster and serpentine) – most, if not all, of local origin – with a skill learned from Egyptian masters.

The exterior was blocked out by pounding with hard stones and finished by grinding with an abrasive powder, either sand or emery from Naxos. The interior was hollowed out with a copper tubular drill rotated by a bow and fed with the same abrasive. The cylindrical core left by the drill was then broken away and the central hole was enlarged with a different type of drill.

The shapes are graceful and varied. Some recall Egyptian proto-types, but most are modelled on contemporary Cretan pottery (see *Ills. 26, 27*).

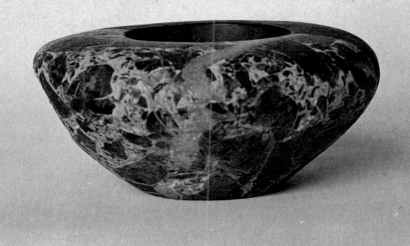

27 A breccia bird's-nest vase from Mochlos, of 2500–2000 B C. It was probably used as an unguent jar, and originally had a lid. The shape was very popular, and examples of it are found over a period of about a thousand years in Crete

A favourite form is the so-called bird's-nest vase (*Ill. 27*), a graceful bowl of roughly the shape of a truncated cone, tapering towards the base. In some examples the vase is engraved on the outside to represent petals, and is known as a blossom bowl (*Ill. 28*). This variety seems to have evolved early in the Middle Minoan period and both persisted virtually unchanged till the fall of the palace at Knossos, about 1375 B C, a phenomenon almost unique in a civilization as addicted to change as the Cretan. The material generally used for Middle Minoan vases is a dark grey serpentine.

Three stone lids have a dog modelled on the top. One was found many years ago at Mochlos, a second at Tylissos; and the third was

28 Blossom bowl of serpentine (often incorrectly referred to as steatite). This form is a development of the bird's nest of *Ill. 27*, with petals carved on the outer surface to imitate a flower. Like the bird's nest, this shape persisted till after 1500 B C

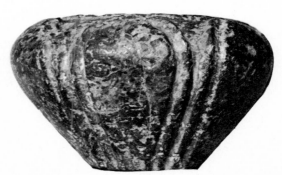

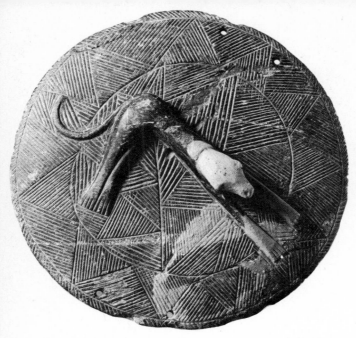

29 Lid of a jar, of green schist, from a tomb near the recently discovered palace at Zakro. There is an almost impressionistic quality about the sprawling village dog which is carved as if resting on it. Two similar lids were found at Mochlos and Tylissos, and the close resemblance between the three suggests that they were made by the same hand

recently excavated at Zakro (*Ill. 29*). All these lids were made in the second Early Minoan phase (2500–2200 BC), surely by the same craftsman. The lifelike representation of a sprawling village dog gives a foretaste of the naturalistic style in which Cretan artists were later to excel.

PLATE

Very little plate has been found in Crete in Early and Middle Minoan levels. The use of vessels of gold and silver in the first palaces might well, however, be assumed from the luxurious nature of the palaces, and is in fact confirmed by the obvious dependence of many pottery forms on metal originals.

The only example actually excavated in Crete is a silver two-handled cup from Gournia (*Ill. 30*) which can be dated, by comparison with pottery vessels, to the nineteenth century BC.

Slightly earlier is a hoard of silver vessels and other articles found at Tod in Upper Egypt and dated by the cartouche of Ammenemes II (*c.* 1929–1895 BC) to the later twentieth century. The vessels comprise for the most part shallow two-handled cups with spirals and

38

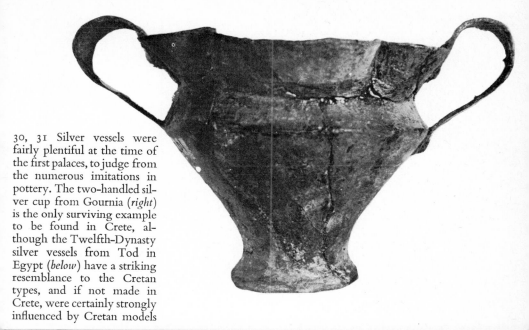

30, 31 Silver vessels were fairly plentiful at the time of the first palaces, to judge from the numerous imitations in pottery. The two-handled silver cup from Gournia (*right*) is the only surviving example to be found in Crete, although the Twelfth-Dynasty silver vessels from Tod in Egypt (*below*) have a striking resemblance to the Cretan types, and if not made in Crete, were certainly strongly influenced by Cretan models

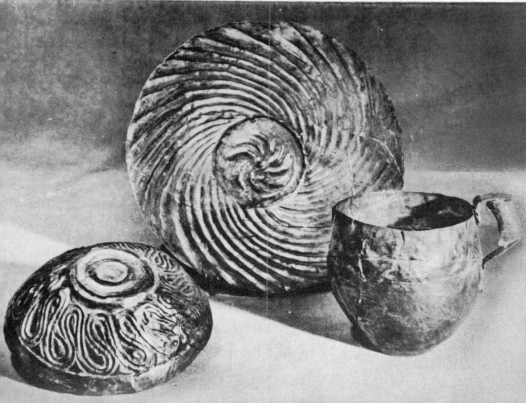

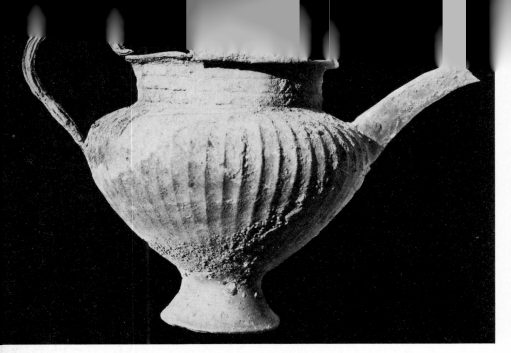

similar Cretan patterns embossed on them (*Ill. 31*). They include a cup with a typically Cretan handle like those on the Vapheio cups and (rather surprisingly) cups with two high handles, which are more common in clay on the Mainland than in Crete (cf. *Ill. 74*). There is some disagreement whether these vessels are Cretan, or were made in Western Asia under Cretan influence. In any event, they are very much the sort of silver plate which would have graced the royal tables in the first palaces.

A fragmentary bowl with spiral decoration, and two silver spouted bowls, all probably Cretan, come from tombs at Byblos of the years around 1800 B C. One of the spouted bowls, with a fluted body, is shown in *Ill. 32*.

A gold cup in the British Museum from the Aegina Treasure (see p. 49) is almost certainly Cretan work of the late seventeenth or early sixteenth century B C (*Ills. 33, 34*). Apart from the loss of its handle, it is in a fair state of preservation. Its shape is a shallow bowl with a separate concave rim and a low foot. The body is decorated with embossed spirals and the base with an embossed rosette.

32 Silver 'teapot' from a royal tomb at Byblos, of *c.* 1800 BC (*opposite*). Like the vessels from Tod (*Ill. 31*), this jar, and others from Byblos, is either true Cretan work or a Levantine imitation of it

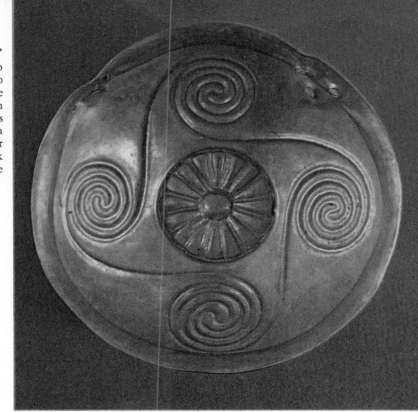

33, 34 A gold cup, the handle of which is now missing, part of the Aegina Treasure in the British Museum. Its affinities indicate Cretan manufacture of *c.* 1600–1500 BC. The sides of the cups are embossed with running spirals and the base with a rosette

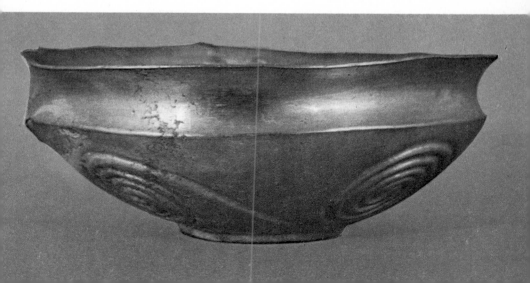

A wealth of decorated weapons could scarcely be expected in a community as peaceful as Crete between 3000 and 1550 BC, yet the palaces must have had their ceremonial guards and the rulers their insignia of office, and the ruins of the first palaces at Mallia have in fact yielded three ceremonial swords of about the eighteenth century BC.

Two blades, 30 inches (77 cm.) and 28 inches (72 cm.) long respectively, were found on the palace floor. The hilt of the smaller sword was also recovered. It was of wood, covered with gold foil, with a bone pommel. Beneath the pommel was a circular gold disk

35 Gold covering of the pommel of a great bronze sword from the palace of Mallia, of the eighteenth century BC. A youthful acrobat is shown with his body arched back so that his feet touch the top of his head. The design illustrates the ability of the Cretan artist to fill the field decoratively without losing touch with reality

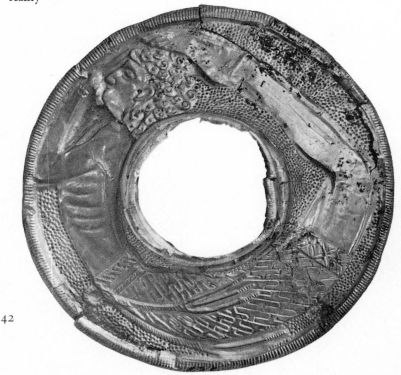

bearing a most realistic embossed representation of an acrobat bending his body backwards in a complete circle (*Ill. 35*).

A third was found in the palace workshop. It was about 40 inches (1 m.) long and had a hilt of grey limestone covered with gold foil and a pommel of rock-crystal cut in eight facets.

In this connection it is interesting to recall an entry in the palace archives of Mari on the Euphrates where mention is made of a Kaphtorite (i.e. Cretan) weapon of which the top is encrusted with lapis lazuli, and the top and bottom are embellished with gold. This entry dates from the later eighteenth century BC, the most probable date of the Mallia swords which so nearly answer to this description.

JEWELLERY

Gold jewellery and beads of semi-precious stones enjoyed an early popularity in Crete. The oldest surviving examples come from tombs on the island of Mochlos, and are dated 2300–2100 BC (EM II–III).

36 A gold diadem, overlooked by the earlier excavators, has recently come to light in a tomb on Mochlos of 2300–2100 BC. It is equipped with three vertical 'antennae' and has pictures of animals in dot repoussé

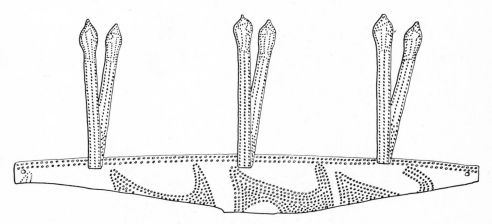

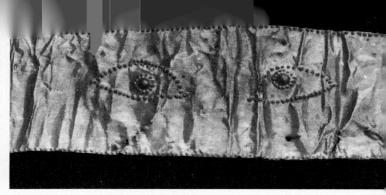

37 A graceful gold pendant from Sphoungaras, contemporary with the Mochlos jewellery, about 2300–2100 BC

38 The central portion of a gold band with two eyes indicated in dot-repoussé, one of a group from the tombs at Mochlos of 2300–2100 BC. These bands were evidently pinned round the forehead or perhaps (to judge from this example) over the eyes of the dead. The clumsy workmanship is probably an attempt to imitate granulated work by the easiest possible means

The antecedents of this early jewellery go back ultimately to Babylonia, to such models as are recorded from the Royal Graves at Ur, but the fashion reached Crete, via Syria, in a considerably weakened form. The basic materials are thin sheet gold, cut into shapes and lightly embossed, and ornamental chains.

The jewellery consists of diadems decorated with primitive figured scenes by means of raised dots (*Ills. 36, 38*); hair ornaments in the shape of flowers and leaves (*Ills. 41, 42*); beads of various shapes; and pendants such as leaves, sprays, axes, and cones hanging from chains (*Ill. 37*). Other beads from this site were made of gold, rock-crystal, amethyst, carnelian, steatite and faience.

39,40 Gold pendants of Middle Minoan date, 1700–1550 BC (*opposite*). The exquisite jewel from Mallia (*above*) shows two bees heraldically arranged about a honeycomb and is probably typical of the lost jewellery worn at Knossos and Phaestos. The Aegina Treasure pendant (*below*) shows a nature-god, the Master of Animals, with a water bird in either hand. Although plainly influenced by Egyptian work, the details of the piece are purely Cretan

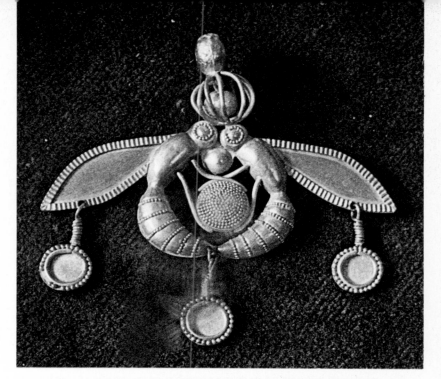

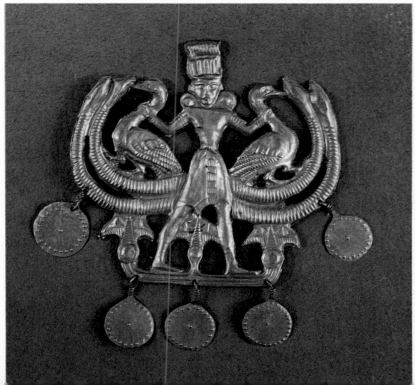

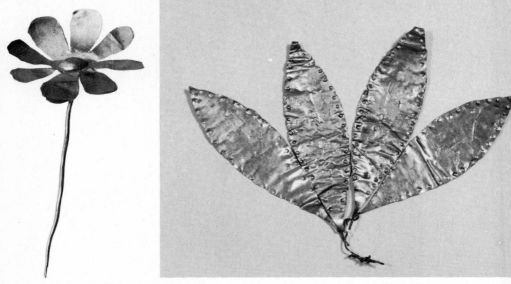

41, 42 Two gold hair-ornaments of 2300–2100 B C, that on the left probably and that on the right certainly from Mochlos. These simply made naturalistic pins are probably inspired by the more elaborate and stylized Babylonian jewellery from the Royal Tombs at Ur of *c.* 2700 B C

After 2000 B C the quality of Cretan jewellery, as of other luxury articles, improved considerably. Advanced technical processes, already familiar in Babylonia, now reached Crete. The route, as before, was by way of Syria. Among these processes are the arts of filigree and granulation (*Ills. 43, 44*). The former consists of decorating the surface of the gold with patterns of fine wire; the latter is a refinement of this process, in which minute grains of gold were substituted for the wire. The secret of attaching the grains was lost after about A D 1000 and has only recently been rediscovered. They were first attached to the background with a mixture of copper salt and glue. When the work was fired, the copper salt turned to copper oxide; the glue turned to carbon; the carbon combined with oxygen from the copper oxide and went off as carbon dioxide, leaving a layer of pure copper binding the grains to the background.

Another process is the inlaying of precious stones in cells (or *cloisons*); and yet another is the embossing of sheet gold by means of punches or with moulds or stamps.

46

It is probable that all these processes were employed to make jewellery for the lords of the first palaces as early as the nineteenth century BC. They make up, with one exception, the complete repertoire of the ancient goldsmith. That exception is the art of enamelling, which was not used till somewhat later (see p. 172), and not perfected till later still.

Surviving jewellery of the Middle Minoan period is not plentiful, as no rich unplundered tombs of this date have as yet been discovered in Crete. The communal tomb at Mallia known as Chrysolakkos has yielded a few outstanding pieces, but the bulk of surviving Middle Minoan jewellery comes from a collection now in the British Museum known as the Aegina Treasure. This collection was allegedly discovered in a Mycenaean tomb on the island of Aegina of the thirteenth century BC, but research has shown that it is Cretan work of the seventeenth and sixteenth centuries BC; it is therefore in all probability the loot of an ancient tomb-robber. The latest pieces from this collection are Late Minoan, but for the sake of convenience it will all be considered in this chapter.

The famous gold pendant from Mallia of the confronted bees shows almost all the new and exotic techniques employed to make a completely Cretan object (*Ill. 39*). It was made in the seventeenth century BC, or perhaps somewhat earlier. Two bees are posed heraldically over a honeycomb (?); from the jewel hang three disks.

43, 44 Two early examples of the techniques of filigree and granulation. A tiny gold lion (*left*) has its mane graphically indicated in gold granules, and a cylindrical bead (*right*) is decorated with filigree spirals. Both came from communal tombs in the Mesara Plain

 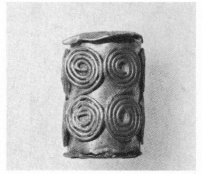

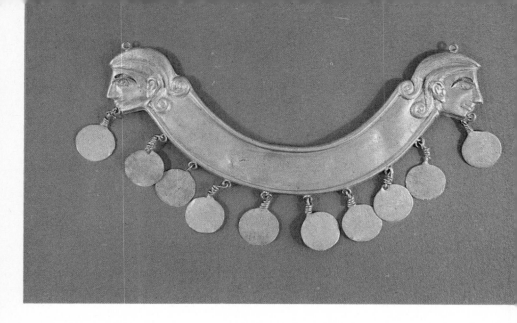

45, 46 Jewellery from the so-called Aegina Treasure. The pectoral (*above*) has profile heads at each end, the eyes and eyebrows of which were probably inlaid with lapis lazuli. The disks may be sun-symbols. The beads (*below*) are of gold and semi-precious stones repeating the same design in gold, lapis lazuli and carnelian, and the rings are also inlaid with lapis lazuli. The ring at the top (not from the Aegina Treasure) is also shown in *Ill. 50*

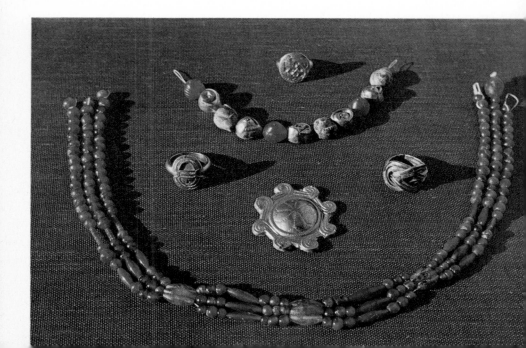

The arts of embossing, filigree and granulation are most effectively combined.

A contemporary pendant of simpler work, without filigree or granulation, comes from the Aegina Treasure in the British Museum (*Ill. 40*). A nature-god, holding in either hand a water bird, stands on a field of lotuses; the birds rest on mysterious objects, probably composite bows. From the base-line hang disks like those attached to the hornet-jewel. We do not know the god's real name, but we may call him the Master of Animals. Although the influence of Egyptian art is strong in this piece, the god is a true Cretan, for he wears the typical tight belt, loin-cloth and frontal sheath.

Another pendant from the same source as the Master of Animals was intended to be worn on the breast, attached by a cord going round the wearer's neck (*Ill. 45*). It consists of a curved plate of gold terminating at either end in a human head, and also hung with pendant disks. The eyes were originally inlaid, probably with lapis lazuli. It will be noted that Middle Minoan artists already favoured the so-called 'Greek profile', the unbroken line of brow and nose.

The same collection includes beads of gold, carnelian, rock-crystal, amethyst, green jasper and lapis lazuli (*Ill. 46*). Identical beads in the shape of a hand holding a breast were made in gold, carnelian and lapis lazuli and there are four magnificent gold finger-rings inlaid with lapis lazuli. One of the latter (*Ill. 46*) has a bezel in the form of a double axe, another of a reef-knot; two others are simple hoops.

Finger-rings of the standard Minoan-Mycenaean form, with an oval bezel at right angles to the hoop (*Ill. 47*), make their first appearance in the eighteenth century BC, and lasted until the end of the Bronze Age. The material was gold, gold-plated bronze, or simple bronze. The bezel was most frequently left plain in the early stages, but in the Late Bronze Age was often engraved as a seal or inlaid with coloured stones or glass (see p. 184).

47 A typical Minoan ring of a style which became equally popular in Mycenaean centres. It has a slightly convex oval bezel set at right angles to the hoop, and was first used *c.* 1700 or even earlier, persisting until after 1100 BC

Seal-engraving was one of the great Cretan arts, and the one most suited to the Cretan genius. As elsewhere in the ancient world, seals were used for four purposes: identification, security, magic, and art. Chests and stores of all kinds were bound with cords and the knots secured with nodules of clay stamped with the owner's seal, and stoppers of jars were sealed in the same way. These sealings served both to indicate ownership and to show if the stores had been tampered with.

Apart from their utilitarian role, seals were also credited with magical properties by virtue of their material, their shape, and the patterns engraved on them. They became, in fact, lucky charms: amulets or talismans. This aspect has survived into our own day, for Sir Arthur Evans found Cretan women wearing ancient seal-stones as milk-charms.

Lastly, there can be no doubt that from an early period seals were appreciated by their owners for the beauty of the stones themselves and of the scenes engraved on them.

Seals had been in use in Babylonia and Egypt before their appearance in Crete. In Babylonia the accepted variety was the engraved cylinder, which was rolled to make a continuous impression; in Egypt the stamp-seal was preferred. The latter variety was adopted in Crete in the second Early Minoan phase (2500–2200 BC) together with other Egyptian fashions.

Cretan seals were mostly made in the form of beads or pendants to be worn strung round the wrist. Gold signet-rings occur from about 1700 BC, but even they are frequently too small to wear on the finger, and must also have been suspended from a cord.

Seals made in the Early and Middle Minoan periods fall into three main groups, our knowledge of which is derived not only from the seals themselves but also from ancient seal-impressions in clay. A selection of Middle Minoan seals and of modern plaster impressions is shown in *Ill. 48*.

The first group starts about 2300 BC. The materials are soft enough to be formed and engraved with a copper knife: bone, ivory and steatite. The shapes are infinitely varied: cones, pyramids,

48, 49 Some Cretan seals and modern plaster impressions. There is a very wide variety of motives, from realistic animal scenes to ritual vessels and purely geometric patterns

buttons, flasks, cubes, cylinders (engraved not on the side but on the ends); and figures of animals such as monkeys, lions, dogs and birds, with engravings on their bases. A large class of three-sided steatite prisms is believed to have been made not for sealing but for magical purposes, as no impressions from them have been found (*Ill. 49*).

The subjects are as various as the shapes, and include geometrical patterns, human beings and animals, ships, and (from 2000 BC) characters of the hieroglyphic script. The engraving is disappointingly clumsy as compared with the modelling of the seal-stones themselves.

The second group covers the second Middle Minoan phase (1900–1700 BC), and corresponds with the life of the first palaces, allowing for a time-lag of a century or so at the beginning. It saw tremendous technical advances. Steatite was still used, but now for the first time hard stones were also employed, thanks to the introduction of the cutting-wheel, which was used with abrasives, in conjunction with the tubular drill. The favoured stones were the quartzes – rock-crystal, amethyst, red and green jasper, carnelian, chalcedony and agate – which had been used for beads, but never yet for seals.

A seal-engraver's workshop discovered in 1956 in the palace at Mallia has produced valuable evidence for the working of steatite, ivory and rock-crystal at this date.

The shapes in common use were reduced to three: three-sided (occasionally four-sided) prisms, now rounded off to a more elegant shape; signets, a metallic form (originally at home in Asia Minor) both beautiful and practical, but not destined for a lasting popularity; and disks with flat or convex faces. Experiments were made with the Egyptian scarab form, but it never became established.

The principal subjects were geometrical patterns, studies of animals, and hieroglyphics. The technical ability of the engravers

was remarkably high, but it was not till the next period that the potentialities of the new techniques were fully exploited.

The third group covers the third Middle Minoan phase (1700–1550 BC) and corresponds with the first century and a half of the second palaces. The materials were much as before, with the omission of steatite, which was no longer used, and with the addition of haematite, a black stone with a high metallic lustre. Of the shapes in common use, signets continued in popularity; the lentoid, derived from the convex-sided disk, and named from its resemblance to a lentil-seed or a lens, made its first regular appearance. Two other new shapes are the amygdaloid, an almond-shaped stone, and the flattened cylinder, a rectangular shape with two convex faces. Signet-rings of gold or bronze also occur for the first time. In many, the hoop is so small that the ring could not have been worn on the finger; they should rather be regarded as signets in the form of a finger-ring. A fine example in the British Museum has an engraving of two goats mating (*Ill. 50*). The hoop in this case is too small to be worn even by a child.

In the seal-engraving of this period, the naturalism observed in contemporary painted pottery and in the few surviving frescoes is well to the fore. Favourite subjects are now religious scenes, studies of people and animals, architectural façades, and hieroglyphics, whose purpose must now have been decorative rather than literary, as the hieroglyphic script was no longer in general use. The engravings of this period convey a constant impression of grace and joyfulness.

A special class, the so-called talismanic stones, remains to be considered. No impressions from these stones have been found, and they are believed to have been used purely for magical purposes. They are usually of the amygdaloid form, with such diverse subjects as sacred vases (the commonest subject), vegetation, fish and insects, all executed in a hasty, scratchy style which is easily recognized.

50 Gold signet-ring with an intaglio design of two goats mating. In both design and execution this is one of the finest surviving Cretan rings; it was made between 1700 and 1550 BC. The hoop is too small for the ring to have been worn on the finger

The Cyclades 3000–1550 BC

The islands of the Cyclades are situated on the map like stepping-stones between Asia Minor and Greece, and have often served just this purpose, as the route whereby the culture of Western Asia reached Europe.

About 3000 BC immigrants from Asia Minor settled in the islands, some of which were now occupied for the first time. Thanks to the obsidian from Melos, to the marble from many islands, and to local sources of gold, silver and copper, the islanders rapidly achieved a high degree of prosperity. The Early Cycladic period is divided archaeologically into three phases, Early Cycladic (or EC for short) I, 3000–2500; EC II, 2500–2200; and EC III, 2200–2000 BC. There seems to have been a cultural break about 2200 BC, but the end of the Early Cycladic period merges imperceptibly into the Middle Cycladic. This is also divided, on the basis of the pottery, into three rather nebulous phases: MC I, 2000–1850; MC II, 1850–1700; and MC III, 1700–1550 BC. During this period the islands became more and more involved with the great power of Crete.

Owing to the accidents of survival and excavation, certain phases appear in the light of our present knowledge to be restricted to certain islands. EC I is represented on a number of islands, especially Paros, Antiparos and Amorgos. EC II is almost confined to the island of Syros, and EC III to Melos, where it covers the First City of the site known by its modern name of Phylakopi. The Middle Cycladic period is represented principally by the Second City of Phylakopi.

POTTERY

The coarse and intractable nature of the local clay always imposed severe limitations on the activites of Cycladic potters, and the wares to be considered here seldom rise above the level of the mediocre. In contrast with Crete and Mainland Greece, where the wheel was

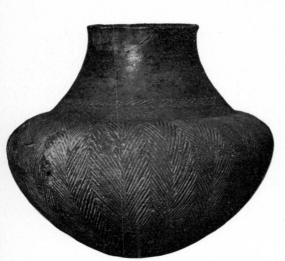
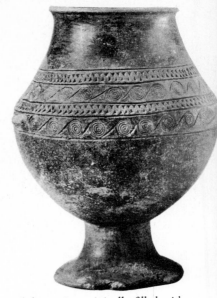

51, 52 Hand-made pottery from the Cyclades with incised decoration originally filled with white paint. The earlier (*left*) is rather awkward in shape as it has no base. The later vase (*right*), which comes from Syros, has a more graceful shape and spiral decoration

introduced around 2000 BC, Cycladic pottery of the Early and Middle Bronze Age is entirely hand-made.

The typical ware of the first Early Cycladic phase (3000–2500 BC) is a coarse pottery decorated with incised herringbone patterns (*Ill. 51*). The clay was either left untreated or was burnished with black or red pigment. The shapes are sturdy but ungainly and the repertoire limited.

The second Early Cycladic phase (2500–2200 BC), which is at present virtually limited to the site of Chalandriani on the island of Syros, saw some important innovations.

Unpainted ware derived from that of the previous phase was the most popular. The decoration now consists principally of spirals and circles, either incised or impressed with stamps. The shapes are now less clumsy (*Ill. 52*). The so-called 'frying-pans', which were very popular in this phase, were decorated in this way; some include crude representations of ships. The 'frying-pans' were probably in reality not cooking-utensils but representations of wombs, for use as fertility charms (*Ills. 53, 54*).

54

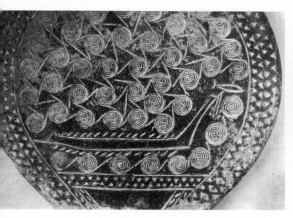

53, 54 Cycladic 'frying-pan' (*right*), probably a fertility charm in the form of a womb, and detail of the decoration from another object of this type (*left*) showing a ship. Both come from Syros and are dated 2500–2200 BC

A second method of decoration appears in this phase, introduced in all probability from Crete. It is an early form of the lustrous black paint (see p. 24). Sauceboats like the popular Mainland variety (cf. *Ill. 70*) were decorated with an all-over wash of this material. On other shapes it was used in angular linear patterns. *Ill. 55* shows a cosmetic jar, in a shape more commonly found in marble vases, decorated in this way; and in *Ill. 56* is a charming vase in the shape of a bear (or is it a hedgehog?) drinking from a bowl.

55 Hand-made Cycladic cosmetic-box with a bold geometric pattern of dots, lines and curves in a lustrous black paint, from Syros, of 2500–2200 BC

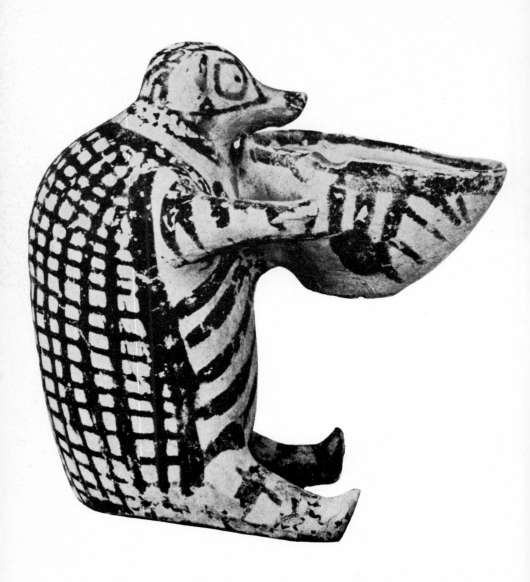

56 Hand-made Cycladic vase in the form of a bear, or perhaps a hedgehog, sitting up on its hind-quarters and drinking from a large bowl. This pleasing piece, which indicates a considerable sense of humour, has typical Cycladic decoration in lustrous black paint

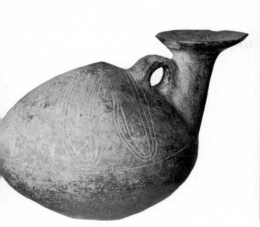
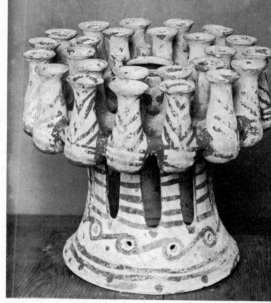

57, 58 Hand-made Cycladic pottery. Typical of the last phase of incised decoration is the oil-flask (*left*) of 2200–2000 BC. The multiple-vase (*right*) is decorated with matt black paint. Its purpose is not clear, but it was probably intended for offerings of grain

The third Early Cycladic phase (2200–2000 BC) sees the last stage of the unpainted ware. Shapes are further refined and patterns are composed of straight lines and curves. A typical product of this phase is the so-called duck-vase, an oil-flask bearing a remote (and possibly unintentional) resemblance to a bird (*Ill. 57*).

Linear decoration in black glaze continued from the previous phase, but a new matt black gradually superseded the semi-lustrous paint, which never sat happily on Cycladic clay. This black was made by the addition of manganese to the standard mixture. It was evidently considered advantageous to sacrifice an indifferent lustre for a more intense, although lustreless, black.

Among the vases decorated in this technique, and made at the end of the Early Cycladic and the beginning of the Middle Cycladic periods (around 2000 BC), is a class of elaborate multiple-vases (*Ill. 58*), whose purpose was probably religious, for the making of many simultaneous offerings to a deity, a common custom in the ancient world.

Middle Cycladic pottery in the earliest phase (2000–1850 BC) differs little from that of the third Early Cycladic phase, except that unpainted wares were no longer made. Otherwise it is true to say that the change to a new era was without ceramic significance.

The typical pottery is now decorated with the matt black paint, a fashion which soon spread to the Greek Mainland (see p. 69). If we take the most popular shape, the beak-spouted jug, we can follow the development of the decoration for some four and a half centuries. The shape is always graceful, a characteristic feature being the raised beak-spout. Sometimes the front of the vase is equipped with minute breasts, and in some cases the spout is decorated with painted eyes.

In the first phase (2000–1850 BC) the patterns are composed principally of straight lines (*Ill. 59*). In the second phase (1850–1700 BC), under the influence of the Kamares Ware of Crete, spirals and curves are freely used in making patterns of an individual and unusual form (*Ill. 60*). And in the last phase (1750–1550 BC), an attempt was made to reproduce animal life, flying birds being an especially popular subject (*Ill. 61*). The matt paint was now sometimes supplemented by touches of red. The vases of this last Middle Cycladic phase were sufficiently attractive to be imported by the rulers of Knossos and Mycenae.

MARBLE STATUETTES AND VASES

If Cycladic pottery is dull and uninspired, the statuettes made in the Early Cycladic period of the local coarse-grained marble are without question among the finest products of the Aegean Bronze Age. Their attraction is due partly to the extreme simplification of the bodily forms, partly to the glistening marble surface, which was originally enriched with touches of colour.

The statuettes take several forms, but all have a family likeness. The earliest form is the so-called Fiddle idol (*Ill. 63*), a highly stylized version of a naked squatting woman which bears an astonishing resemblance to a modern violin. It is a local creation of the Neolithic period (one was recently found in a Neolithic level at Saliagos near Antiparos) and persisted until about 2500 BC.

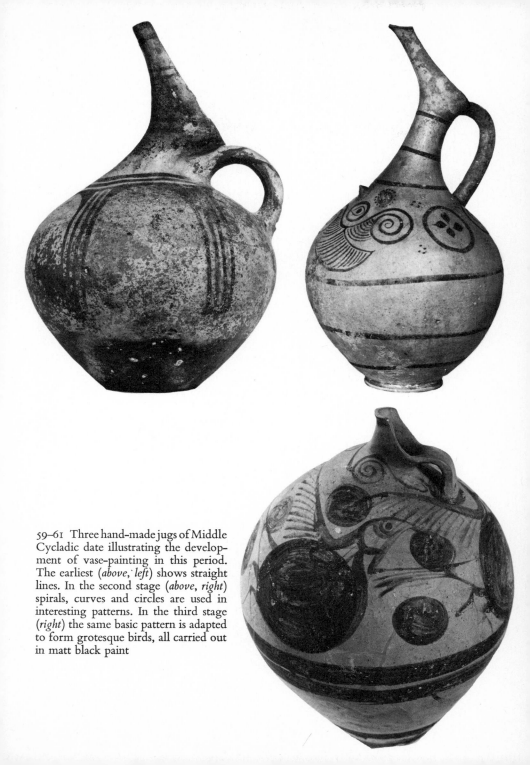

59–61 Three hand-made jugs of Middle Cycladic date illustrating the development of vase-painting in this period. The earliest (*above, left*) shows straight lines. In the second stage (*above, right*) spirals, curves and circles are used in interesting patterns. In the third stage (*right*) the same basic pattern is adapted to form grotesque birds, all carried out in matt black paint

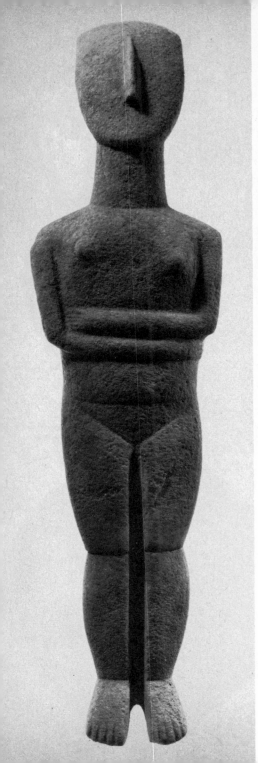

62, 63 Cycladic marble idols. The earlier form of this type is the so-called Fiddle idol (*right*) which later developed into a standing female figure of really outstanding elegance and simplicity (*left*). This type evolved under Asiatic influence in the Cyclades in the Neolithic period, and continued to be produced until *c.* 2000 BC

64, 65 The earliest extant musicians from the ▶ Aegean area are the marble figures of a seated harpist (*opposite, left*) and a standing pipe-player (*opposite, right*) from the island of Keros, *c.* 2500 BC

A commoner type is more naturalistic but still very stylized (*Ill. 62*). A woman (or very occasionally a man) stands naked with head tilted back, arms crossed over the chest. Head and body are very flat. The characteristic head is oval in shape and flattened at the top, with the nose modelled as a high ridge. Although the women are occasionally rendered as pregnant, there is none of the usual emphasis on sexual characteristics to be found in oriental fertility-figures.

Figures of this group, several hundreds of which have been found in tombs, average a foot (30 cm.) in height, but midgets of a few inches and life-size giants are also found. They succeeded the fiddle idols about 2500 BC and persisted until about 2000 BC.

A third class, related to that described above, consists of musicians: a standing pipe-player and a seated harp-player (*Ills. 64, 65*).

These 'Cycladic idols', as they are often called, were evidently as popular in antiquity as they are today, for they were imported (especially the second group) in large numbers into Crete, and in a fair quantity into Mainland Greece.

The method of manufacture was, of necessity, primitive. The sculptor selected a thin rectangular slab of marble and worked it painstakingly with an abrasive, undoubtedly emery from Naxos. The same material (next in hardness to a diamond) was used for cutting the figure and for rubbing it smooth. A splinter of emery

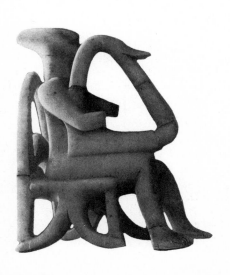

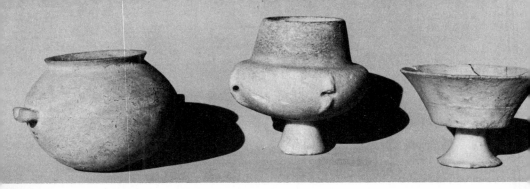

66 Three Cycladic marble vases of characteristic shape. These vessels sometimes show Egyptian influence but more often they are based on pottery originals, and are frequently more successful than their prototypes

would be used for cutting and engraving, a block for rubbing down. Details such as hair and features were picked out in black and red paint which, however, seldom survives.

Marble vessels were also made in the Early Cycladic period. The shapes are inspired by the clay vases, and are often more successful in this medium. They vary considerably in size, from a few inches to as much as a foot (30 cm.) in height. Some of the more graceful are shown in *Ill. 66*. These vases were made in the same way as the contemporary Cretan coloured stone vases (see p. 36).

PLATE

The Cyclades are comparatively rich in vessels of precious metal, and we may conclude that the gold and silver mines, exploited in later periods, were in existence even at this early date.

A shallow silver bowl with an offset rim was found on the island of Amorgos in association with pottery of the Early Cycladic period, and is therefore to be dated between 2500 and 2200 BC (*Ill. 68*). A contemporary treasure of gold and silver vessels, illicitly excavated, was allegedly found on the island of Euboea. The round–bottomed gold bowl of *Ill. 67* is clearly a translation into gold of the pottery of its period.

The Early Cycladic period has produced a certain amount of simple jewellery, mostly of bronze but some of silver. The best pieces come from tombs at Chalandriani on the island of Syros (2500–2200 BC). From the discovery of a pin on the shoulder of a skeleton in one burial, we can be sure that some at least of the pins were used to fasten the dress on the shoulders. In five tombs in the same cemetery pins were found in pairs, another argument pointing in the same direction.

The pins in *Ill. 69* are of bone (on the left); of bronze (the three central); and of silver (on the right). The heads comprise a double spiral (a widespread motive originating in Asia Minor), a jug, a cage and a pyramid.

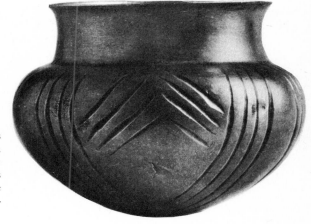

67, 68 Vessels in precious metals were used in the Cyclades at an early date. The gold bowl (*right*) with simple linear ornament dates from 2500 to 2200 BC, and the shallow silver bowl from Amorgos is of the same period

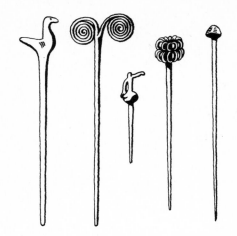

69 Five Cycladic dress-pins from the island of Syros, of 2500–2200 BC. The varied motives, a bird, a double spiral, a jug, a cage and a pyramid, were probably all at home in north-west Asia Minor. From the neighbourhood of Troy they passed to the Cyclades, and thence to Mainland Greece

A diadem like the gold diadems from Mochlos (see *Ill. 38*), but of silver, comes from the settlement of Chalandriani on Syros. It is decorated by means of embossed dots with figures of goddesses and dogs alternating with wheel-like rosettes. The workmanship is clumsy indeed, but this is an important document from an early period. The date is 2500–2200 BC.

No jewellery of the Middle Cycladic period (2000–1550 BC) has yet been found, but there can be no doubt that it existed.

Mainland Greece 3000–1500 BC

The Early Bronze Age in Greece is divided, as in Crete and the Cyclades, into three phases. The first phase is marked by the arrival about 3000 B C of immigrants who came from Asia Minor by way of the Cyclades, and settled down with the Neolithic inhabitants. Not much is known of the first phase of the Early Helladic period, but it seems to have lasted for some three centuries, and to have merged peacefully into the second phase.

Here we are on firmer ground. This phase lasted from 2500 to 2200 BC, and was marked by a considerable increase in prosperity. There were palaces at Lerna, at Tiryns, and probably elsewhere, in contact with the fortress of Chalandriani on Syros and with the Second City of Troy. Nearly all the equipment of these palaces has been destroyed, but a gold vase from Arcadia and a collection of gold jewellery from Thyreatis in the Eastern Peloponnese give some idea of the luxury goods of this period.

It ended about 2200 B C. In the Argolid and the Corinth district (and probably throughout the Peloponnese, but the evidence is defective) the end was brought about by invasions and mass burnings. The invaders, who came perhaps from Asia Minor, were almost certainly the first true Greeks (that is to say, speakers of the Greek language) to arrive in Greece.

In central Greece this phase ends fairly suddenly, but peacefully. Their troubles were yet to come.

The third Early Helladic phase has certain common features throughout Greece, with the difference, however, that in the south there were Greeks, as we may now call them, with their characteristic 'Minyan' pottery, living amongst the descendants of the earlier inhabitants, while in the centre there was no change of population.

This phase was much less prosperous than the second phase. It ended everywhere about 2000 BC, in central Greece with

65

destructions like those which had afflicted the south some two centuries earlier. In the south the transition was peaceful, marked perhaps by the arrival of more Greeks.

The Middle Helladic period lasted from 2000 to 1550 BC. It has not as yet been possible to subdivide it into phases. It was characterized in its early stages by a return to near-barbarism, but prosperity gradually returned, and by 1600 BC contacts with Crete and the civilized East were being renewed. The Middle Helladic period merges peacefully into the Late Helladic or Mycenaean, marked, chiefly at Mycenae, by the rapid adoption of the Cretan way of life.

ARCHITECTURE

We know little of the architecture of the first Early Helladic phase, but our knowledge of the second phase is now considerable, thanks to the excavation of the so-called House of Tiles at Lerna. Built about 2300 and burnt down about 2200 BC, it may with justice be called a real palace. It was rectangular in shape, and measured about 40 × 82 feet (12 × 25 m.). There were two principal rooms on the ground floor, surrounded by corridors, and there was at least one upper storey. The walls were of mud-brick, on stone foundations. Some of the interior walls were plastered. Timber was used for doorways, and for much of the upper storey. The roof, also of timber, was gabled and had tiles of terracotta and stone.

An enormous circular building at Tiryns, underneath the Mycenaean palace, was also roofed with tiles, and was probably contemporary with the House of Tiles at Lerna.

Our knowledge of the architecture of the third Early Helladic phase and of the Middle Helladic period is too fragmentary for any discussion to be profitable.

POTTERY

The pottery of the Early Helladic period is, with the exception noted below, entirely hand-made. In the first phase (3000–2500 BC) the characteristic ware is red and brown pottery, slipped and burnished, in simple rounded shapes. Bowls, small jugs and jars are the most popular forms.

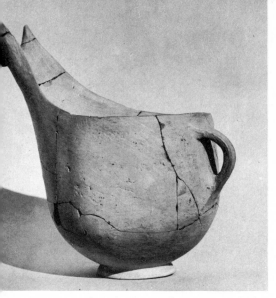
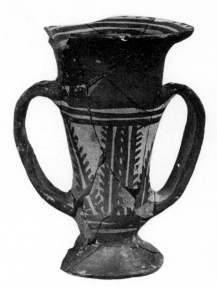

70, 71 Hand-made pottery from Lerna. The 'sauceboat' (*left*) is of a type very common in the Early Helladic period. It is decorated with an all-over wash of semi-lustrous paint known as Urfirnis. The two-handled tankard (*right*), a shape probably derived from Asia Minor, is simply decorated in lustrous black paint

The second phase (2500–2200 BC) sees considerable changes. The finish is now often semi-lustrous paint, in place of a burnished slip. This finish, usually known by its German name of Urfirnis (primitive glaze), has a variegated red-brown-black appearance. The mottling resembles that on the contemporary Vasiliki Ware from Crete (see p. 25), but is less pronounced, and was probably accidental. Favourite shapes are now the so-called 'sauceboats', a very common type whose function is unknown (*Ill. 70*), and small saucers, basins and handled jars.

The third phase (2200–2000 BC) sees two distinct kinds of pottery. The first is the patterned ware, probably derived from the Urfirnis of the previous phase. The shapes are two-handled tankards (*Ill. 71*), cups, and large round-bellied jars with flaring mouths (*Ill. 72*). The patterns, composed of networks of fine lines, were either in white paint over a dark glaze or in dark glaze on the vase body; the former system belonged chiefly to central Greece, the latter to the Peloponnese.

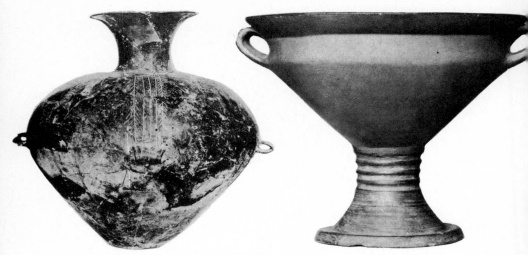

72, 73 Amongst the latest hand-made pots are the large globular jars (*left*) with flaring mouths and incised decoration. Before the opening of the Middle Helladic period, wheel-made Grey Minyan Ware such as the (restored) goblet (*right*) was introduced

The second kind of pottery is the wheel-made Minyan Ware, which occurs at certain sites in the Peloponnese before 2000 BC. As, however, it is not common till the Middle Helladic period, it will be discussed under that heading.

The Middle Helladic period (2000–1550 BC) is characterized throughout its duration by Minyan Ware. Shortly after the beginning of the period a hand-made pottery, Matt-painted Ware, was introduced from the Cyclades. Finally, towards the end of the period we find imitations of Cretan polychrome pottery of the seventeenth and early sixteenth centuries BC.

Minyan Ware is an important and unusual fabric, and deserves our attention. It is the first wheel-made pottery to be found in Mainland Greece. Its origins lie in north-western Asia Minor, and almost identical wares appeared at Troy at the same time. It is generally believed to have been brought by the first Greek-speakers, a fact which leads to the surprising (but by no means impossible) conclusion that the Trojans were also in some sense Greeks.

First, the name. It is an unfortunate name, but it has been current for so long that any attempt to dislodge it would be hopeless. It was

invented by Schliemann, who first found this pottery at Orchomenos in Boeotia, the legendary seat of King Minyas and the Minyan tribe.

The ware is technically excellent, made of well-refined clay and fired hard. The surface is smooth and soapy to the touch. The shapes are angular and are probably taken from metal originals. The repertoire is small, being almost restricted to a goblet (a cup with a ringed stem, *Ill. 73*), a kantharos (a graceful two-handled bowl, *Ill. 74*) and a fruit-stand (a stemmed bowl).

The original form, Grey Minyan, lasted from 2200 BC in the south, 2000 BC in central Greece, until 1550 BC. The colour, which is uniform throughout the vase, is obtained by one-stage firing in a reducing atmosphere. Strangely enough, this fabric, so common in settlements, is very rare in burials.

In the course of the Middle Helladic period, perhaps about 1700 BC, a variant evolved, the so-called Yellow Minyan, which was essentially the same ware, but fired in an oxidizing atmosphere. This ware gradually superseded the Grey Minyan, and lasted until about 1400 BC side by side with decorated Mycenaean pottery.

The shapes are partly new, partly refined versions of those found in Grey Minyan. Goblets, one-handled cups, and round-bellied jugs are commonly found in this fabric.

Local varieties, with only local currency, are also found.

Matt-painted Ware differs from Minyan in almost every possible way, yet the two fabrics co-existed for a considerable time. In the first place, Matt-painted is hand-made, whereas Minyan was made

74, 75 Two-handled cups (kantharoi) of characteristic Middle Helladic types. The wheel-made pottery (*left*) has the shiny surface typical of Grey Minyan Ware, but the hand-made version (*right*) has matt-painted linear patterns derived from Cycladic models

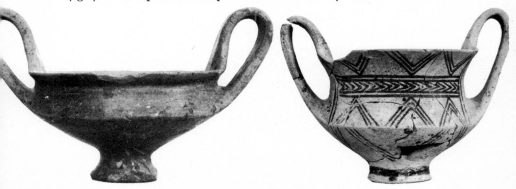

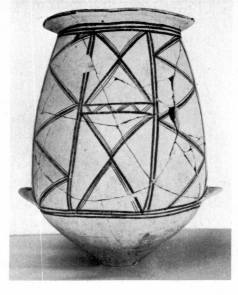

76 Large hand-made storage-jar (pithos) of Matt-painted Ware from Lerna, decorated with simple and uninspired linear patterns in dull manganese black. Such jars were used mainly for foodstuffs, but also for burials

on the wheel. In the second place, Matt-painted is decorated with linear patterns in the dull manganese-paint invented somewhat earlier in the Cyclades (see p. 58), whereas Minyan was undecorated.

The patterns are at first angular, later rounded; otherwise there is little development. Towards the end of the Middle Helladic period, red colouring was occasionally used in addition to the matt black.

The shapes comprise jugs with flaring mouths or (less commonly) beak-spouts; one-handled cups; imitations of Grey Minyan kantharoi (*Ill. 75*); and large storage-jars (also used for infant burials) with swelling bodies and flaring mouths (*Ill. 76*). A fine style (chiefly on smaller vases) and a coarse style (for larger storage vessels) have been distinguished.

PLATE AND JEWELLERY

Only one form of gold or silver plate has been recorded from Mainland Greece for this period. That form, known in two surviving examples, is a translation into gold of the common pottery 'sauceboat' shape. A fine example in the Louvre, believed to come from Arcadia, is shown in *Ill. 77*. Another is in private possession; it was until recently on loan to the Israel Museum.

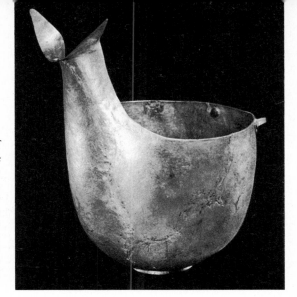

77 Gold 'sauceboat' of Early Helladic II date (2500–2200), said to come from Arcadia. A somewhat similar vessel was found in Troy, but this is a common pottery shape in Greece, and this gold example may be presumed to have been made locally

Like its Cycladic counterparts, Early Helladic jewellery was inspired by that of Western Asia Minor. Surviving material is scarce; by far the richest source is a collection, now in the West Berlin Museum, believed to have been found in the Thyreatis, a district on the borders of the Argolid and Laconia (*Ill. 78*). Correspondences with the Second City of Troy date this jewellery in the

78 A collection of gold jewellery said to come from Thyreatis in the eastern Peloponnese. The wire beads, chains and miniature jug (a pin-head) are similar to those from Troy II, whence the inspiration came to Greece, perhaps via the Cyclades

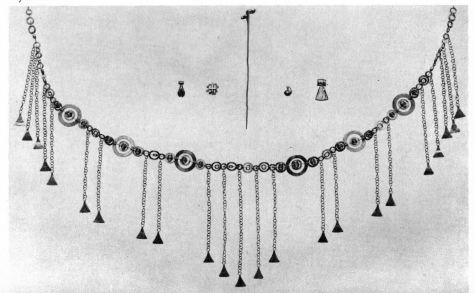

second phase of the Early Helladic period (2500–2200 BC). It was probably hidden by its owner about 2200 in the disturbances which ended that phase, and never recovered.

The jewellery, all of gold or electrum (a natural alloy of gold and silver), includes a pin with a head in the form of a bull's head and a minute jug which probably formed the head of another pin. There are a number of beads composed of concentric hoops of wire with eyes at two points on the circumference; from some of the latter hang chains with wedge-shaped pendants. A few other varieties of beads and pendants are included in this collection. Although this material in many ways resembles that from Troy, there is no reason to doubt that Mainland goldsmiths were capable of producing simple jewellery such as this, for they certainly made the gold sauceboat of *Ill. 77*.

In the Middle Helladic period (2000–1550 BC) jewellery is even rarer. Simple gold hoop-earrings are occasionally found. From tombs in Corinth come a pair of bracelets of sheet-silver and a gold diadem decorated in repoussé, with dots, circles, spirals and rosettes. Diadems rather more elaborate but essentially similar, are common in the Shaft-Graves of 1550–1500 BC (cf. *Ill. 211*).

SEALS

Until the recent excavations at Lerna, seals and seal-impressions were rare in Mainland Greece before the Late Bronze Age. The position has now been radically altered by the discovery at this site of two rich deposits of clay seal-impressions from burnt buildings of the second Early Helladic phase (*Ill. 79*).

The first deposit, not yet fully published, consists of about a hundred impressions from the ruins of a house destroyed about 2300 BC.

The second deposit consists of well over a hundred impressions from a total of seventy original seals. It was found in the ruins of the House of Tiles, which was destroyed about 2200 BC, and has been fully published.

The impressions average about an inch (2·5 cm.) in diameter, and were probably made with seals of ivory or wood; the material was evidently perishable, since no seals have survived. They were used

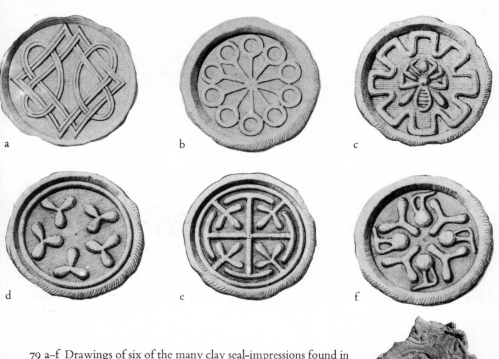

a b c

d e f

79 a–f Drawings of six of the many clay seal-impressions found in the House of Tiles at Lerna. The favourite motives are geometrical, but occasionally spiders (c) or ritual vessels (f) were used. 79g is a photograph of one of these seal-impressions

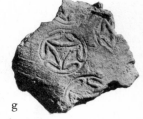

g

for sealing wicker boxes, wooden chests and clay jars. The contents of these containers are not known to us, but it has been conjectured that the boxes held grain or manufactured goods, the jars oil or wine.

The motives are mostly complicated interlaced geometrical patterns – curves, loops and spirals – so planned as to fill the circular field as skilfully as possible. Many are produced by the convolutions of a continuous line. With the exception of the spider, natural forms were not reproduced.

The origins of this brilliant style are not known, but should probably be sought in Asia Minor. Cretan parallels are surprisingly few. Indeed, contemporary Cretan seal-engravers were quite incapable of producing work of this degree of sophistication.

73

The Major Arts in the Late Bronze Age

In Crete no cultural break can be observed between the Middle and the Late Minoan periods. Nor, as far as our knowledge extends, was there any substantial change in the Cyclades at this date, except, perhaps, a greater political and artistic dependence on Crete. But in Mainland Greece the transition from Middle to Late Helladic (or Mycenaean – the terms are synonymous), although peaceful, was far-reaching; for it marks the transformation of a relatively backward community into a people almost as civilized as the Cretans, on whom they modelled themselves. This is therefore the moment at which to gather together the three separate strands, Cretan, Cycladic and Helladic, with which we have previously been concerned.

CRETE

Life in the palaces continued much as before. Crete was, if anything, even more prosperous, a state of affairs which lasted until about 1450 BC, when all the cities in the island, with the exception of Knossos, were apparently laid low at the same time.

It used to be thought that these disasters were caused by the cataclysmic eruption of the volcanic island of Thera (also known today as Santorini), which occurred about this time, or by events associated with it, such as earthquakes, tidal waves or shock waves. Recent research has, however, shown that the eruption took place about 1500 BC, within a very short space of time. It was consequently some fifty years too early to have caused the Cretan destructions.

It is now believed by many that Crete was invaded about 1450 BC by Mycenaeans from the Greek mainland. They captured the Palace at Knossos virtually intact and ruled all Crete from there, having destroyed the other palaces as a security measure.

New evidence for life and art in the last days of the second palaces comes from the recently excavated palace at Zakro in Eastern Crete.

Storage basements yielded elephants' tusks from Syria and copper ingots from Cyprus. An archive-room produced clay tablets in the Linear A script, and ritual vessels of superb quality were found in the Royal Treasury and in the Great Hall.

Only the palace at Knossos was capable of restoration, and the expedition from Mainland Greece, as has been said, occupied the palace, restored the damage, and ruled over all Crete. We know that the newcomers came from the Greek mainland for archaeological reasons connected with their pottery and burial customs. We know further that they were speakers of Greek, from the inscribed clay tablets which they used. These tablets, in the so-called Linear B script, were deciphered as Greek by the late Michael Ventris in 1952. This script replaced the Cretan Linear A script (as yet undeciphered) which was in use at Knossos (and elsewhere in Crete) before the arrival of the Mycenaean Greeks.

But this state of affairs was not to last. Shortly after 1400 BC, the palace at Knossos was finally destroyed, by what agency is not known, and from this date the leadership in the Aegean passed from Crete to Mycenaean Greece. The palace at Knossos was never rebuilt (although squatters settled in the ruins), and during the fourteenth and thirteenth centuries BC Crete was a second-class, though never, it would seem, a negligible power. The island was spared the mass destructions which occurred on the Mainland about 1200 BC, and seems to have enjoyed another century of comparative prosperity. The precise course of events is far from clear, but it would seem that the Minoan civilization was finally ended about 1100 BC by the arrival of Dorian Greeks.

THE CYCLADES

The role played by the islands of the Cyclades in the Late Bronze Age was until recently scarcely known apart from the island of Melos, where it is contemporary with the last years of the Second Palace, and all of the Third Palace at Phylakopi. Lately, however, American excavations at Keos have done much to clarify the picture.

In general, Cycladic art was Cretan-inspired until about 1450 BC. The islands must have suffered considerably from the eruptions of Thera about 1500 BC, and then came under Mycenaean dominance. They seem to have escaped the mass destructions which devastated the Mainland about 1200 BC, and to have enjoyed a brief Indian summer until the arrival in some of the islands of the Dorian Greeks about 1100 BC.

MAINLAND GREECE

In the Middle Helladic period (2000–1550 BC) Mainland Greece was a backward country out of touch with all its neighbours except the Cyclades. About 1600 BC there are signs of renewed contact with Crete, and suddenly about 1550 BC a brilliant culture came to bloom, based largely upon that of Crete.

The period between 1550 and 1500 BC is characterized chiefly by the two Grave-Circles at Mycenae. The richer, now known as Grave-Circle A, was discovered by Schliemann in 1876 (*Ills. 80, 81*). It consists of six royal shaft-graves, richer in luxurious grave-goods than any other graves in Greece of any period. The other circle, Grave-Circle B, was excavated in 1952–4. It contained twenty-four graves, fourteen of which were shaft-graves like those of Circle A. Some of the graves from this circle are slightly older than Schliemann's, but the shaft-graves, which are the richest, are contemporary with it.

Graves in both circles were marked by tombstones. Let us take a look at the contents of a rich shaft-grave. The dead man lay fully dressed on the pebble-lined floor of a pit. There were gold ornaments on his clothes, jewellery on his brow, neck and wrists, and a gold mask over his face. Beside him were bronze weapons and vessels of clay, metal and stone. The women were as richly equipped as the men.

Many of the treasures from these two Grave-Circles are of Cretan origin, and nearly all show Cretan influence, so that Sir Arthur Evans believed, after his discoveries at Knossos, that Mycenae was ruled at this date by a Cretan dynasty. But this cannot be, for the method of burial is not Cretan, the dead men (to judge by the masks), were not

76

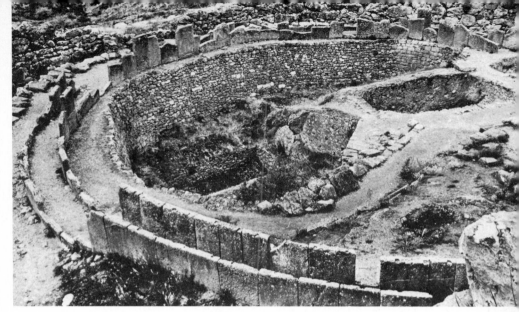

80, 81 Grave-Circle A, within the Citadel at Mycenae, as it is today (*above*), and a reconstruction of its appearance in the thirteenth century BC (*below*), after its earlier form was modified to enclose it in the new fortress wall

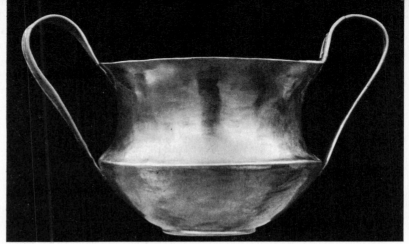

82 Gold kantharos from Shaft-Grave IV at Mycenae. The shape is Middle Helladic (cf. *Ill. 74*) but the work is Cretan, possibly by an immigrant craftsman

Cretans, and the scenes of fighting and hunting on daggers and rings are at variance with Cretan taste.

An analysis of the grave-goods leads to the conclusion that three types of object are represented: pure Cretan work (e.g., *Ill. 176*); work executed by Cretans for Mycenaean customers or masters (e.g., *Ills. 82–84*); and Mycenaean work (e.g., *Ill. 85*). How the lords of Mycenae suddenly found themselves in a position to import works of art and possibly slave-artificers from Crete is a question to which an answer is yet to seek.

To explain this phenomenon the late Professor Wace suggested an analogy with the spread of Greek culture and art in Etruria in the seventh century BC. In that instance we know that the Greeks never conquered or colonized any part of Etruria, but we can observe

83, 84 Scenes of war and the hunt are far more common in Mycenaean than in Cretan art, but the fine workmanship of these seal-rings from Shaft-Grave IV could only be Cretan. They show (*left*) a man fighting three adversaries and (*right*) a stag-hunt

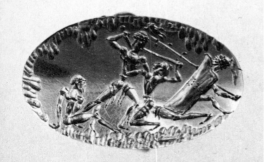
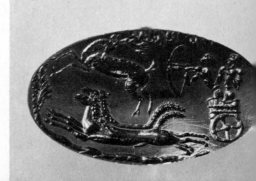

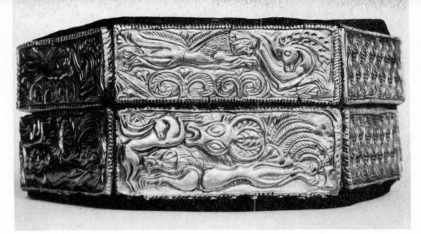

85 Hexagonal gold-plated wooden box from Shaft-Grave V. The plates are decorated with scenes of lions attacking their prey, the crude and barbarous execution of which indicates indigenous Mycenaean manufacture

phenomena exactly parallel with Shaft-Grave art: pure Greek objects; works made by Greeks for Etruscan customers; and Etruscan imitations and adaptations of Greek art.

A somewhat different picture emerges from recent excavations in the neighbourhood of Pylos in Western Messenia, where the evidence would seem to point to limited Cretan settlement at this period, based no doubt on the colony which had been established on the island of Kythera as early as 2000 BC.

In the fifteenth century BC Mycenaean culture spread throughout Greece. At Mycenae itself there was evidently a change of dynasty, for the royal dead were no longer buried in shaft-graves but in tholos tombs (see p. 86), which were already common in Messenia, and which were surely introduced from that quarter. In matters of taste, Mycenaean art was moving closer to that of Crete. On the other hand, after the conquest of Knossos about 1450 BC, Mainland preferences were having a certain effect on the art of Knossos.

About 1400 BC the leadership in the Aegean passed to Mainland Greece. The Mycenaeans expanded widely over the Eastern Mediterranean, to Macedonia, Thrace, Asia Minor, Cyprus, Syria, Palestine and Egypt, and ventured westwards to Sicily and South Italy.

What has been aptly named the Mycenaean Empire lasted approximately from 1400 to 1200 BC. It is marked by great prosperity and by

79

a considerable uniformity of culture over the vast area which the Mycenaeans now controlled. Crete was part of this complex, but her culture was never completely merged into the Mycenaean.

The Empire came to an end about 1200 BC, when many of the most important centres on the Mainland were burnt down by enemy action. Whether the enemy were the Peoples of the Sea who ravaged the Egyptian Delta at this time, or whether they were the first contingent of the Dorian branch of the Greek family, are matters still under discussion.

We used the analogy of Greece and Etruria in the seventh century BC to explain the relationship between Crete and Mycenae in the sixteenth. For the position in the fourteenth and thirteenth centuries BC it would perhaps be helpful to think of the art of the Roman Empire. This was predominantly Greek art executed by Greeks but adapted to the taste of Roman customers. So we must imagine the art of the Mycenaean Empire as being executed to a certain extent by Cretan artificers for Mycenaean customers. Indeed, the legendary Daedalus was a Cretan who worked in Athens; and in the archives of Pylos of the late thirteenth century BC we find references to bronze vessels of Cretan manufacture.

Our knowledge of the arts and crafts of the Mycenaean Empire has been increased lately by the partial excavation of the palace of Cadmus at Thebes, and the complete excavation of the palace of Nestor at Pylos.

The Theban palace had been partly excavated in 1907–12, and again in 1921, and frescoes, jewellery and other objects discovered. It was again excavated in part in 1963–4 when further remains came to light during building operations. The date of the two, or possibly three, building periods of the palace is still under discussion, but the treasures from the last palace appear to belong to the fourteenth century BC. They comprise a group of oriental cylinder-seals of lapis lazuli; Mycenaean gems, agate beads, and jewellery of gold, lapis lazuli, glass and ivory. Complete publication is still awaited.

The palace at Pylos is more fully described below. Few precious works of art were discovered in it, but frescoes, pottery and (possibly

most important historically) archives in the form of inscribed tablets were found in plenty. It was destroyed by fire about 1200 BC.

The history of the last century or so of the Bronze Age is extremely complicated and imperfectly understood. In the worst devastated areas there was little artistic activity; elsewhere, there was something of a renaissance, short-lived though it was. Crete, Rhodes, Cos, the Cyclades and Eastern Attica enjoyed a new pottery style with a vitality not seen for over two centuries. And refugee settlements of Mycenaeans in Cyprus were producing gold-work and ivory-work of superb quality.

For reasons which are still obscure, this latest manifestation of Bronze Age culture finally petered out about 1100 BC. It is hard to escape the conclusion that it was the arrival of Dorian Greeks which administered the *coup de grâce* to the already tottering Mycenaean world.

ARCHITECTURE

Palaces. In Crete, there was little new in the palaces in the Late Bronze Age, except that at Knossos a throne room was built in the West Court about 1450 BC by the Mycenaean conquerors (*Ill. 86*).

86 The Throne Room at Knossos, executed by the Mycenaeans about 1450. The stiffness and formality of the reliefs (restorations based on the fragments now in Heraklion) is typically Mycenaean. The gypsum throne is original

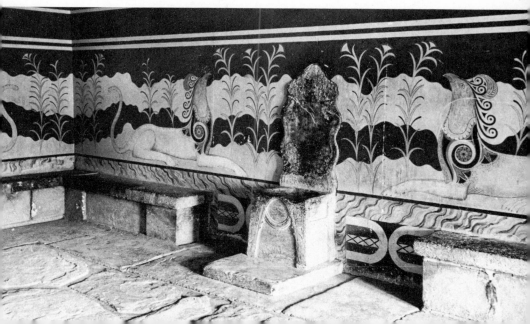

There is, however, much to say about architecture on the Mainland in this period, where a number of palaces have been discovered and excavated, notably at Mycenae, Tiryns, Gla (the ancient Arne) and Pylos. Traces of the palace at Thebes have also been uncovered.

A Mycenaean palace in its heyday would in many superficial respects have resembled its Cretan counterpart, but there were certain fundamental differences. In the first place, Mycenaean palaces were heavily fortified with circuit walls of enormous stones, whereas Cretan palaces were unfortified. In the second place, Mycenaean palaces were designed on a fairly rigid plan, based on one or more units known to archaeologists as the *megaron*, whereas Cretan palaces possessed a much more elastic layout.

The megaron deserves our consideration. In Homer the word just means a large hall, but modern archaeological usage restricts its meaning to a particular architectural form found in all Mycenaean palaces. It consists of an entrance-porch, a vestibule and a large hall with a central hearth and a throne. The porch faced on to a courtyard, which was entered by an ornamental gateway. The origins of this type of building are probably to be sought in Asia Minor, where it had a long history.

For the fortifications of a Mycenaean palace, let us consider the Acropolis at Mycenae (*Ill. 87*). The walls and buildings whose ruins confront us today all probably date from the thirteenth century B C. The massive walls, believed by the Greeks to have been built by the Cyclopes and known today as Cyclopean, are made of enormous limestone boulders roughly shaped or left untrimmed, and packed together with small stones and clay. The walls average about 15 feet (4·5 m.) thick. Their original height cannot now be determined; we may guess about 50 feet (15 m.). The Lion Gate, however, and the walls on either side of it, are built of squared masonry.

The Lion Gate (*Ill. 1*) was the principal entrance to the citadel; it was erected about 1250 B C. The sculptured lions which decorate it are discussed below. From here a path led up past Schliemann's Grave-Circle to the palace. There was a postern gate in the north wall and an underground passage at the extreme east end, leading to a secret cistern.

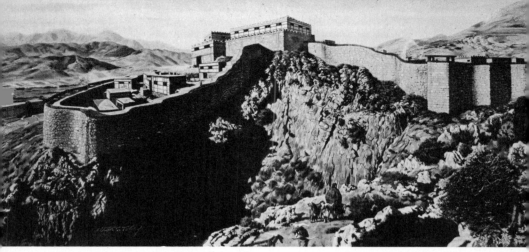

87 The Citadel of Mycenae from the south-east. A reconstruction as it would have been in the thirteenth century BC. Many details of the palace (*centre*) were borrowed from Crete but the basic conception is entirely different. The Citadel had immensely thick walls of Cyclopean masonry

The palace at Mycenae is poorly preserved, and it is better to turn to Pylos, where a palace was built about 1300 BC and totally destroyed by a great fire about 1200 BC. It has recently been excavated with all modern techniques by an American expedition, and our knowledge of it is therefore considerable (*Ills. 88–91*).

The layout consists of two residential and administrative blocks (each with its own wine store), and a workshop building, for the repair of chariots and equipment. The residential blocks were two storeys high. Construction was in wood and stone. The walls were chiefly of rubble braced with horizontal and vertical timbers. Exterior walls were faced with squared limestone blocks, while interior walls were plastered and (in important rooms) painted. Columns, ceilings and roofs were of wood.

The principal unit was large, about 163 × 104 feet (50 × 32 m.) in extent, and evidently served as the royal apartments. It gave on to the usual courtyard, which was entered through an ornamental gateway with two fluted wooden columns. The heart of this unit was a megaron. Entrance-porch, vestibule and Great Hall had floors and walls of painted plaster. In the Great Hall was a central hearth surrounded by wooden columns, which supported a balcony. A high

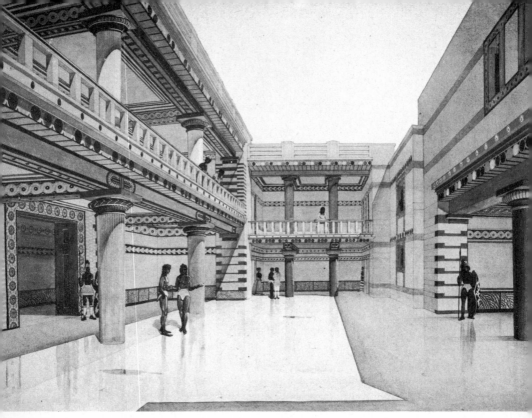

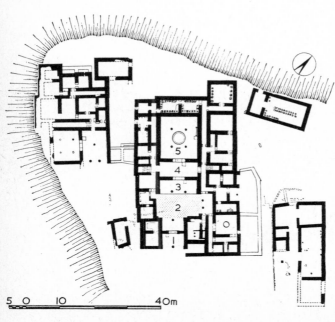

88–91 The palace of Nestor at Pylos. The reconstructions of the Entrance Court (*above, left*) and the Throne Room (*above, right*) with four columns and a central hearth are tentative, but based on sound archaeological evidence indicated by the actual site (*right*). The plan of the palace (*left*) is typical of a Mycenaean scheme: an ornamental gateway (1) leads to a courtyard (2), at the end of which is the megaron consisting of an entrance porch (3, and *Ill. 88*), a vestibule (4) and the Throne Room (5, and *Ills. 89* and *91*)

5 O 10 40m

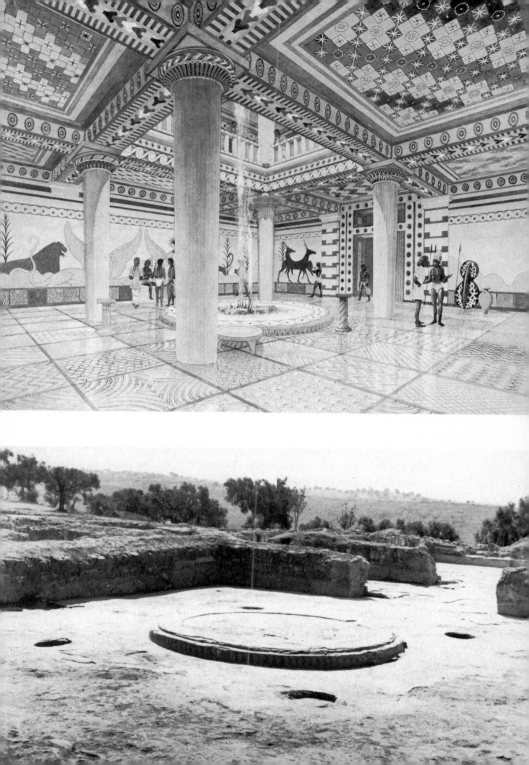

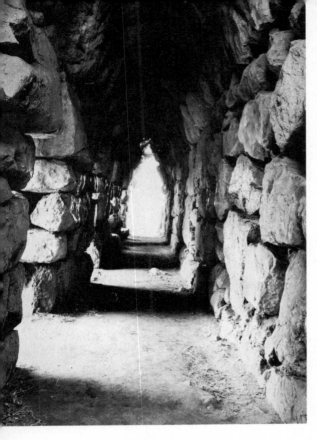

92 Galleries known as the casemates within the walls at Tiryns. The roof is not a true arch, but is corbelled like the contemporary tholos tombs, by overlapping the stones inward until they meet at the top

clerestory above the hearth served to let in the light and to let out the smoke by way of a terracotta chimney. On the right side as you entered, against the wall, was the throne, flanked by painted griffins like its counterpart at Knossos (*Ill. 91*). On each side of the megaron were suites of rooms.

In the famous palace at Tiryns, the outer walls were hollowed out in places to form galleries, whose purpose is not clear (*Ill. 92*), but which have a truly monumental appearance.

Tholos Tombs. The standard form of royal burial from about 1550 BC in the Western Peloponnese, and from about 1500 elsewhere in Greece, was a dome-shaped masonry tomb known to archaeologists as a beehive tomb or (from the ancient Greek word for a round building) a *tholos* tomb.

The derivation of this kind of tomb is uncertain, but in all probability it evolved in Crete from the earlier round tombs of the south, of which some were open to the sky, while others were roofed. True tholos tombs were first built on the Greek Mainland near Pylos about 1550 BC. The earliest are associated with Cretan-type burials, and one actually has a Cretan mason's mark carved on the entrance. The Cretan tombs were used for the collective burial of commoners, but the general form was evidently adapted in Mainland Greece for royal usage.

At first these tombs were built on the flat ground; but soon, under the influence of contemporary chamber-tombs, they were set in hillsides and approached by long unroofed passages.

Well over a hundred have been found in Greece, and there are probably many more to be discovered. They may be classed among the greatest architectural achievements of antiquity, and include the largest single-span buildings in existence until the Pantheon was built in Rome by the Emperor Hadrian.

The best sequence occurs at Mycenae, where there are nine, ranging in date from about 1500 to about 1225 BC. As time went on, they became larger and more elaborate.

Let us consider the best preserved, and one of the latest, the so-called Treasury of Atreus, in some detail (*Ills. 93–98*). Although the tomb has been visible throughout the ages, the identity of the occupant or occupants (for the royal family would be buried with the king) has long been forgotten. The name is modern, but based on a misunderstanding dating from Roman times, when these tombs were thought to be the treasure-chambers of heroic kings. Its other modern name, the Tomb of Agamemnon, is equally without foundation – all we can say is that the principal occupant of this tomb was a powerful king of Mycenae who ruled about the early thirteenth century BC.

The tomb is approached by a passage about 20 feet (6 m.) wide and 120 feet (36 m.) long, faced with dressed stones. An imposing façade at the end of the passage, some 34 feet (10·5 m.) high was faced with carved red and green marble, fragments of which are now scattered over the museums of Europe. An enormous doorway was

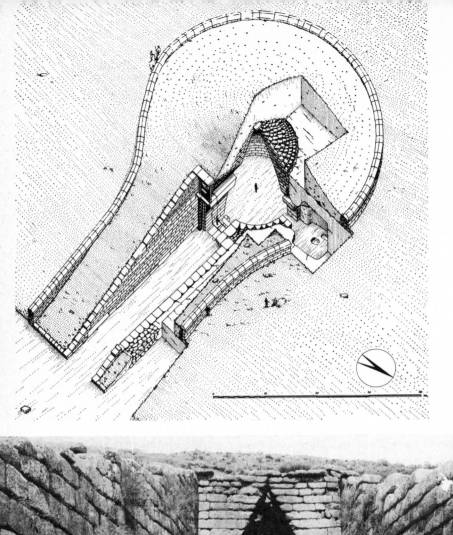

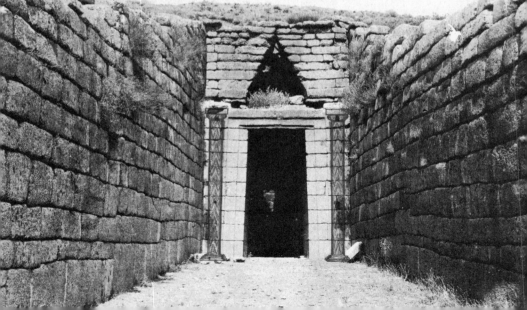

93–5 The largest and best built of the Mycenaean tholoi is the so-called Treasury of Atreus. The isometric plan (*left*) shows the small side-chamber where earlier burials were deposited at the time of each new funeral. The façade (*below*, *left*) shows the original placing of the half-columns and the relieving triangle over the lintel. The main chamber had a corbel-vaulted roof (*right*) nearly fifty feet high

flanked by half-columns of green marble decorated with chevron patterns (*Ills. 97, 98*), and equipped with capitals very like the Classical Doric capitals. Parts of these columns are in Athens, parts in the British Museum. The doors were probably of bronze-clad wood. The enormous lintel, which survives intact, is in two sections; the inner section weighs over a hundred tons.

Over the doorway is a triangular space, designed to take the weight off the lintel. It was masked with a skin of red marble, decorated with carved spirals, some of which is now in the British Museum. On either side of the triangle were further half-columns of green marble, like those below, and centred on them, but half the size; parts of these are in Athens. In *Ill. 96* is an attempted reconstruction of the façade.

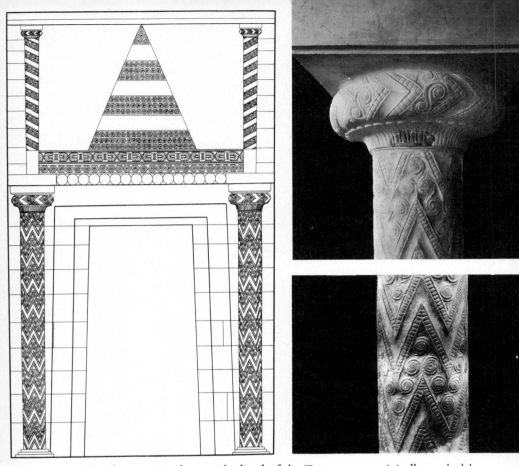

96–98 The relieving triangle over the lintel of the Treasury was originally masked by a marble slab carved with spirals (*left*) and the door was flanked by engaged half-columns (*below, right*) of green marble carved with spirals and hatched chevrons in the Cretan style. The capitals, a cast of which is shown (*above, right*), appear to be the direct ancestor of the Classical Doric style of capital

The chamber was the shape of an enormous dome, about 50 feet (15 m.) high by 50 feet wide. It was not, however, built on the principle of the dome, but was corbelled; that is to say it was composed of horizontal courses of stone, each course narrower than the one below. The interior was decorated with bronze fittings.

An unusual feature of this tomb was a rectangular side-chamber whose function was to accommodate previous burials. It is now a

ruin, but was in all probability once faced with carved stone (see p. 93).

The tomb was not intended to be concealed, but was covered with a mound, which was supported by a retaining wall of masonry.

SCULPTURE

Large-scale sculpture was alien to the Cretan temperament, and not greatly favoured by the Mycenaean; a surprising fact in view of the popularity of life-size or even over-life-size statuary in the neighbouring civilizations of Egypt and Western Asia.

In Mainland Greece, stone reliefs were made spasmodically from the sixteenth to the thirteenth centuries BC. Earliest are the tomb-stones of carved limestone which were set up at Mycenae over the Shaft-Graves (*Ill. 99*). In all, thirteen sculptured and between seven and nine plain tombstones (probably once painted) are recorded. The subjects are scenes of chariotry and war, rendered in a spirited but crude manner, interspersed with patterns of running spirals. These tombstones are among the few objects from the Shaft-Graves exhibiting little or no Cretan influence; their clumsy style can only be of local origin.

99 Limestone gravemarker from Shaft-Grave V at Mycenae. The low relief carving is arranged in two registers; the spirals in the upper part are purely Cretan in character, but the chariot scene below and the quality of the workmanship in general are surely of local origin

100 Limestone relief masking the relieving triangle over the lintel of the Lion Gate at Mycenae, of *c.* 1250 BC. The sculpture shows two heraldically opposed lions on each side of a column. Their forefeet and the column rest on two altars placed side by side, and their heads, separately carved and originally attached by a dowel, are now lost. The subject and the arrangement are Cretan, but the translation into a large-scale monument is a purely Mycenaean conception

Of much greater merit is the famous limestone relief over the Lion Gate at Mycenae, of about 1250 BC (*Ill. 100*). It was made to mask the triangular space over the lintel of the gateway, and depicts two lions heraldically confronting each other across an architectural column. Their forefeet rest on altars of a Cretan type. Their heads, which are now missing, were made separately (perhaps of steatite) and fastened with pegs; they were probably set facing outwards, and the whole composition was crowned with an upper ornament, which has now vanished.

The design is not new; it is found on Cretan seals as early as the fifteenth century BC, and was probably transmitted by way of engraved seals or carved ivories (cf. *Ill. 48*). What is new is the effective translation of a miniature theme into a major sculptural creation; in this we must acknowledge the Mycenaean, rather than the Cretan genius.

This famous relief was never lost to sight. It was seen by Pausanias in the second century A D, and must have been familiar to Athenian audiences of the Agamemnon of Aeschylus in the fifth century B C, who would visualize Agamemnon passing through this very gate to his death on his return from Troy.

The carved patterns from the Treasury of Atreus have been considered as architectural ornament (see p. 91); but two fragmentary gypsum reliefs of bulls in the British Museum are true relief-sculpture. They were collected by Lord Elgin in the early nineteenth century, and are believed to have been found in or near the Treasury of Atreus at Mycenae. Recent excavations have established the fact that gypsum was used in this tomb and it seems more than probable that they formed part of the facing of the inner chamber. They have been plausibly restored in the manner of the reliefs of the Vapheio cups (cf. *Ills. 178–80*).

A painted plaster head, possibly from a sphinx, is another of the few pieces of large-scale sculpture in the round from this epoch (*Ill. 101*). It was found in one of the houses at Mycenae situated to the south of Grave-Circle A, and probably dates from the late thirteenth century B C. Slightly under life-size, it presents a rather fearsome aspect, due in part to the severe modelling, in part to the garish

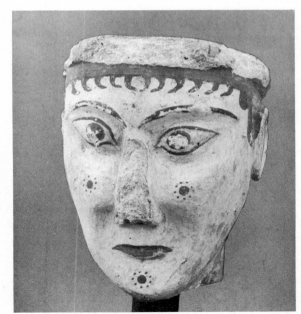

101 Painted plaster head from Mycenae. One of the few surviving examples of Mycenaean sculptures in the round, its harsh colouring and chilling stare indicate that it may represent a sphinx. The flat triangular face seems to foreshadow the conventions of the later Greek Archaic statues

colouring. The flat-iron shape of the face anticipates in an uncanny way the so-called 'Dedalic' style which was to emerge some six centuries later.

The terracotta statues from the island of Keos are considered below (see p. 128).

(see p. 128).

Crete. Painted walls had a long history in Crete. Early Minoan house-walls were plastered and painted red or brown. In the first palaces of Knossos and Phaestos (2000–1700 BC) there is a little, but sufficient, evidence to show that the walls were decorated with ornamental designs painted on the plaster. But it is not till the era of the second palaces, which came into being shortly after 1700 BC, that surviving wall-paintings are at all common, and most date after 1550.

A word about technique. A recent study of wall-paintings from Knossos has shown that Minoan 'frescoes' were not true fresco, the *buon fresco* of the Renaissance, where the pigments were applied direct to the wet plaster without any binding agent. They were more akin to the *fresco secco*, and were applied to the plaster after it had dried. A mixture of lime, or an organic binding agent such as albumen, added to the pigments would have enabled them to adhere to the plaster.

The base was a lime-plaster. The colours in general use were black (carbonaceous shale), white (hydrate of lime), red (haematite), yellow (ochre), blue (silicate of copper), and green (blue and yellow mixed).

Occasionally the scene to be painted was modelled in very low relief in the plaster, to give a slight, but none the less telling, tri-dimensional effect.

The surviving material comes principally from the second palace at Knossos and on Thera. In addition, a few frescoes were found at Hagia Triada, at Amnisos, and on Melos, but very little has been found in the palaces of Phaestos and Mallia. This latter omission may be due to the accidents of survival and excavation.

Unfortunately, all the frescoes are fragmentary and incomplete, having disintegrated when the walls collapsed. Many, too, are discoloured by fire. Most have been imaginatively, but not always accurately, restored, and our judgment of them is based all too often on the work of the modern restorer rather than on that of the original artist.

The vast majority of surviving Cretan frescoes were made between 1550 and 1450 BC; a few were made slightly earlier and a few slightly later. Apart from a noticeable rigidity and monumentality in the latest group, which point to Mycenaean influence, there is little stylistic development, and it is more profitable to group them by subjects.

The style is the first truly naturalistic style to be found in European, or indeed in any art. It includes the two chief Cretan characteristics: the reproduction of natural forms in a vivid and impressionistic manner, and the ability to fit the painting to the area to be decorated.

In most cases the frescoes were framed by bands of geometrical patterns above and below, echoes of which we find in contemporary vase-paintings.

The subjects may be classed under two broad headings: palace life, and scenes from nature.

The scenes of palace life comprise processions, court ceremonial, and religious festivals. They include such famous frescoes as the Cup-bearers and the Priest-King relief. The latter (*Ill. 102*) is extremely fragmentary, the head being entirely missing, but the rendering of muscles on his chest and left leg bear witness to an almost vanished masterpiece.

The Campstool Fresco depicts pairs of young people seated on campstools and apparently drinking each other's health. The best-preserved portion of this fresco is the so-called Parisienne (*Ill. 103*), the most charming of all surviving Cretan paintings. The dancing-girl of *Ill. 104* is important because she is one of the few figures in Cretan frescoes, apart from the Parisienne, whose head is preserved.

The celebrated bull-sports were popular subjects. Male and female acrobats are shown turning somersaults over the backs of charging bulls.

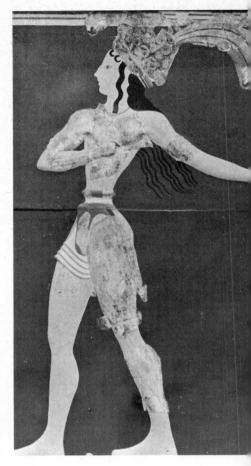

102 The Priest-King fresco from the palace of Minos at Knossos. The fresco, showing a young prince wearing a feathered crown walking in a flower-garden, is considerably restored, but the crown, the torso and most of the left leg are original. The body is delicately modelled in low relief, and these surviving portions are executed with a fresh-ness and brilliance typical of the best period of Minoan fresco-work

Subjects from nature include such pictures as the flowers from a room at Amnisos (*Ill. 105*). Three walls of a room each had a separate subject: on one, lilies; on another, irises; and on the third, plants in stone vases.

But more frequently we find animals in their natural surroundings. The so-called Saffron Gatherer turned out on further examination to be a blue monkey in a field of crocuses. There are also charming and lifelike studies of birds, monkeys, a cat stalking a pheasant, and a roebuck leaping over rocks and flowers.

103–5 The dominant characteristics of Cretan fresco-work are grace, delicacy and naturalism. One of the few surviving representations of the human face is the exquisite lady known as the Parisienne (*above*) from a group of young people sitting on stools and drinking. The dancer from the Queen's Megaron (*above, right*) is spinning so rapidly that her long curls fly out on either side of her head. A room in a villa at Amnisos was painted with different flowers on each wall, including a group of lilies (*right*) very similar to those used on the pottery of the time

Marine life was another aspect of natural history to be portrayed. A fresco painted by a Cretan artist at Phylakopi in Melos in the sixteenth century BC presents a superb study of flying fish (*Ill. 108*), and a related scene of blue dolphins and fish of many kinds decorates a room in the palace at Knossos.

A somewhat more exotic form of animal life is provided by the heraldically disposed griffins from the Throne Room (*Ill. 86*). They show the new Mycenaean ideals of monumentality (for the current ruler was a Mycenaean).

This is now the point to describe a unique monument of Cretan painting, which is dated around 1400 BC. It is the famous Hagia Triada Sarcophagus, a limestone coffin covered with plaster and painted in fresco with religious scenes. Unlike the wall-paintings, it has the advantage of being substantially complete. Both sides and both ends are occupied by self-contained scenes, each scene being framed with elaborate bands of ornamentation. Each end shows two goddesses in a chariot, one drawn by goats, the other by griffins. On one long side (*Ill. 106*) a pipe-player and three women approach a table on which lies a trussed ox; below it crouch two calves. In front, a woman in ceremonial dress makes an offering on an altar. Beyond the altar stands a double axe on a tall shelf, with a bird perching on it, and behind it is a shrine. The other side (*Ill. 107*) is divided into two sections. On the left a woman pours liquid, perhaps the blood of the ox, into a bucket, set between two double axes. Behind her stand a woman carrying two more buckets and a man playing a lyre. The second scene faces the other way. Three men carry votive gifts – two figures of animals and a model boat – to the dead man, who stands outside his tomb. These scenes raise many problems, but are evidently concerned with the worship of the dead.

Mainland Greece. Mycenaean fresco-painting owed everything technically, and almost everything stylistically, to Crete, but Mycenaean artists lacked the gay and spontaneous quality of their masters, and adopted a more monumental style. The subjects which they preferred were religious processions, which they inherited from Cretan art, and scenes of war and the chase, which were their own contribution.

106, 107 Painted limestone sarcophagus found in a tomb at Hagia Triada near Phaestos, of *c.* 1400 BC. A trussed bull is lying on a table (*above*) while the officiating priestess pours a libation at an altar, to the music of a pipe-player. On the other side (*below*) votive offerings are brought to a tomb in front of which stands the dead man

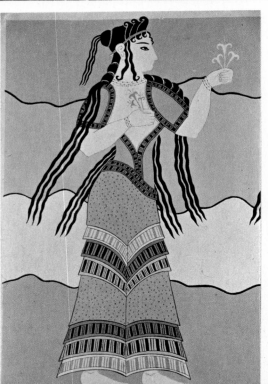

108, 109 The difference between Minoan and Mycenaean painting styles is demonstrated by these watercolour restorations. The flying fish from Phylakopi in Melos (*above*) are full of the Cretans' spontaneous delight in fluid natural forms, in sharp contrast to the woman in a procession bearing votive gifts from the Palace at Thebes (*below*). The statuesque, almost ponderous appearance of the figure is typical of Mycenaean taste

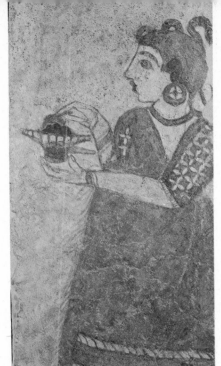

110, 111 The recently discovered frescoes from the Late Bronze Age site at Akrotiri on the island of Thera (Santorini) have given a new dimension to our knowledge of Minoan and related painting. The best of them are now exhibited in the National Museum in Athens. *Right*, a richly dressed priestess holds a glowing brazier and sprinkles it with incense. *Below*, three walls of a reconstructed room show the Theran landscape as it was before the eruption of about 1500 BC, with coloured rocks, lilies and swallows.

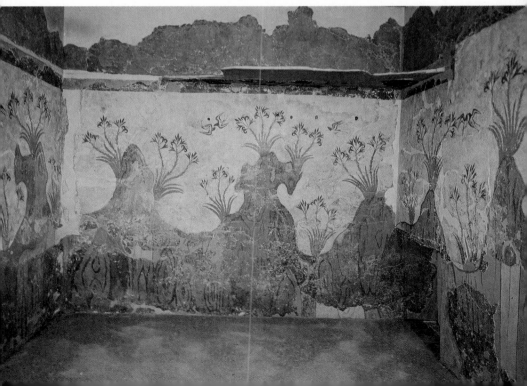

A procession of women bearing gifts was found in the usual fragmentary condition in the ruins of the Mycenaean palace at Thebes (*Ill. 109*). Its date is uncertain but it was probably painted in the early fourteenth century BC, and destroyed not long after.

There were originally between nine and twelve women slightly over life-size, bearing gifts for a goddess: flowers, pitchers and caskets. They wear the usual Cretan costume of long flounced skirt and low-cut jacket leaving the breasts exposed, with beads round their necks and their wrists. Their hairdressing is elaborate in the extreme. The background is composed of contrasting bands of colour separated by wavy lines: blue, yellow, white, blue.

Although technically and stylistically the debt to Crete is immense, there is an appreciable difference between these buxom wenches and their delicate Cretan counterparts. Similar processions which decorated the walls of the palaces at Tiryns and Pylos in the thirteenth century BC are even farther from their Cretan prototypes.

Warfare is illustrated by a fresco from the megaron at Mycenae depicting a siege of a three-storeyed palace. Other subjects include a musician and heraldic sphinxes from Pylos, and a procession of Cretan demons from Mycenae.

Thera. A third school of fresco-painting has recently been discovered in the excavations of the late Professor Marinatos and Professor Christos Doumas on the south coast of the island of Thera. Here were found a number of rich mansions destroyed in the eruption of about 1500 BC which turned Thera into a sort of Bronze Age Pompeii.

The frescoes are clearly made under Cretan influence, but by local craftsmen, for they betray a certain coarseness of execution and, in many cases, a strong local flavour.

The subjects include women richly dressed and bejewelled; one such, believed to be a priestess, is shown in *Ill. 110*. Other subjects are a Theran landscape before the eruption, with flowers and birds (*Ill. 111*); two children boxing; fishermen; exotic animals; and a miniature fresco depicting a kind of naval regatta.

The Minor Arts in the Late Bronze Age

The term minor arts is used here in no derogatory sense. Indeed, the Minoan-Mycenaean genius expressed itself perhaps most fully in the carving of ivory and the engraving of seals. There is, however, a difference in scale between the arts discussed in the previous chapter and those now to be considered, which perhaps justifies their separate treatment.

POTTERY

The pottery of the Late Bronze Age is best considered in three stages: the first and second phases of this period (1550–1400 BC); the Mycenaean Empire (1400–1200 BC); and the last century (1200–1100 BC).

1550–1400 BC. In Crete, the feature which distinguishes the pottery of the Late Bronze Age from the earlier period is the victory of the dark-on-light style over the light-on-dark. In addition, the fabric is of better quality: more refined and fired at a higher temperature. The clay is a clear yellow and the decoration at its best a fine glossy black, helped out with touches of red and white.

The first stage (1550–1500 BC) comprises the Pattern and Floral Styles (*Ills. 113, 115*). The most usual shapes are tea-cups, jugs with cutaway or horizontal spouts, rhytons (vessels for pouring libations) of various shapes, and large pear-shaped storage-jars. There is a tendency to divide the vase into zones for purposes of decoration. The motives are of two kinds, both stemming from contemporary frescoes. From the borders of the frescoes come such geometrical patterns as rows of thick-rimmed, solid-centred spirals joined by tangents (the Pattern Style). From the background come much less formal representations of flowers, grasses and reeds (the Floral Style). The two styles were not infrequently combined in the same vase (*Ill. 112*). The human content of the frescoes is ignored: when we

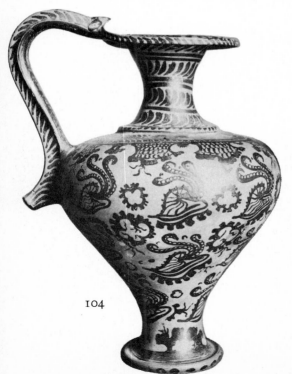

112–114 In Late Cretan pottery, motives were frequently borrowed from the repertoire of the fresco-painter. Bulls' heads and double-axes (*above, left*) are skilfully adapted to the shape by a filling of spirals, which were sometimes used alone (*above, right*) in a regular all-over pattern. The Marine Style developed in Crete about 1500 BC. The Marseilles Ewer (*left*) with its elegant shape and free use of delicate marine motives is one of the most successful Cretan vases so far known

104

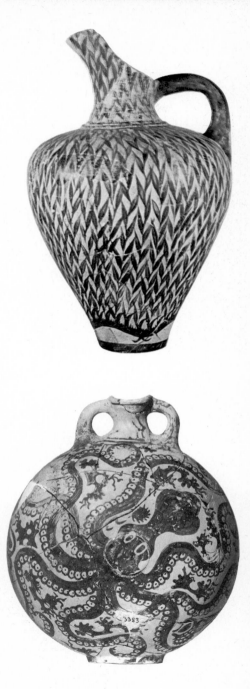

115–17 Cretan love of purely natural subjects appears in the Floral Style, where graceful plants, flowers and reeds are arranged in an all-over pattern (*right*). The Marine Style sometimes used a number of small motives grouped together, as on the rhyton from Zakro (*below, left*) and sometimes one large main motive as in the 'pilgrim flask' which has a realistic writhing octopus covering most of its surface

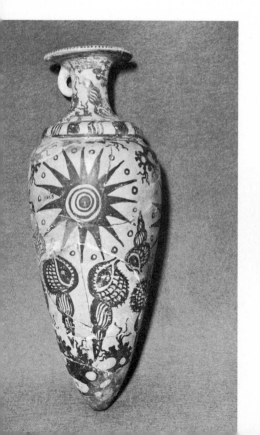

consider the average pictorial style of the fourteenth century BC we may applaud the potters' wisdom.

In the next stage (1500–1450 BC) the previous styles continue, and the Marine Style makes its appearance. In this style, the tendency to zoning is dropped and a new repertoire of sea-creatures is introduced (*Ills. 114, 116, 117*). Nearly every form of marine life is represented: octopuses, argonauts, dolphins, fish and starfish swim round the vase against a background of corals, seaweed, sponges and weeds. This style, which lends itself particularly well to an over-all arrangement over the whole vase, was one of the most successful in Cretan art, and is worthy to rank with the Kamares Style which, in its spontaneity and inventiveness, it somewhat resembles. The Marine Style seems to have died, in Crete at least, with the hitherto unexplained mass destructions of 1450 BC. A fine example of the Pattern Style of 1500–1450 BC is the stirrup-jar from Zakro shown in *Ill. 118*. This is an early version of a pottery shape which was to become exceedingly popular in the fourteenth century BC and after (see p. 110).

The next stage, the so-called Palace Style, which was really a Mainland development and was in any event confined to Knossos, is best considered in connection with Mycenaean pottery, to which we now turn.

Mycenaean pottery in its early stages (1550–1450 BC) can best be described as provincial Cretan, but with two reservations. The fabric, which is really the old Yellow Minyan, is even better than the Cretan; and certain Mainland shapes, such as the goblet, are added to the Cretan repertoire. The reliance on Cretan pottery is so great, and

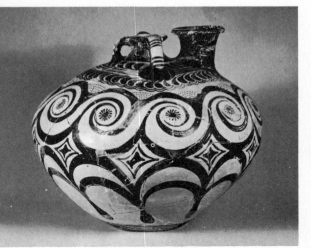

118 Stirrup-vase from the palace at Zakro decorated with a bold design of running spirals over arcades. This vessel, dating from 1500 to 1450 BC, is an early example of a type which became very common in the Mycenaean Empire. The painted decoration is clearly influenced by contemporary metal-work (cf. *Ill. 184*)

119, 120 The styles developed by Mycenaean potters in the fifteenth century are directly descended from Cretan types. A Mainland version of the Marine Style (*left*) preserves the same motives but uses them without the vitality characteristic of Minoan wares, and in the Palace Style (*right*) flower motives have developed into a stately monumental decoration used almost exclusively on large jars

the wares are so different from Middle Helladic, that one can only assume the arrival of Cretan potters in the Mainland Greek centres (*Ill. 119*).

Shortly before 1450 BC the Palace Style evolved on the Greek Mainland. In 1450 or so it was taken to Knossos when Mycenaeans occupied the ruined palace; it is found nowhere else in Crete. In this style, previously used motives are stiffened into a monumental pose: clumps of stylized lilies, octopuses and architectural motives are preferred. The shapes are few: by far the most popular is a large jar, derived from an earlier Cretan shape (*Ill. 120*).

121 'Ephyrean' goblet from Mycenae, of the fifteenth century BC. One of the most successful native Mycenaean adaptations of Cretan pottery design was the so-called Ephyrean Goblet, in which a single motive was placed on either side of a large goblet, with a small subsidiary ornament beneath each handle. This economical approach is quite foreign to the exuberance of Cretan potters

Another popular shape is the so-called Ephyrean Goblet, the finest product of the Mycenaean potter's craft (*Ill. 121*). The name is taken from an old name for Corinth – Ephyre – in which neighbourhood this class was first found. The shape is a stout short-stemmed goblet (a Mainland form) and the decoration is confined to the centre of each side and the area under the handles. A single pattern, comprising a flower, a rosette or an argonaut, forms the main design on each side. The motives are Cretan in origin, but the treatment is Mycenaean. Knossian imitations of this style are abundant but inferior in design and execution.

The potters of the Cycladic islands continued to produce their own varieties of pottery down to the destructions of about 1450 BC. The principal centre was the Third City of Phylakopi on Melos, whose wares were closely modelled on those of Crete. The most typical variety is the Red and Black Ware, in which the patterns were painted in a red or brown glaze of poor lustre, with the details picked out in a matt black. A monochrome style, similar but without the matt black, existed side by side with the Red and Black, and gradually superseded it.

This is probably the place to mention the large unpainted storage-jars which are such a feature of the ruins of Cretan palaces. Gigantic jars (pithoi) for the storage of oil and grain were made in Crete from about 1900 to about 1400 BC, and not dissimilar jars are made in Crete today. They were always hand-made, for such large objects cannot be thrown on the wheel: many are as tall as a man, and some are taller. They were decorated with patterns in added clay, frequently imitating the rope 'cradles' which would have been used to transport them. Many were found at Knossos in the West Magazines and are there to be seen today (*Ill. 122*). That shown in *Ill. 123* comes

122, 123 The population of the palace at Knossos was so numerous that vast quantities of foodstuffs were needed for their support, and these supplies were kept in magazines (*above*) in the basement of the palace, where many of the large storage-jars used for this purpose were found. These were too large to be thrown on a wheel and had to be built up by hand (*right*)

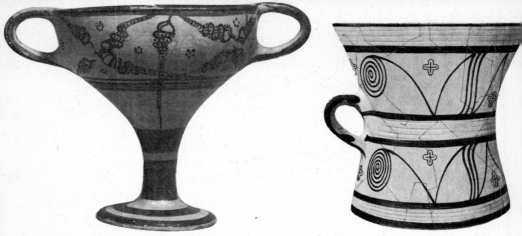

124, 125 Although Cretan influence can be seen in such objects as the stemmed cup (*left*) with its choice of shell motives, the process of stylization had begun in the fourteenth century, and the tankard (*right*) lacks the freedom and spontaneity of Cretan painting, although its decoration is well chosen

from the same part of the palace, but is now in the British Museum. They date from the fifteenth century B C.

1400–1200 BC. The pottery of the Mycenaean Empire is remarkably homogeneous over a very wide area. Cycladic pottery now loses its individuality and is merged in a common style which extended from Sicily and South Italy in the West to Western Asia Minor and the Levant coasts in the East. Only Crete stood somewhat aloof. The fabric is excellent; the clay well refined, skilfully thrown and fired at a high temperature.

The shapes are mostly developments of those current in the fifteenth century with a few additions. Stemmed cups evolve from Ephyrean Goblets; as the period progresses, the stem becomes longer and the bowl shallower (*Ills. 124, 130*). The claret-glass shape of the fifteenth century has evolved into the champagne-glass of the thirteenth. Tea-cups and tankards (*Ill. 125*) were also used for drinking. For pouring, elegant plump jugs with cutaway necks were used (*Ill. 126*).

For the storage and export of oil and wine, stirrup-jars were principally used (*Ill. 127* left). This oddly named shape deserves a word of explanation, since it is by far the commonest variety of storage-jar from 1400 B C onwards. It was invented in Crete in the

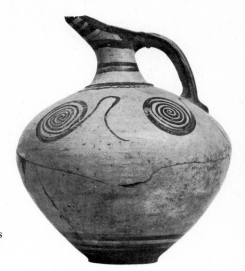

126 The economical technique of the Ephyrean Style is visible in this attractive jug with its cleverly spaced spiral motives, from Ialysus in Rhodes. It dates from towards the end of the fifteenth century BC

later sixteenth century BC (cf. *Ill. 118*) but did not become really common till the fourteenth. The body of the jar could be globular, pear-shaped or cylindrical. On the top is a solid rod of clay, which looks like a spout but is not, over which is set a double stirrup-shaped handle; the junction of handle and rod is expanded in a disk. The true spout rises vertically beside the stirrup-shaped handle. In size, stirrup-jars varied from a few inches to 20 inches (50 cm.) tall.

127 Two pear-shaped storage-jars from Aegina. That on the left is a stirrup-jar, having a dummy spout as the centre-piece of the handle, and the real spout beside it

128 Alabastron from Mycenae. Jars of this type, probably used to contain unguents, were first made of alabaster, hence the name. The decoration is based on natural forms, but stylized almost out of all recognition

Their ancient name has been recovered from the Mycenaean tablets as 'chlareus', or some such word.[1]

Another type of storage-vessel, second in popularity to the stirrup-jar, is the alabastron; a squat jar (of Mainland origin) with usually three ribbon-handles on its upper surface (*Ill. 128*). It is first found in the fifteenth century BC, when it occurs not only in pottery but also in alabaster, to which fact it owes its (modern) name.

For the storage of dry goods, deep bowls and jars of various shapes and sizes with two or three handles were used (*Ills. 127, 129*).

There were two principal styles of decoration, the Pattern Style and the Pictorial Style. The pottery of Crete, which was somewhat nonconformist, may be regarded as forming a third style.

This is perhaps the point at which to mention another form of decoration. It has recently been observed that certain undecorated

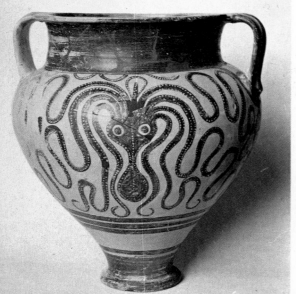

129 The Mycenaean tendency to formality and stylization is clearly seen in this large fourteenth-century jar from Ialysus. Based on Marine Style prototypes (cf. *Ill. 117*) its effect of meticulous restraint is completely at variance with Cretan temperament and execution

131 Not all Mycenaeans could afford ▶ gold and silver vessels, so they sometimes used a plating of tin to achieve a similar effect. This goblet (*right*) still has traces of tin-plate which originally covered it

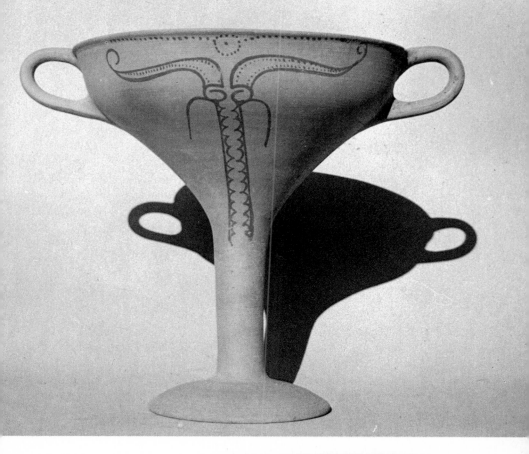

130 The happiest combination of Cretan motive and Mycenaean restraint was achieved in the making of a stemmed cup (kylix) from Kalymnos (*above*), where the simple and elegant cuttlefish motive bears little resemblance to the natural form. It was probably made in Corinth in the thirteenth century

vases had been plated with tin, to imitate silver. A two-handled cup of about 1400 BC, shown in *Ill. 131*, was originally so decorated.

Pattern Style. The motives are simplified versions of those current in the fifteenth century: scales, spirals, chevrons, octopuses, shells and flowers. As the period progresses, the motives become more and more simplified till they are little more than calligraphic squiggles. To economize their efforts, the vase-painters tended to cover most of the vase with horizontal bands, painted while the pot was revolving on the wheel, and used only a small zone, usually on the shoulder, for the patterned decoration. Occasionally, however, the principles of Ephyrean decoration (cf. *Ill. 121*) were followed, to good effect. The cup in *Ill. 130* gives an especially happy example of this alternative method.

Compared with the sixteenth and fifteenth centuries, the decoration, although always competent, shows a distinct lack of invention. It seems that the vase-painters were living on the capital laid up by Cretan craftsmen, which could sustain them for some time, but not for ever.

Pictorial Style. Most surviving examples of this style have been found in Cyprus, and were long believed to have been made there. There was, however, always the embarrassing presence of a few on Mainland sites, especially in and around Mycenae, and now, thanks to an analysis undertaken at Oxford, it has been established that the home of these vases was in the Peloponnese.[2] In view of the distribution of the few examples found on the Mainland, we might well go further and specify Mycenae as their principal home.

The style is not in its early stages a pleasing one. The principal subjects were evidently copied from palace frescoes, by vase-painters completely lacking in the ability to do such work. The subsidiary ornament, on the other hand, which sometimes encroaches on the figured scenes, comes from the repertoire of the ordinary patterned ware.

The favourite pictorial vases of the fourteenth century are large jars (necked craters) with chariot scenes (*Ill. 132*). The shape is descended from the Palace Style amphora of *Ill. 120*. The neck is widened, and the three handles are replaced by two running from

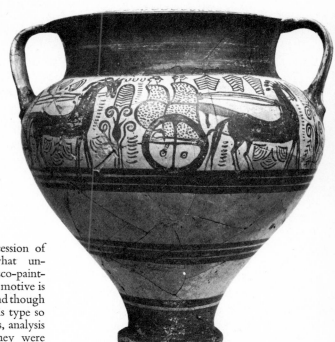

132 Jar painted with a procession of riders in chariots, somewhat unsuccessfully adapted from fresco-painting (cf. *Ill. 110*). The human motive is rare in Cretan vase-painting, and though all the 'chariot-craters' of this type so far known came from Cyprus, analysis of the clay indicates that they were made in the Peloponnese

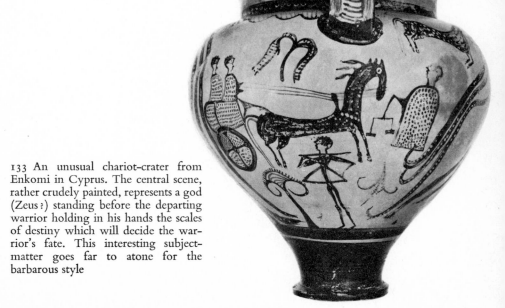

133 An unusual chariot-crater from Enkomi in Cyprus. The central scene, rather crudely painted, represents a god (Zeus?) standing before the departing warrior holding in his hands the scales of destiny which will decide the warrior's fate. This interesting subject-matter goes far to atone for the barbarous style

lip to shoulder. One of the most interesting examples of this style is the so-called Zeus Crater in the Cyprus Museum (*Ill. 133*). A chariot, with the usual two occupants, is moving to the right. In front of the chariot stands a male figure in a long robe, holding a pair of scales, while in the foreground another human figure holds a bow. Other pictures in the field are probably irrelevant, being merely ready-made patterns from the vase-painter's repertoire. The main scene has been interpreted as Zeus holding the scales of destiny in front of a warrior before he drives out to battle.

A very different style of drawing developed in the fourteenth century and achieved great popularity in the thirteenth, when a deep bowl succeeded the necked crater as the favourite shape. The subjects are bulls or other animals, birds and sphinxes, either moving in procession or facing each other heraldically (*Ills. 134, 135*). The animals are drawn in outline and the bodies divided into sections which are filled with repeated patterns of dots, crosses, chevrons or circles. The patterns look very much as if they were inspired by embroidery stitches and it may well be that this figure-style was based not on frescoes but on textiles. In a few exceptional pieces the scenes are in white on a black ground (*Ill. 136*).

Cretan pottery. Although much Cretan pottery of the fourteenth and thirteenth centuries was very like canonical Mycenaean wares, there

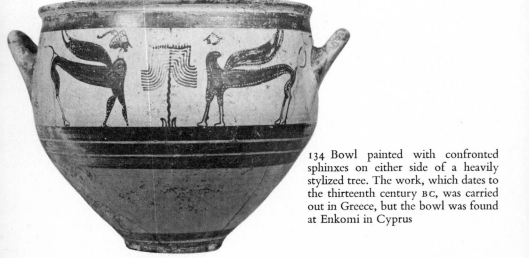

134 Bowl painted with confronted sphinxes on either side of a heavily stylized tree. The work, which dates to the thirteenth century BC, was carried out in Greece, but the bowl was found at Enkomi in Cyprus

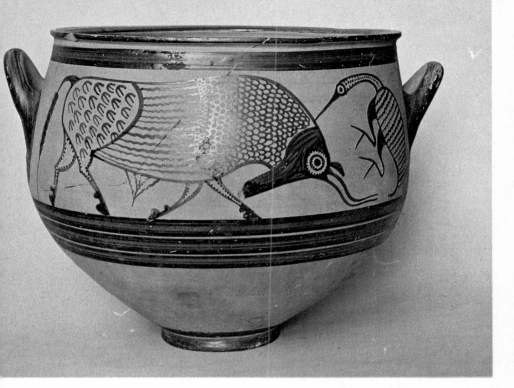

135 Large bowl painted with a bull and a bird apparently removing a tick from its hide. The bizarre but not unattractive style, common in vases of the late fourteenth and thirteenth century, is probably inspired by contemporary textiles

136 Jar painted with confronted swans in the rare light-on-dark technique which recalls Middle Minoan pottery

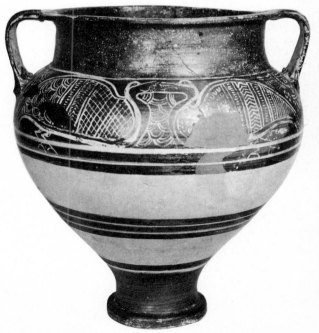

was still an inventive spirit at work which occasionally manifested itself in a more creative style. This style, at its best in pictures of birds, abounds in rich all-over patterns (*Ill. 139*). The Mycenaean love of zoning was probably never really sympathetic to the more exuberant and less disciplined Cretan spirit.

1200–1100 B.C. In the twelfth century the astonishing homogeneity of the Empire style was broken and local decorative idioms emerged. The shapes remained much as before, except that the stirrup-jar now has a small air-hole near the handle, and the disk over the central rod rises to a conical shape. The decorative styles are extremely hard to systematize, but seem to fall into about four main groups.

The Close Style evolved in the Argolid. It was clearly influenced by Cretan pottery of the thirteenth century. The shapes are few: deep bowls, stirrup-jars and occasionally large jugs. The entire vase, or a selected zone, is completely filled with complicated, close-set patterns, which generally include rosettes and strange aquatic birds (*Ill. 138*). The tapestry-like effect has a certain charm. A tankard recently discovered at Miletus, decorated with fish and aquatic birds, shows a variation of this style (*Ill. 137*).

The Granary Style also evolved in the Argolid. Here the decoration is reduced to a minimum: an all-over monochrome wash, or dark bands and wavy lines. This impoverished style led on to the Sub-

137, 138 In the twelfth century, Cretan love of natural subjects began to make a welcome reappearance after the stylized patterns of the two preceding centuries. The three-footed tankard (*left*) from Miletus is painted with lively birds and fish, and the bowl from Mycenae is decorated with swans in the Close Style

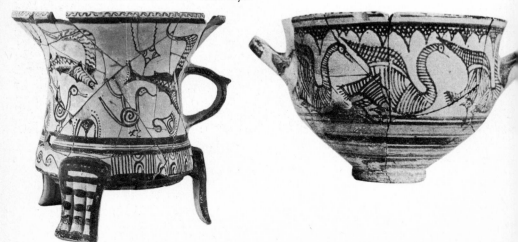

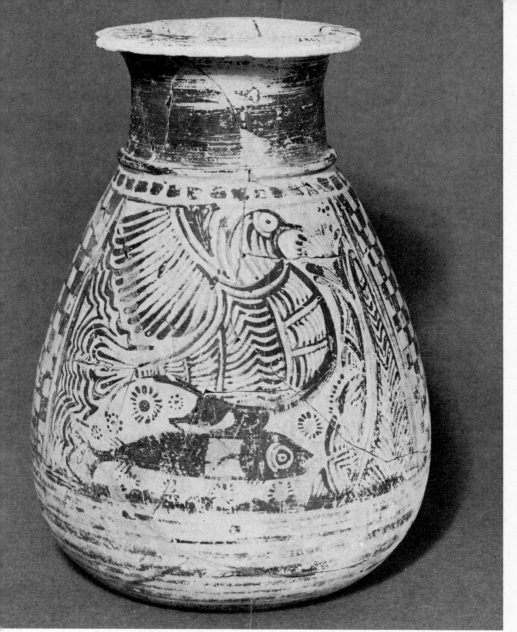

139 Jar from Phaestos in Crete decorated with birds and fish. The potters of Crete never entirely succumbed to the rigid uniformity of the Mycenaean Empire. This jar, of the fourteenth century BC, is an example of the survival of their *joie de vivre* and love of natural subjects

mycenaean of 1100–1050 BC (*Ill. 141*) which in many areas (Athens in particular) was interposed between the true Mycenaean and the Protogeometric pottery of the full Iron Age.

The Fringed and Octopus Styles. These have more to recommend them. The Fringed Style (*Ill. 140*) evolved in Crete. It is composed of thick calligraphic curves frequently equipped with fringes, the interstices being filled in with finely drawn subordinate elements. The shapes are mostly stirrup-jars, cosmetic-jars and tankards.

A variety of this style, the Octopus Style, grew out of a favourite Cretan way of decorating stirrup-jars with a thick black octopus-pattern. In the developed form of the style, which perhaps evolved in the Dodecanese, small birds and fish are drawn between the tentacles of the octopus (*Ill. 142*). Stirrup-jars decorated in this way are found in Rhodes, Cos, the Cyclades and Eastern Attica, where many superb examples have been found in the cemetery at Perati. Other vases from Perati exhibit a hybrid style which combines elements of the Octopus Style and the Close Style.

The Pictorial Style. This style continued into the middle of the twelfth century. The most famous example is the Warrior Vase discovered by Schliemann in a house on the Acropolis at Mycenae (*Ill. 143*). Eleven fully armed warriors march out to war. Tied to their spears, which they carry on their shoulders, are bags of what looks suspiciously like the day's rations. A woman bids them farewell. Scenes

140 Motifs from the Fringed Style, a Cretan technique which evolved in the twelfth century. It obtains its effect by the use of thick areas of primary decoration with secondary ornament of fine lines arranged in abstract patterns

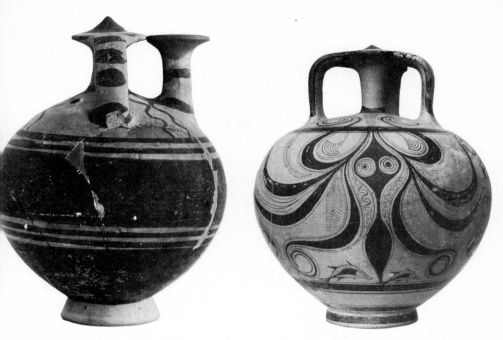

141–3 In the early twelfth century a unique vase was painted with a line of marching warriors (*below*) giving an interesting sidelight on contemporary armaments. A short-lived renaissance of fine painting in the twelfth century gave rise to the Octopus Style (*above, right*) but after 1100 BC, Mycenaean work degenerated into the Submycenaean (*above, left*) painted with plain bands and wavy lines

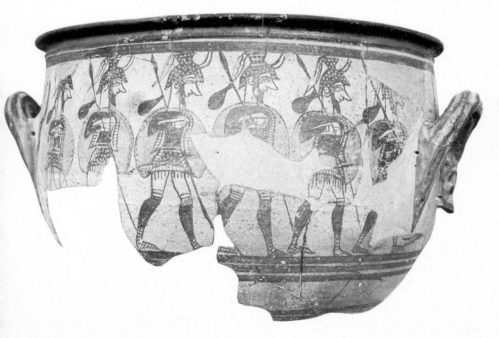

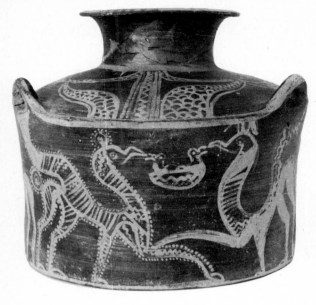

144 Unguent jar (alabastron) with light-on-dark decoration showing two griffins feeding their young in a nest on the top of a rock, from Lefkandi in Euboea. The use of white paint and the style of execution both recall the swans of *Ill. 136*

such as this must have been all too common in the troubled times in which the vase was painted.

Another vase, an alabastron from Lefkandi in Euboea, of the middle twelfth century, has an entirely different treatment (*Ill. 144*). The decoration, in white on a black ground, is quite charming. On one side two griffins are feeding their young in its nest; on the other are a sphinx, a stag and a young deer.

COFFINS

Terracotta coffins had been occasionally used in Crete from about 2200 BC, but did not become popular until about 1400 BC. They were almost universal in the fourteenth, thirteenth and twelfth centuries.

These coffins are instances of Cretan peculiarities in the midst of the Mycenaean Empire. They were made of coarse clay and were decorated by the same means and with much the same motives as contemporary pottery. Abstract designs, flowers, birds and marine life, are popular subjects. Human figures are avoided. Two shapes are known: the bath-tub, a variety which probably served in fact as a bath before doing duty as a coffin (*Ill. 147*) and the chest (*Ill. 145*), a copy in clay of a rectangular wooden clothes-chest with a gabled lid.

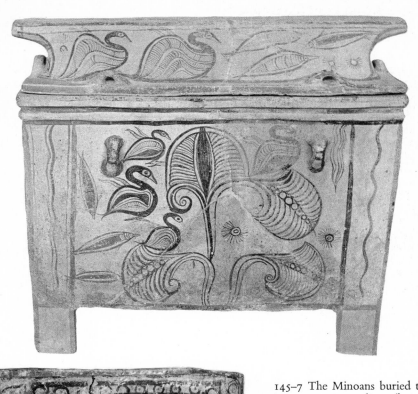

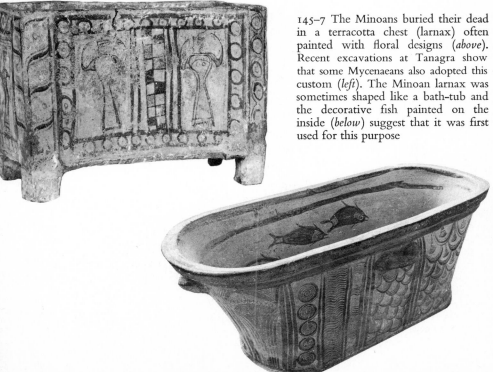

145–7 The Minoans buried their dead in a terracotta chest (larnax) often painted with floral designs (*above*). Recent excavations at Tanagra show that some Mycenaeans also adopted this custom (*left*). The Minoan larnax was sometimes shaped like a bath-tub and the decorative fish painted on the inside (*below*) suggest that it was first used for this purpose

Clay coffins are rare on the Mainland, and were almost unrecorded until the recent excavation of an extensive cemetery at Tanagra in Boeotia of approximately 1400–1200 BC (*Ill. 146*). They are evidently copies of Cretan funerary chests, but are painted in a barbarous fashion which can only be indigenous.

The subjects are mourning women, and sometimes mourning men, with occasional birds and flowers. There are resemblances in style to the Warrior Vase of the same date.

TERRACOTTA FIGURINES

In Greece and Crete the sixteenth and fifteenth centuries are poorly represented by surviving terracotta figurines.

Two varieties of rhyton in the shape of bulls were, however, recovered from Pseira in East Crete and are more profitably considered as statuettes than as vases. They date between 1550 and 1450 BC. The finer, and later, variety is shown in *Ill. 148*. They are interesting not only for accurate observation and careful workmanship, but also because they are mould-made. This is the first recorded use of the mould in this part of the world for terracotta figures, as it was also to be the last for some six centuries or more.

We turn now to Mainland Greece and the islands; in fact, to the whole Mycenaean Empire, with the significant exception of Crete.

Terracotta figures made throughout the Mycenaean Empire in the fourteenth and thirteenth centuries BC show a remarkable degree of homogeneity. They were made by the potters who made the vases,

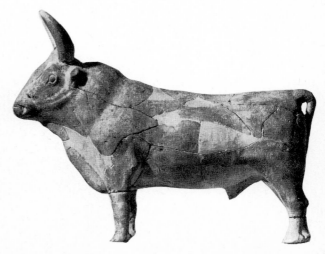

148 Terracotta rhyton (libation vessel) in the shape of a bull from Pseira in eastern Crete. This life-like study, and others like it, is remarkable for having been made in a mould. After a brief spell, this practice was dropped, not to be resumed until the seventh century BC

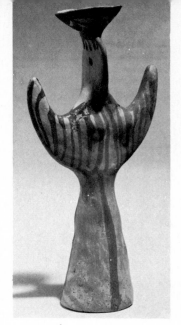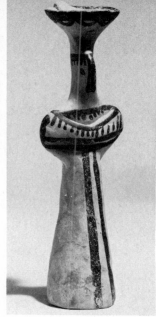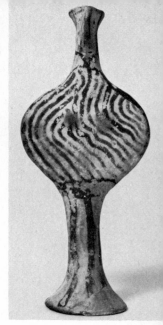

149–51 Three Mycenaean terracotta figurines of standard forms. These very stylized figurines are found wherever Mycenaeans settled, from Syria in the east to southern Italy in the west. The dress and pose are Cretan, and the goddess may actually have been a Cretan conception, but the style is purely Mycenaean and shows the same degree of simplification as the contemporary Mycenaean vase-painters' work

and bear no resemblance whatever to the contemporary statuettes of bronze and ivory.

Made with a certain slickness, but with no aesthetic feeling, these statuettes are of more interest to the social historian than to the student of Mycenaean art.

Production continued into the twelfth century when, as with the vases, the homogeneity was broken, and local varieties emerged.

The typical Mycenaean terracotta is the standing female figure, the 'Mycenaean dolly' of excavators' jargon. She wears the long Cretan skirt, a jacket, and usually a spreading headdress. Her arms may be either folded across the breast (two varieties are known, *Ills. 150, 151*) or raised (*Ill. 149*). Other popular types are a seated goddess, a chariot-group (*Ill. 155*) and a bull. A group of a man and a woman in bed (probably a Sacred Marriage) provides a note of variety in an otherwise stereotyped repertoire.

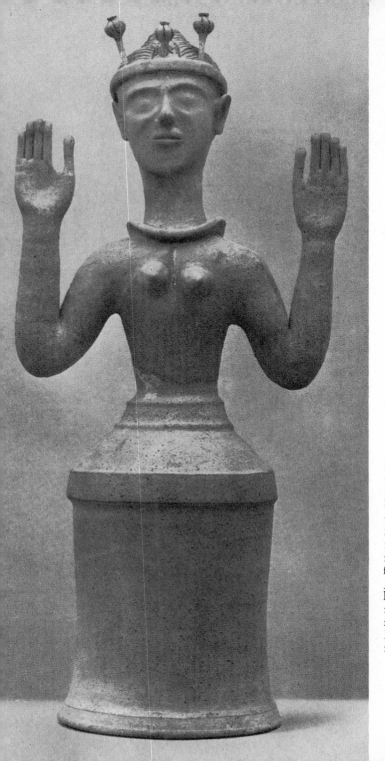

152 Large terracotta figurine of a goddess wearing a crown of poppy-heads from Gazi near Knossos, of the thirteenth century BC. Although immeasurably more stylized than the earlier faience figures (cf. *Ills. 3* and *22*) these 'household goddesses' are still much more naturalistic in treatment than the Mycenaean goddess figurines

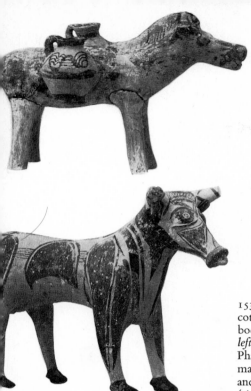
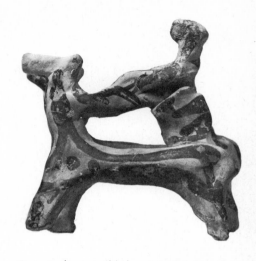

153-5 Crete is the most likely source of the terracotta animals with painted detail and wheel-made bodies. The mule carrying a load of wine-jars (*above, left*) and the staring bull (*below, left*) both come from Phaestos. A sort of artistic shorthand was used in making the extremely simplified figure of a warrior and his driver in a two-horse chariot from Ialysus (*right*)

The significance of these figures has often been discussed. Most would appear to represent deities, sacred animals or sacred events.

Meanwhile in Crete, where the standard Mycenaean statuettes were almost unknown, a quite different type of female figure, the so-called Household Goddess, evolved about 1400 BC and lasted for some three centuries. A hollow wheel-made cylinder forms a skirt for the goddess and a firm base for the figure. Some of these figures are over 2 feet 6 inches (75 cm.) tall. One has three poppy-heads on her crown (*Ill. 152*). As the poppies have apparently been slashed in the way they are cut today to extract opium, it has been suggested that she is a goddess of drug-induced peace and forgetfulness.

Finally, a class of animals with wheel-made bodies and hand-made heads and limbs which arose about 1200, probably in Crete, and lasted till as late as 1050 in some parts of Greece. A Cretan bull with

127

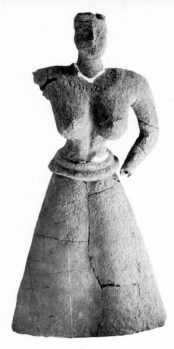

156 Terracotta female figurine from the island of Keos, of the fourteenth century BC. This large figure, and others like it, were found in a temple on Keos, the first building of Bronze Age Greece to be definitely identified as such. The figures have a very Cretan look, but they are evidently local creations, for nothing at all like them has ever been found in Crete

his open-mouthed gaze and body painted like contemporary vases (*Ill. 154*), and a mule carrying jars in a pannier (*Ill. 153*), are some of the most attractive of this class. They cannot be called great art, but they have a vitality denied to most terracottas of the Late Bronze Age.

Life-size (or nearly life-size) statues of terracotta were until recently unknown in Bronze Age Greece, but excavations on the island of Keos have produced as many as nineteen female figures dating from the fifteenth century BC (*Ill. 156*). They are found in what has been described as the earliest temple known in the Aegean.

Most wear Cretan dress, with the breasts exposed, and some also wear a necklace. These figures, which were hand-made over a wooden armature, are quite unlike any other forms of Cretan or Mycenaean art, and may perhaps be a genuine Cycladic creation. It is not certain whether they are human or divine. It is tempting to see them as Cycladic versions of a Cretan goddess, but nineteen cult statues in one sanctuary seems excessive. So perhaps they are worshippers.

They must have made an impressive show when their bright colouring – yellow, red and white – was fresh.

FAIENCE

Vases and statuettes of faience are surprisingly rare in Crete after 1550 BC, while those vases from Mainland Greece are generally believed to have been imported from Syria.

By way of exception, we show in *Ill. 157* a faithful representation of an argonaut in this material. It comes from the palace of Zakro in Crete, and was made about the beginning of the fifteenth century BC.

IVORIES

Although surviving carved ivories from Crete after 1550 BC are few, the tradition evidently continued, since tusks ready for carving have been found in the palace workshops at Phaestos and Zakro. One of the few surviving late Cretan ivories of any artistic merit is the charming plaque of *Ill. 158* which probably decorated a piece of furniture. Made in the fifteenth century BC, it depicts a bird, possibly a heron, alighting in a rocky landscape. The craft was, furthermore, one of the few to survive transplantation from Cretan to Mainland Greek soil with its vitality unimpaired. It may be, indeed, that most of the surviving ivories from Mycenaean sites were made by immigrant Cretan craftsmen, for ivory-working was always as much a mystery as a craft.

157 A lifelike and naturalistic representation of a favourite Cretan subject, the argonaut shell, in faience. It dates to 1500–1450 BC and comes from the palace at Zakro

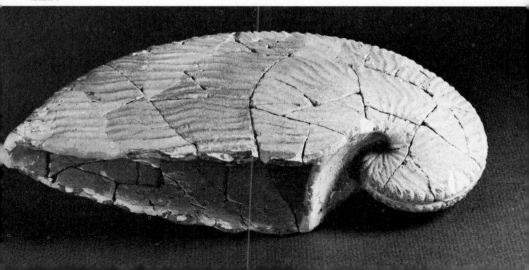

158 Ivory relief-plaque from Palaikastro in eastern Crete, showing an alighting bird, perhaps of the heron family. The graceful and delicate carving of the bird and the impressionistic treatment of the rocky landscape background is reminiscent of the Marine Style of vase-painting (cf. *Ills. 114, 116* and *117*)

The next ivory to be considered is the famous group of two goddesses and a holy child from a shrine attached to the palace at Mycenae (*Ill. 159*). The goddesses are dressed in the usual Cretan costume, and share a cloak. From its style, this charming group is normally dated around the middle of the fourteenth century, but a date in the thirteenth century is equally possible. It seems more than likely that the goddesses are the *wanasso*, the 'two queens' to whom offerings are recorded in the archives from the palace at Pylos.[3]

Another fourteenth-century masterpiece, one of two cosmetic-boxes from a tomb in the Agora in Athens, is shown in *Ills. 160, 161*. It is carved from a cross-section of a tusk with scenes of griffins attacking deer on a rocky hillside. The sympathetic interest in animal life, real or imaginary, is characteristically Cretan. The lid is decorated in a similar way.

Many fine ivories have been found at Mycenae, not least from the post-war excavations of Professor Wace. In the thirteenth-century houses outside the Citadel which he christened the House of Shields and the House of Sphinxes he found quantities of ivory reliefs and cut-outs which had been attached to furniture. One of the finest was a plaque with heraldically confronted sphinxes (*Ill. 162*); below

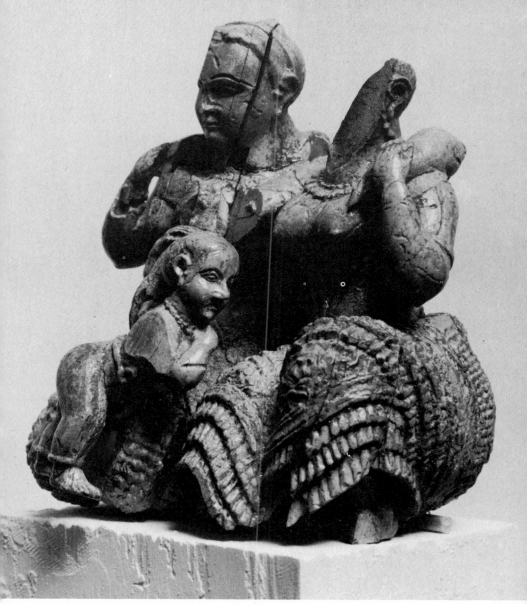

159 Ivory group of two goddesses and a divine child from the acropolis of Mycenae, of the fourteenth or thirteenth century BC. The quality of this work is so high that it must surely have been made by a Cretan, or a Cretan-trained artist

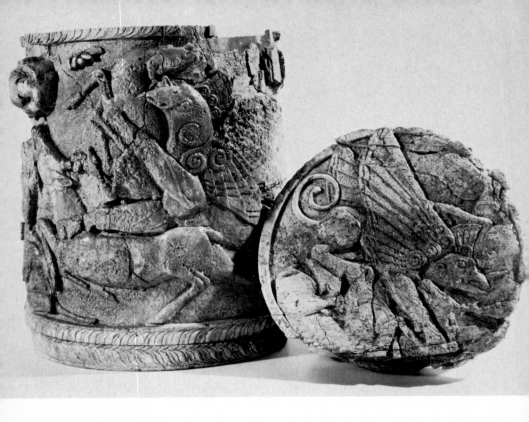

160, 161 Ivory pyxis (cosmetic-box) carved from a cross-section of a tusk (*above*) from a tomb at Athens of the fourteenth century BC. A development of the decoration (*below*) shows a lively scene of winged griffins hunting deer. Crouched near the top rim are two small lions, seen from above

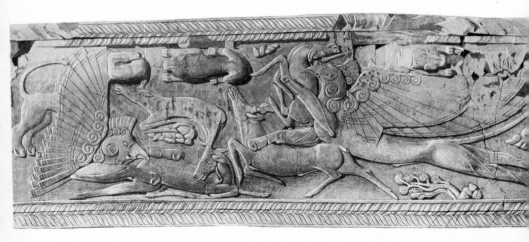

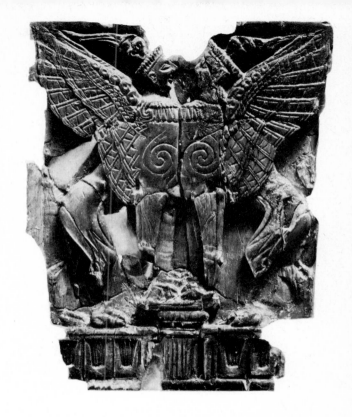

162, 163 The sphinx was a favourite subject for Mycenaean ivory-workers. The relief of the two heraldically opposed sphinxes (*above*), recalling the relief over the Lion Gate (cf. *Ill. 100*), comes from Mycenae, and the recumbent sphinx (*below*) is from Spata in Attica

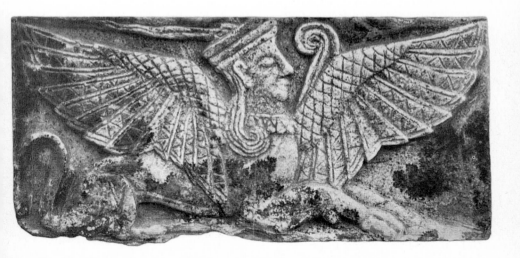

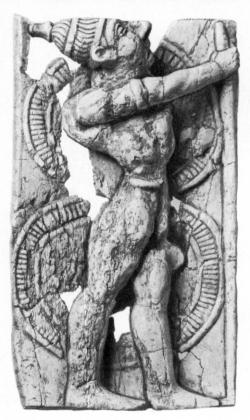

164 Ivory relief of a warrior from Delos, of the fourteenth or thirteenth century BC. He wears a helmet plated with boars' tusks and a Cretan loin-cloth, and carries an enormous Cretan figure-of-eight shield. Although the details are Cretan the treatment of the relief is entirely Mycenaean

165, 166 An ivory mirror-handle from ▶ Enkomi in Cyprus, of the twelfth century. One side (*left*) shows a lion attacking a bull, the other (*right*) a warrior killing a griffin. This exquisite work was probably executed by a refugee Mycenaean craftsman fleeing from the disturbances in his own country

them, a fluted column with a capital recalling the Treasury of Atreus, and sacred horns flanking it. The composition is strongly reminiscent of the Lion Gate, with which it is probably contemporary.

Another fine thirteenth-century ivory is a relief of a recumbent sphinx from a tomb at Spata in Attica (*Ill. 163*). A warrior from Delos (*Ill. 164*) is less satisfactory. He wears a helmet decorated with boars' tusks (a kind known to Homer), and the Cretan loin-cloth and sheath, and carries an enormous Cretan figure-of-eight shield; but the uninspired treatment is alien to the Cretan spirit.

In the twelfth century, articles of luxury were rare in Greece and Crete, but settlements in Cyprus of refugees from the wars and invasions in Mycenaean Greece have proved very rich in such things as carved ivories. We show in *Ills. 165* and *166* two sides of the carved

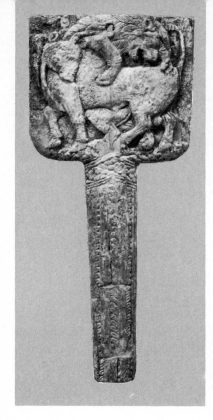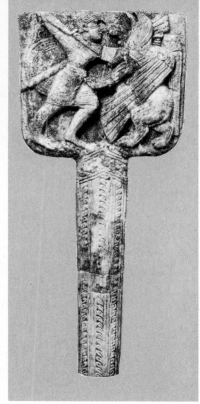

ivory handle of a fine mirror. The mirror (which would have been of bronze) has perished, but the handle is in an excellent state of preservation. On one side a lion attacks a bull in a skilfully arranged composition which recalls the best Cretan seals. On the other side a warrior kills a griffin: the grim determination of the man and the mortal agony of the beast are movingly depicted.

BRONZE STATUETTES

It is not clear when the manufacture of bronze statuettes started in Crete, but it was probably in the transitional period between the Middle and the Late Minoan periods, in the early sixteenth century B C. Hence, though the earliest examples may just fall within the limits of Chapter One, it is convenient to consider the whole class

here. How long bronze statuettes continued to be made in Crete is another question to which at present there is no answer, but it would probably be safe to say that they were made down to 1100 B C, when this survey ends. In any case, the finest bronzes are the earliest of the sixteenth and fifteenth centuries B C.

Bronze statuettes were cast solid by the *cire perdue* (lost wax) process, which is still employed in a modified form today. A wax model was first made, and surrounded by a thick coating of clay, which was then heated. The wax melted and ran out of a hole left in the clay, and molten metal was poured into the space so left. After cooling, the clay was chipped away and the bronze was complete except for any finishing touches which might be required. Although the term bronze is used, the tin content was always very low, and some statuettes seem to have been made of pure copper.

The characteristically rough surface of Cretan bronzes was probably intentional, and was caused by three factors: the impressionistic modelling of the wax in the first instance, the omission to retouch the finished bronze, and the nature of the metal. This surface was effectively copied by Rodin in the nineteenth century.

The subjects include men, women and animals. The men (*Ill. 168*) are generally in the attitude of worshippers, with the right hand raised to the forehead, but some have both arms in front of the body. Most wear a tight belt, a frontal sheath and a loin-cloth, which is the usual Cretan male costume. In some more portly examples, such as the one illustrated, the belt was (no doubt, thankfully) loosened.

The women, too, fall into two main types, with the right hand raised to the forehead or with both hands held before the body (*Ill. 167*). They wear the usual Cretan costume as seen on the faience and ivory Snake Goddesses. The finest of the animal studies is shown in the Frontispiece. An acrobat is depicted alighting on the back of a charging bull after somersaulting over its horns (cf. *Ills. 25* and *231*).

ORNAMENTAL WEAPONS

Ornamental daggers with inlaid blades are among the finest products of Late Bronze Age metalworkers. Many superb examples have been found at Mycenae, in Grave-Circle A, and so date between 1550 and

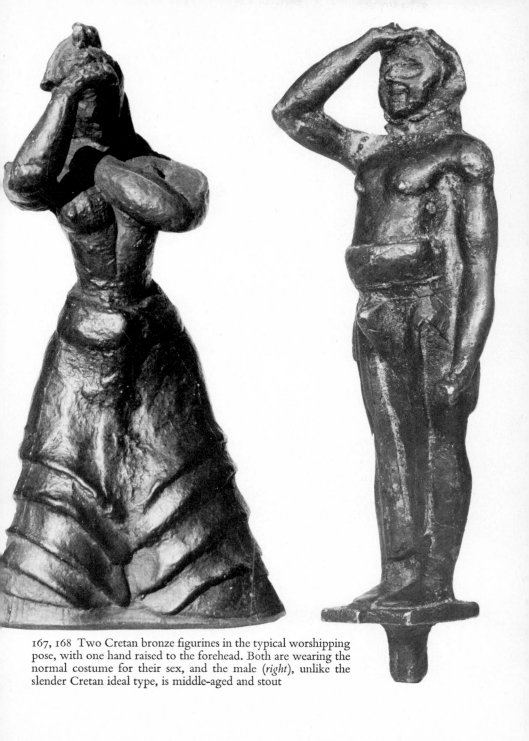

167, 168 Two Cretan bronze figurines in the typical worshipping pose, with one hand raised to the forehead. Both are wearing the normal costume for their sex, and the male (*right*), unlike the slender Cretan ideal type, is middle-aged and stout

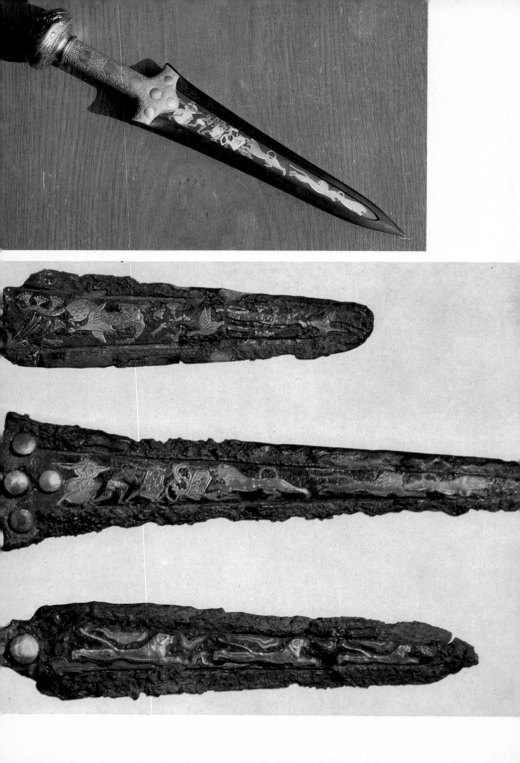

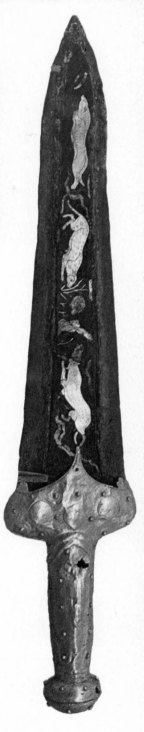

169–72 Amongst the most attractive products made by Cretans for the Mainland market were the gold-hilted daggers of bronze inlaid with gold, silver and niello. The reconstruction (*above, left*) shows how such daggers once looked, and the original upon which it is based is the middle one of the three blades shown *below, left*. A detail of a blade from the Argive Heraeum (*above*) shows a charmingly executed dolphin, a single motive reminiscent of the Ephyrean pottery technique. The only dagger with the hilt surviving intact (*right*) comes from Pylos and is decorated with hunting leopards. To make these daggers, the craftsman carried out the inlaid work on a plate of oxidized silver, which was then slotted into channels cut for it in the bronze blade of the dagger. Niello, an attractive metallic black finish, seems to be a step on the way to the use of enamelling, involving as it does the use of dry powdered components which solidify to form a glassy surface bonded firmly to the background. The earlier daggers are typically Cretan in the crowded movement and incident depicted on the blades, but as Cretan influence waned, the more severe and restrained Mycenaean taste gradually became apparent in the reduction of decoration. Throughout the history of their making, Cretan art seems to dominate the choice of motives, which are most frequently drawn from scenes of nature, although one example shows an abstract design of running spirals

1500 BC. A fragmentary blade of the same date was found on the island of Thera; and others, of the fifteenth century, have been excavated at the Argive Heraeum, at Vapheio, and at Pylos. After about 1400 BC the inlaying of dagger-blades seems no longer to have been practised, although metal vessels were decorated in this way for another two centuries.

The method of decoration was as follows. Into each side of a bronze dagger-blade was slotted a plate of oxidized silver, or, less commonly, of gold. These plates had already been decorated with elaborate scenes by means of inlays of gold, silver, copper, alloys of these metals, and niello – a process which has been graphically described as 'painting in metal'. Niello is a somewhat unfamiliar substance today, but was used by metalworkers in antiquity and in the Middle Ages. It is a bluish black material with a slight gloss. Further research on Mycenaean niello is urgently needed, but in the light of our present knowledge, it would appear that the craftsmen inserted the raw material, in the form of powdered sulphides of copper and silver, into recesses in the metal. When the work was gently heated, the powder became plastic and was pressed into place. Sometimes it was used to fill thin channels in the metal; at others it formed a bed in which to set metal cut-outs.

The hilts of the daggers were also richly ornamented, but have largely perished.

The origin of these daggers is disputed. The technique of 'painting in metal' is first found in Asia Minor about 2300 BC; from there it

173 Silver knife from a tomb at Byblos of *c.* 1800 BC. The blade is inlaid with gold, the handle gold-plated and inlaid with niello, in the same technique as the Mycenaean dagger-blades. The art was probably introduced into Crete from Syria, and exported thence to Greece

spread to Syria, where it is found about 1800 BC, together with the use of niello. A knife from Byblos, similar in technique, but not in the style of decoration, to the daggers under discussion is shown in *Ill. 173*. The style of the Mycenaean daggers is, however, definitely Cretan, and, although no examples of this technique have been found in Crete, we may assume that it was in fact started there. Furthermore, we know that Crete had strong commercial contacts with Byblos on the dates in question. A decorated dagger from Lasithi was formerly regarded as the 'missing link', but has recently been shown to be too late to have any relevance.[4]

In *Ill. 169* we see a restored copy of one of the best of the Shaft-Grave daggers; in *Ill. 170*, three of the actual blades. Above is a scene taken from Egyptian life, but represented in a purely Cretan manner. Leopards are hunting wild-duck in a papyrus swamp. In the centre is the famous lion-hunt. Some of the huntsmen carry the characteristically Cretan figure-of-eight shield; others have a rectangular shield. Below is a group of running lions. Their curious gait, with legs stretched out horizontally fore and aft, is a Cretan convention used to evoke rapid movement. It is known to archaeologists as the 'flying gallop'.

In *Ill. 172* is a fifteenth-century dagger from a tholos tomb at Pylos, one of the very few whose hilt is preserved in its entirety. On the blade is a charming scene of leopards hunting in a forest.

Many of the fifteenth-century daggers are decorated in a much less elaborate way than those from the Shaft-Graves. Indeed, a dagger from the Argive Heraeum with a single picture on each side, a dolphin and a flying fish (*Ill. 171*), makes the same powerful impact as the isolated patterns on Ephyrean Goblets. This love of simplification seems to be one of the Mycenaean characteristics in which they surpassed their Cretan masters.

Echoes of this process survived in literature long after it had ceased to be practised. In the eleventh book of the *Iliad* of Homer, Agamemnon's cuirass is decorated with inlays of gold, tin and niello (?), and in the eighteenth book the shield of Achilles is inlaid even more elaborately with gold, silver, tin and niello (?). Before Schliemann's day it would have been hard to believe that the poet

174 Votive double-axes of gold with engraved patterns, from a sacred cave at Arkalochori in central Crete. It is likely that the presiding deity was a warlike goddess, perhaps Athena herself

was recalling, however dimly, actual pieces of armour: now it is at least credible.

One other class of object could well be considered here, and that is a collection of miniature double-axes in gold and silver which were found in a votive deposit in a cave at Arkalochori in central Crete. The deposit consisted of offerings of the faithful in the form of real weapons of bronze and small-scale imitations in precious metal.

A number of gold axes from this cave is shown in *Ill. 174*. One of this series, bearing an inscription in the Linear A script, has recently been acquired by the Museum of Fine Arts, Boston. The date of these axes is not certain, but to judge from the patterns on some examples, they were probably made between 1550 and 1450 BC.

The recipient of these offerings must have been a remarkably war-like deity, an anomaly in the peaceful Cretan community. We do, however, know of an armed goddess (cf. *Ill. 240*) and our thoughts turn naturally to Athena herself, who is apparently mentioned in the archives of Knossos as the recipient of offerings.

GOLD AND SILVER PLATE

The gold and silver plate of the Late Bronze Age continues the tradition established in Crete in the Middle Minoan period. The richest collections come from the two Grave-Circles at Mycenae, from tombs at Dendra in the Argolid and Peristeria (near Pylos) in Messenia, and from Cyprus. Very little has been found in Crete.

The plate may be divided into three groups, according to the method of manufacture: plain, embossed and inlaid vessels.

Plain vessels of precious metal are not rare. An early example is a gold two-handled cup from Grave-Circle A at Mycenae, of the kind known to archaeologists as a kantharos (*Ill. 82*). The shape is Mainland Greek, but the work is probably Cretan.

Other plain vessels are gold and silver cups in the shape of tea-cups, and in the shape of the Vapheio Cups (see p. 144), and goblets (*Ill. 175*). They seem to have been made from 1550 BC down to the thirteenth century BC.

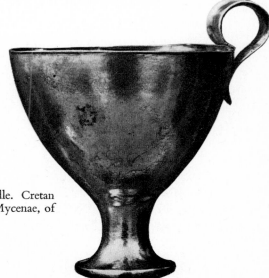

175 Plain gold goblet with one handle. Cretan workmanship from Shaft-Grave IV at Mycenae, of 1550–1500 BC

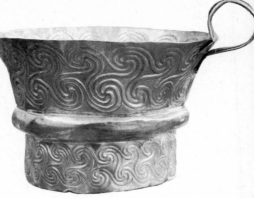

176 Gold cup with ribbon handle, embossed in two registers with a Cretan pattern of running spirals, from Shaft-Grave V at Mycenae. Cups of this type are usually imports from Crete

177 A poor man's version of the embossed gold cups was made in bronze. This example from Mochlos, of *c.* 1550 BC, has a spool handle (cf. *Ills. 31* and *179*) and was decorated with stylized ivy-leaves

Embossed vessels were possibly as common as plain ones, and it is sometimes possible to follow the progress of a particular shape over several centuries.

Cups of the so-called Vapheio shape are found in gold in Grave-Circle A at Mycenae, decorated most frequently with spiral or floral patterns not unlike those found on contemporary pottery (*Ill. 176*). Similar cups have recently been discovered in a tomb of the same date at Peristeria. The Cretan origins of this type of cup are assured by many examples in clay which go back to an earlier period and one in bronze from a tomb at Mochlos of about 1550 BC (*Ill. 177*).

We pass now to the two Vapheio Cups, which are among the finest examples of Cretan art to have come down to us. They were found together in a tholos tomb at Vapheio near Sparta, in association with pottery of 1500–1450 BC, which serves to date them. They consist of an embossed outer case, and a plain lining, all of gold. A gold spool-shaped handle was attached with rivets.

The subjects embossed on them are related, being both concerned with the capture of wild bulls, doubtless for the arena.

144

178, 179 Two magnificent gold cups ornamented with reliefs of bull-trapping, in the highest tradition of Cretan artistry, were found in a tomb at Vapheio. The first cup shows the bull caught in a net (*right*), the distorted body giving a startling impression of violent movement, and (*below*) an escaping bull trampling his captors

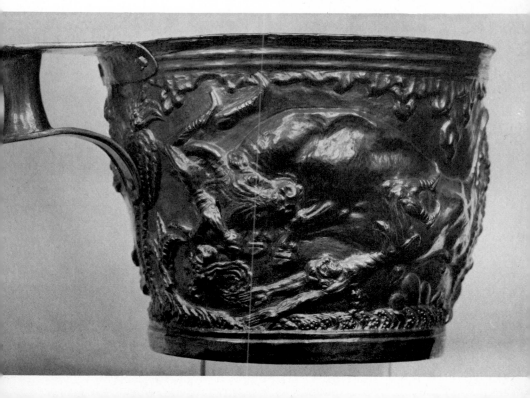

The first cup (*Ills. 178, 179*) presents a scene of speed and confusion. In the centre a bull is trapped in a net slung between two olive-trees. His body is deliberately distorted in the manner popular with gem-engravers of this period (cf. *Ill. 234*), to make a satisfactory pattern and to underline his agony. On either side a bull gallops away in fright. One bull has thrown one of the huntsmen while another man is grappling with its horns and trying to mount it.

The second cup (*Ill. 180*) has a more peaceful theme. Evans interpreted it as three episodes in the capture of a wild bull by means of a decoy cow, and he was probably correct. From right to left, the scene shows: first, the bull following the cow's trail; second, the bull and cow conversing; third, the bull captured by the huntsmen, who tether it by the hind leg.

We can bring the development of this type of cup one step farther with a fragmentary example from the tholos tomb at Dendra, of

180 The second Vapheio Cup shows a bull being caught peacefully by means of a decoy cow, and tethered by the hind leg. The vivid impression of life and motion conveyed by both these cups places them amongst the finest Cretan work so far known

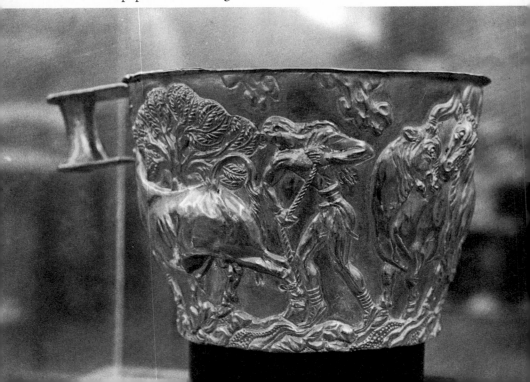

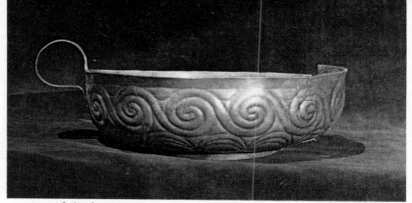

181 One of the few surviving gold cups actually found in Crete is the 'tea-cup'
from a tomb at Knossos. It has a ribbon handle and is embossed with a band of
double running spirals over an arcade pattern

about 1400 B C. It has a lining of gold, while the handle and the
embossed casing are of silver. It is decorated with galloping bulls in
a manner recalling the first Vapheio Cup.

The tea-cup shape had a similar history. We meet it at Knossos
where a set of silver cups decorated with spirals comes from a house
of 1550–1500 B C. A gold cup from a tomb at Knossos is rather later,
about 1500–1450. It has a band of double running spirals over an
arcade pattern (*Ill. 181*).

Then comes the famous gold Octopus Cup of about 1400 from
the tholos tomb at Dendra (*Ills. 182, 183*). It is beautifully embossed
with octopuses against a background of coral, sea-anemones,
dolphins and argonauts.

A large silver jug from Grave-Circle A at Mycenae (*Ill. 184*) is
particularly worthy of remark. It is richly embossed with a row of
spirals above an arcade pattern. The rest of the body is decorated
with horizontal fluting. A similar vase, but of bronze, comes from
Knossos, and serves to indicate the origin of the type (*Ill. 185*).

We now pass to vessels with inlaid decoration. The technique is
similar to that of the inlaid weapons, which have already been dis-
cussed, and is perhaps immediately of Cretan, though ultimately
of Syrian origin.

182, 183 Bottom and side view of a gold 'tea-cup' from a royal tomb at Dendra in the Argolid, of *c.* 1400 B C. This lovely cup is embossed with scenes of marine life executed in the impressionistic Cretan manner (cf. *Ills. 114, 116* and *117*)

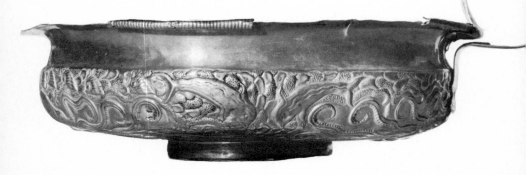

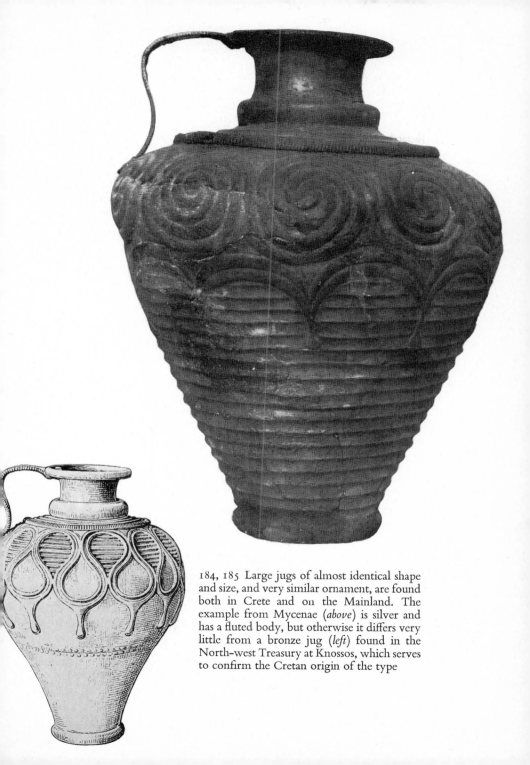

184, 185 Large jugs of almost identical shape and size, and very similar ornament, are found both in Crete and on the Mainland. The example from Mycenae (*above*) is silver and has a fluted body, but otherwise it differs very little from a bronze jug (*left*) found in the North-west Treasury at Knossos, which serves to confirm the Cretan origin of the type

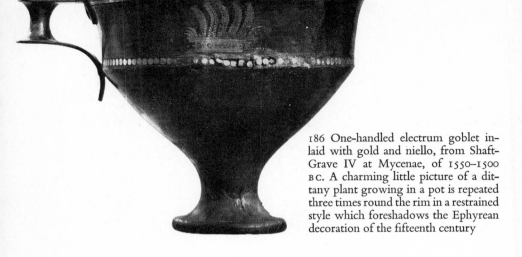

186 One-handled electrum goblet inlaid with gold and niello, from Shaft-Grave IV at Mycenae, of 1550–1500 BC. A charming little picture of a dittany plant growing in a pot is repeated three times round the rim in a restrained style which foreshadows the Ephyrean decoration of the fifteenth century

A charming silver goblet of 1550–1500 BC comes from Grave-Circle A at Mycenae (*Ill. 186*). The rim is decorated in gold and niello with scenes of fern-like plants growing in pots. It is, strangely enough, the only inlaid vessel from the Shaft-Graves, where so many inlaid daggers were found.

Inlaid vessels of the fifteenth century are rare in themselves, but inlaid cups of the Vapheio shape are represented in Egyptian tomb-paintings of 1500–1440 BC, being brought as tribute by Cretan emissaries. They are drawn too large, but otherwise (it would appear) accurately.

The tomb of Senmut, of about 1500 BC, shows one of bronze (?) with inlay of copper, gold and silver, representing bulls' heads and rosettes (*Ill. 187*). Another has inlaid spirals.

Recently part of a bronze Vapheio-type cup inlaid in silver with bulls' heads and double-axes appeared on the market as having been found in Crete. We can therefore vouch for the accuracy of the Egyptian painters, if this attribution is correct.

Two very similar inlaid cups made about 1400 BC have been found in widely separated areas: at Dendra in the Argolid and at Enkomi in Cyprus. The latter is shown in *Ill. 188*. It is of silver, decorated in gold and niello with bulls' heads and floral patterns.

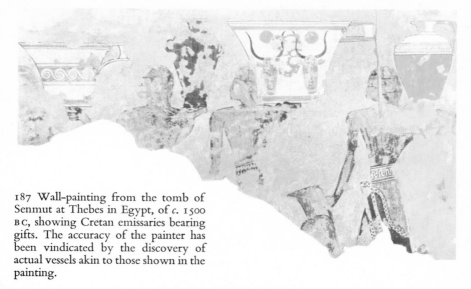

187 Wall-painting from the tomb of Senmut at Thebes in Egypt, of *c.* 1500 BC, showing Cretan emissaries bearing gifts. The accuracy of the painter has been vindicated by the discovery of actual vessels akin to those shown in the painting.

188 Silver cup of hemispherical form with wishbone handle from Enkomi in Cyprus, of *c.* 1400 BC. The outer surface of the cup is decorated with bulls' heads above an arcade pattern. The cup is a traditional Cypriot shape, but the choice of motive and its treatment are typically Mycenaean, suggesting that it was made in Greece expressly for the Cypriot market

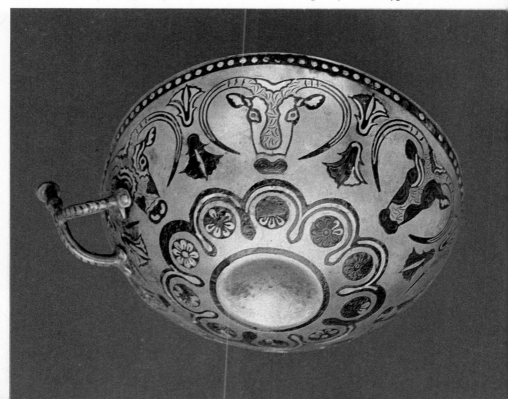

Finally, a silver tea-cup with inlaid male heads of gold and niello brings us down to the thirteenth century (*Ill. 189*). The cup, which was found at Mycenae, cannot be dated by itself, but the heads are very like some detached heads found at the palace at Pylos, and therefore of the thirteenth century B C, which look as if they once adorned a similar cup.

Two other classes of object could well be considered at this point.

The first comprises the gold masks which were found in the Shaft-Graves at Mycenae (in both Grave-Circles) and which were placed over the faces of the dead at the time of burial. It is doubtful whether they can be regarded as portraits in the modern sense of the word, but they give us some idea of the physiognomy of the lords of Mycenae in the later sixteenth century B C. The mask shown in *Ill. 190* is the one which Schliemann mistakenly identified as belonging to Agamemnon himself.

189 Silver cup from Mycenae decorated in gold and niello with a row of bearded male heads between two foliate bands. Similar heads, detached from their background, were found in the ruins of the palace of Nestor at Pylos, and date this cup to the thirteenth century B C

190 Gold mask from Shaft-Grave V at Mycenae. Masks like this were laid over the faces of the dead in the Shaft-Graves, and it is likely that they represent an early attempt at an actual portrait. This particular example was believed by Schliemann to belong to Agamemnon himself, but the mask is some three centuries earlier in date than the reign of the hero

A gold-plated hexagonal wooden box is shown in *Ill. 85* to demonstrate the work of a Mycenaean craftsman to whom the Minoan spirit was still somewhat alien. The palm-trees and the animals are without a doubt inspired by Cretan originals, but in the execution have been completely changed. Style there is of a kind, but it is not a Cretan style.

STONE VASES

Ritual vases (rhytons) made of soft stone in various shapes and decorated with scenes in low relief, were popular in Crete in the first half of the fifteenth century BC; numbers have been found in the ruins of palaces and houses destroyed in 1450, and vases (whole or fragmentary) in a similar style have been recovered from Mainland sites. From the flakes of gold leaf which were found adhering to some of these rhytons, it would appear that all were originally gilt and were in consequence cheaper versions of embossed gold plate like the Vapheio Cups of *Ills. 178–180.*

153

The finest of these vases come from the Villa at Hagia Triada near Phaestos and from the newly discovered palace at Zakro.

Of the three from Hagia Triada, two (the Harvester Vase and the Chieftain Cup) have lately been re-examined by Forsdyke, who regards them as products of the same artist.[5] The remarks which follow are based on his conclusions.

The Harvester Vase (*Ill. 191*) was a rhyton which had an oval bottom. The lower part, which was made separately, has not survived, but the upper part, with the top two-thirds or so of the figured scene, is preserved in its entirety. It is a procession of twenty-seven people, twenty-one of whom carry on their shoulders hoes with willow-shoots attached to the ends, and bags of seedcorn suspended from their belts. They are led by an older, long-haired man wearing a voluminous cloak with a pine-cone pattern and carrying a long stick. Midway in the procession comes a singer waving a sacred rattle, who is followed by a choir of three. Towards the end of the procession one man turns to shout at another, who is dancing his way through the procession, hurling abuse at his comrades. This is not, as was once thought, a harvest festival, but a sowing festival, for which Forsdyke has been able to produce many parallels ancient and modern, including our own Plough Monday.

191 The Harvester Vase, a serpentine rhyton from Hagia Triada, only the top part of which is preserved. The scene is a seed-time festival performed by a procession of revellers. The artist has shown very great skill in fitting twenty-seven human figures into the small field at his disposal without any loss of clarity

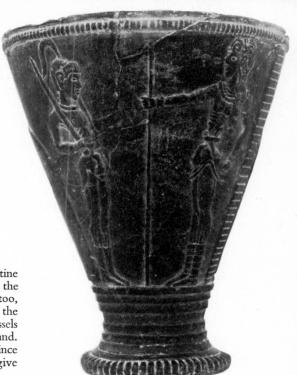

192 The Chieftain Cup, a serpentine cup, was originally gold-plated like the piece in *Ill. 191*. Its workmanship, too, is very similar, and it was found at the same site, suggesting that both vessels may have been made by the same hand. The relief shows a young prince standing outside his palace to give orders to the Captain of the Guard

The Chieftain Cup (*Ill. 192*) is substantially complete. The scene is as follows. A young man of aristocratic demeanour stands in front of a building. He wears the usual Cretan costume augmented by high boots and an elaborate jewelled collar, and holds a sceptre in his right hand. He is without doubt a ruler standing in front of his palace, or (more probably) in the Central Court in front of the State Apartments. He has been interpreted as Minos of Knossos, but, if the vessel was made locally, I would prefer to see him as the Lord of Phaestos. Whoever he is, he is giving orders to an official dressed much like himself. This official carries on his right shoulder a long sword about the same size as those from Mallia (p. 42), and on the other shoulder a ritual sprinkler. He is attended by three men carrying hides, probably the skins of newly sacrificed bulls destined to be made into shields. The scene is so lifelike that one notices with surprise the

155

profile head and legs of the king, while his chest is turned through ninety degrees to the front.

The third rhyton to be considered comes from the palace at Zakro. It is shown in *Ill. 193* without the top part which has since been identified and attached; it was similar to that of the rhyton in *Ill. 200*. There are plentiful traces of the gold-leaf with which the vase was originally covered. The scene is a mountain-sanctuary, recognizable by the sacred horns (Evans calls them 'horns of consecration') which surmount it, and by the three altars which are set in front of it. The door and the doorway are elaborately decorated with spirals like the doorway of the tomb on the Hagia Triada Sarcophagus (cf. *Ill. 107*). On the roof, over the doorway, four wild goats are seated in a heraldic pose, flanking what appears to be an abstract representation of a god or goddess.

Two more wild goats are shown clambering on the rocks on which the shrine is built. Two hawks are also shown in the neighbourhood. The rendering of the goats on the roof is a particularly telling example of the Cretan facility in combining truth to nature with the making of decorative patterns. Fragments of another rhyton with a similar scene were found some years ago at Knossos.

A contemporary rhyton from a tomb at Mycenae is decorated with two spirited representations of octopuses swimming on a coral-strewn sea-bed: an effective translation into stone of the Marine Style of vase-painting (cf. *Ill. 116*).

Vases of ornamental stone, made to be enjoyed in their own right, were immensely popular in Crete between 1550 and 1450 BC, especially in the latter part of this period. In the quality of workmanship, the beauty of the stones used, and the variety of shapes, stone vases of this period reached a standard of excellence not seen since Early Minoan times (cf. *Ills. 26, 27*).

Graceful vases of limestone, variegated marble, alabaster, porphyritic stone (especially a green variety from near Sparta), obsidian (volcanic glass), rock-crystal, serpentine and steatite are recorded from a number of Cretan sites including Knossos and, above all, the recently excavated palace at Zakro. Such vases were also exported to the Greek mainland, where a number have been found at Mycenae.

193 Serpentine rhyton with decoration in relief with traces of the original gold-plating from the palace at Zakro. It shows a mountain-top shrine with wild goats on the roof; more goats and hawks are seen in the surrounding rocky landscape. The accurate observation betrays the keen delight of the Cretan artist in nature for its own sake

194 A graceful chalice
of obsidian from the
palace at Zakro, of
1500–1450 BC. Obsid-
ian, a form of volcanic
glass, is one of the most
difficult materials to
carve, and the feat was
seldom attempted, but
here it has been carried
out very successfully

195, 196 Several elegant tapered chalices were found in the palace at Zakro. Variations on the plain outline of *Ill. 194* were horizontal fluting in variegated marble (*left*) and an effective quatrefoil shape (*right*)

Of the many shapes now current, the 'blossom bowl' (cf. *Ill. 28*) and the 'bird's nest' (cf. *Ill. 27*) continue, now rather higher in the shoulder. But perhaps the most graceful shape, richly represented at Zakro, is the chalice. Undecorated chalices are recorded from Mycenae in alabaster, and from Zakro in obsidian (*Ill. 194*). Two more from Zakro are of variegated marble: one is fluted horizontally (*Ill. 195*), the other carved in a quatrefoil form (*Ill. 196*).

197 A noble two-handled jar of marble, from the palace at Zakro. The graceful shape, with its thin rimmed neck and sweeping curves, not really at home in stone, is clearly indebted to a metal original

A globular jar of variegated marble with two high-swung handles, also from Zakro, was hitherto known only from representations on frescoes from Knossos and Thebes (*Ill. 197*).

Another popular shape at Knossos and at Zakro is a pear-shaped ritual sprinkler (rhyton) with a beaded collar and a spool-shaped neck. An example from Zakro of marble is fluted vertically (*Ill. 200*). Another from the same source is made of rock-crystal, with a separately made collar and a high-swung handle, both also of rock-crystal.

Two other less common shapes are represented at Zakro in porphyritic stone: a bridge-spouted jar (*Ill. 198*) and a fluted bowl with two perforated lugs for bronze handles (*Ill. 199*). Both are re-worked from imported Egyptian vases of an earlier date.

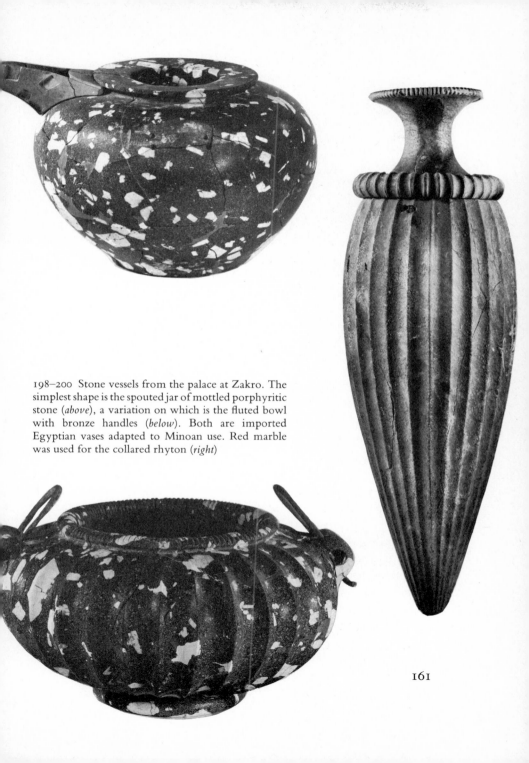

198–200 Stone vessels from the palace at Zakro. The simplest shape is the spouted jar of mottled porphyritic stone (*above*), a variation on which is the fluted bowl with bronze handles (*below*). Both are imported Egyptian vases adapted to Minoan use. Red marble was used for the collared rhyton (*right*)

201 Unguent-vase of rock-crystal in the form of a duck, from Grave-Circle B at Mycenae, of 1550–1500 BC. The Cretan artist who carved it has transformed a basically Egyptian motive into something characteristically Cretan

A rock-crystal vase of great charm from Grave-Circle B at Mycenae is almost certainly Cretan work, of 1550–1500 BC. It consists of a bowl, probably for cosmetics, with a handle ending in the head of a duck (*Ill. 201*).

Serpentine rhytons in the form of bulls' heads are recorded from Knossos and Zakro, and fragments have been found at other Cretan sites and at Mycenae. Those from Knossos and from Zakro, although not complete, have been skilfully restored, and are minor masterpieces of sculpture. The Knossian version (*Ill. 202*) was originally equipped with horns of gilt wood. The eyes (of which the right is perfectly preserved) had a lens of rock-crystal, painted on the underside with red for the pupil, black for the iris, and white for the rest of the eye. The crystal is set in a surround of red stone to give a frighteningly blood-shot effect. Round the nostril is an inlaid band of white shell.

Long shaggy hairs are engraved on the animal's forehead, brows and cheeks, and other engraved lines indicate dappling. The

202 Serpentine rhyton in the form of a bull's head (*opposite*) from the Little ▶ Palace at Knossos. The horns (now restored) were of gilded wood, the eyes of rock-crystal realistically painted, and the muzzle of shell. Numbers of such rhytons are known, but this is both the finest and the most complete. Such a natural and sympathetic study of an animal was not to be seen again in Greek lands until the fifth century BC

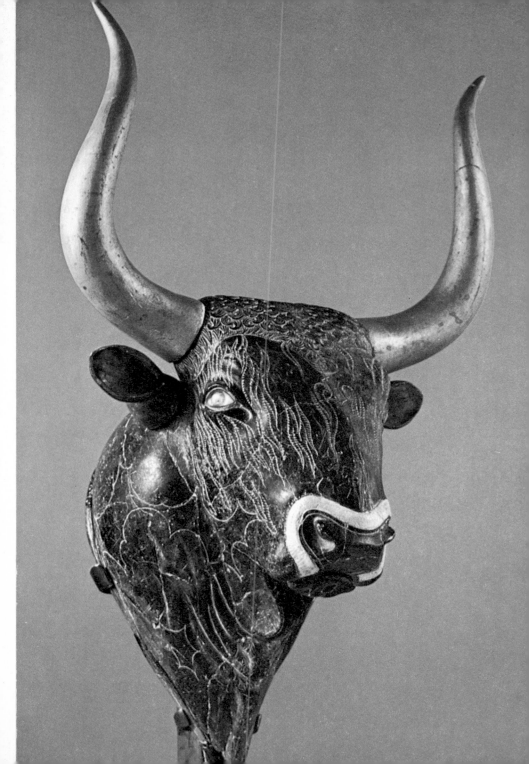

filling-hole is in the neck and a small hole in the muzzle served as a spout.

The Zakro version is smaller and less complete, but is of even finer workmanship, and the fragment from Mycenae is of an equally high standard.

In Egyptian tomb-paintings of about 1500–1450 BC, Cretan emissaries are shown carrying bulls'-head rhytons of just this kind.

Marble lion-head rhytons were also made in Crete in this period, but are less common. Examples are recorded from Knossos and from the later oracular shrine at Delphi, a site of legendary Cretan connections.

Between the disasters of 1450 and the fall of Knossos about 1375 BC stone vases continued to be made at Knossos, now under Mycenaean domination, but not at other Cretan centres. The vases tend to be larger and less graceful. Squat alabaster jars of the form shown in clay in *Ill. 128* were actually in use in the Throne Room at Knossos when the palace was destroyed, and other large stone vases were recovered from the ruins. In addition, two large jars were in the process of being worked in the palace at Knossos when the final

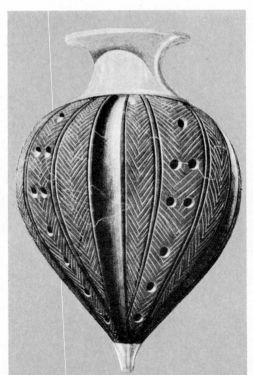

203 Serpentine rhyton in the shape of a peg-top, from a house at Mycenae of the thirteenth century BC. The segmental divisions and herringbone carving were supplemented with inlays of coloured stone, or perhaps glass

blow fell. They were found unfinished in the so-called Lapidary's Workshop.

After 1375 BC very few stone vases were produced in Crete, but the tradition was maintained on the Greek Mainland. A serpentine rhyton of peg-top shape was found in the so-called House of Shields at Mycenae of the thirteenth century BC (*Ill. 203*). It is divided into segments like an orange; the segments, in groups of three, are lightly incised with herringbone patterns. The central segment of each group is drilled with holes for an inlay, which has now vanished; each group is separated from the other groups by a deep groove.

JEWELLERY

By the end of the Middle Bronze Age, Cretan goldsmiths had mastered every process which was to be used in antiquity except that of enamelling. It remained for them to exploit these resources with the new stimulus of the far greater wealth and more general demand which arose in the Mycenaean world. Of jewellery from Crete itself there is surprisingly little in the early part of this period, but the so-called Mycenaean jewellery is completely in the Cretan tradition,

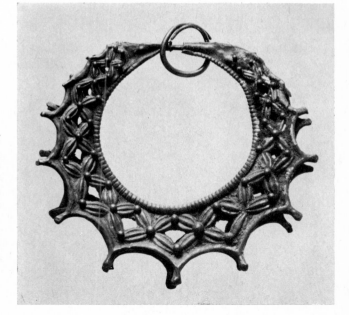

204 Gold ear-ring, one of a pair from Shaft-Grave III at Mycenae. These ear-rings are remarkable for two things: they are the only objects in the Shaft-Graves embellished with granulation, and they are almost the only ear-rings to be found in a Mycenaean context

205, 206 Two varieties of gold relief-bead from tombs at Mycenae, of *c.* 1400 BC. They represent stylized ivy-leaves (*left*) and heraldically paired argonauts (*below*). The artist has imposed a variety of decorative patterns on the natural forms by means of repoussé-work, granulation and blue enamel, with wholly admirable results. Such beads are hollow with flat backs, and the gold sometimes hides a core of filling material employed by the goldsmiths to reinforce the strength of the finished article. It is typical of Mycenaean temperament to lavish so much painstaking care on minute detail, and the large numbers of these beads which have survived indicate that a high standard of craftsmanship was common

207 Silver pin in the shape of a crook with a gold pendant head, from Shaft-Grave III at Mycenae, of 1550–1500 BC. The pendant comprises an embossed figure of a Cretan goddess holding a double garland in her hands. On her head are two pairs of volutes supporting three palm-branches which curve down on either side of the figure. She must be a Cretan nature goddess, the female counterpart of *Ill. 140*. The pin is an imposing piece of jewellery, designed with an eye to splendid effect rather than functional efficiency; the shank is so massive and heavy that a large head was needed to keep it in position, and if it was worn on any but a very thick fabric it must have caused considerable damage

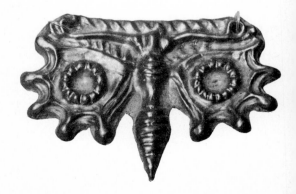

208–10 Three cut-out ornaments of embossed gold, many variations of which were sewn to the clothing of the woman buried in Shaft-Grave III. The goddess with the doves (*above*) is unusual in the art of this era, where the nude is very rarely portrayed; the octopus (*left*) and the butterfly (*below*) are both common in Cretan art

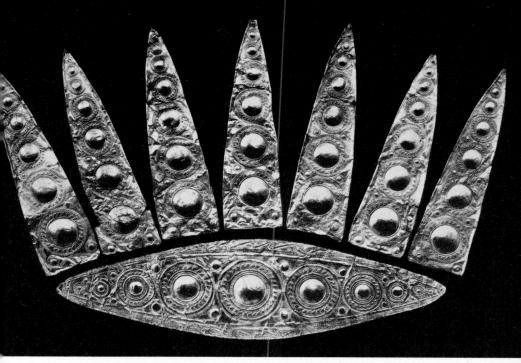

211 Gold diadem from Shaft-Grave III at Mycenae. Embossed diadems of very thin gold, apparently mounted on a backing of leather or fabric, seem to have been generally worn by Mycenaean women of high rank. This example is decorated with Cretan motives, but nothing like it has been found in Crete, and it can be presumed to be a Mainland contribution

and we may assume that in the early days at least it was actually made by Cretan artificers.

Our earliest Mainland source, the Shaft-Graves at Mycenae, is perhaps a disappointment so far as jewellery is concerned. Apart from the finger-rings, to be considered below, the repertoire comprises little but flimsy reliefs for attachment to clothing, diadems, pins and ear-rings of various kinds (*Ills. 204, 211*).

The clothing-ornaments include cut-out reliefs representing a Cretan shrine, a Cretan goddess, a naked goddess of a more oriental kind (*Ill. 208*); a butterfly, octopus (*Ills. 209, 210*), sphinx, griffin; and a heraldic arrangement of cats, deer and birds.

212, 213 Two necklaces of gold relief-beads from tombs at Mycenae, of *c.* 1400 BC. Unlike the related beads of *Ills. 205* and *206*, there seems to be no attempt to reproduce natural forms, but simply to create pleasing calligraphic shapes. The hollows in the rosettes (*below*) were originally filled with blue enamel

214 Gold relief-beads must have been common all over the Mycenaean Empire. These come from a tomb at Volo in Thessaly, dating to *c.* 1400 B C. The beads in the upper row are a double version of the calligraphic spiral of *Ill. 213* (the one on the right is made of blue glass). The row below is of double argonauts (cf. *Ill. 206*). Blue enamel and granulation are both used to diversify the surfaces. It seems that after the destruction of the Cretan palaces, the main creative impulse died down, for though these beads are made with meticulous care and considerable technical skill, there is little advance or variation in the traditional Cretan designs to be seen

There is one exceptionally fine piece of jewellery, a gold pendant attached to a silver pin (*Ill. 207*). It represents a woman (or more probably a goddess) in Cretan dress holding in her hands a sort of fillet and supporting on her head three sets of papyrus branches; above the topmost branch are three papyrus flowers. The papyrus ornament is Egyptian in origin, but the pin has all the marks of Cretan art. It stems from the same tradition as the earlier Master of Animals of *Ill. 40*.

The jewellery of the fifteenth, fourteenth and thirteenth centuries BC shows little formal development. The principal forms were worked out in the fifteenth century, and continued with very little change down to the great destructions of 1200 BC. In the fifteenth and fourteenth centuries technical proficiency increased. Granulation was used with even smaller grains. Enamel was introduced about 1450, and inlay with stones and coloured glass became popular in rings. In the thirteenth century the same forms continued, but blue glass was increasingly used, sometimes covered with gold foil as a cheap substitution for sheet-gold, sometimes by itself as an inexpensive imitation of lapis lazuli, which was used for beads between 1550 and 1400 BC.

The typical article of jewellery of the Mycenaean Empire is the relief-bead. These beads were made in considerable quantities, but in a small repertoire of types: an early example of mass-production. In the fifteenth and fourteenth centuries they were sometimes decorated by means of little blobs of dark blue enamel set in hollows surrounded by fine granulation. This is the earliest recorded example of enamelling (that is to say, the fusing of molten glass to the surface of the gold) in the ancient world, and it was probably a Mycenaean invention (*Ill. 214*).

The subjects of the relief-beads are nearly all borrowed from the repertoire of the fifteenth-century potters and solidified: marine life, such as argonauts and shells; plants, including papyrus, lilies and ivy leaves; and graceful curls and squiggles which have already lost any resemblance to natural forms which may have been once intended. These forms continued in use for some two and a half centuries, changing only in the lowered standards of execution. Being tri-

215 Gold ear-ring with conical pendant from the Mavro Spelio cemetery near Knossos, of the fourteenth or thirteenth century BC. The pendant is covered with granulation. Ear-rings of this style were comparatively common in Crete at a time when elsewhere in the Mycenaean Empire ear-rings were not being worn at all

dimensional, they could not, however, degenerate to the same extent as did the motives on painted vases.

A few examples from tombs at Mycenae are shown in *Ills. 205, 206, 212, 213*: two argonauts back to back, a spiral, an ornamental curl, and an ivy-leaf. Here and there traces of blue enamel can be seen still in place; it seldom survives burial in the soil, and we can never expect to find much of it. Similar beads found in a tomb at Volo in Thessaly are shown in *Ill. 214*.

In *Ill. 216* is a selection of beads from tombs at Ialysus in Rhodes: glass relief-beads, which were cast in serpentine moulds (numbers of which have survived), and beads of carnelian and rock-crystal.

Finger-rings were also popular in the Late Bronze Age. The Cretan type of ring with a plain oval bezel at right angles to the hoop was still fashionable (cf. *Ill. 47*). Sometimes the bezel was engraved or stamped for use as a seal (see p. 184). At other times it was decorated with inlay of precious stones or enamel in gold cells.

173

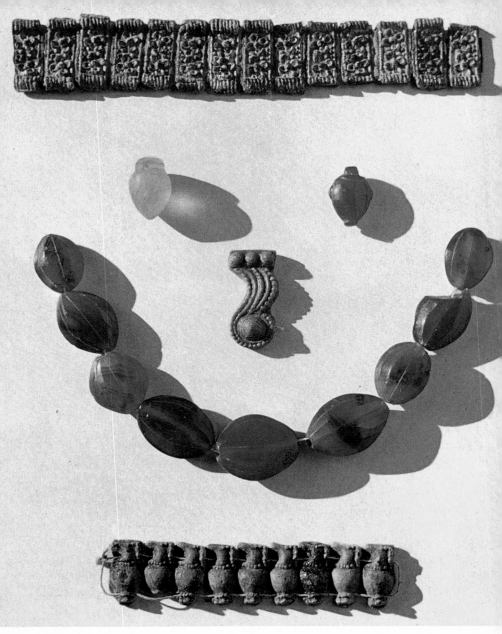

216 Beads of carnelian, rock-crystal and blue glass from tombs at Ialysus in Rhodes, of 1400–1100 BC. The glass beads were cast in serpentine moulds, and frequently imitate the form of the gold relief-beads. Some forms such as the jugs at the bottom of the picture were originally covered with gold foil to make a cheaper version of the gold beads

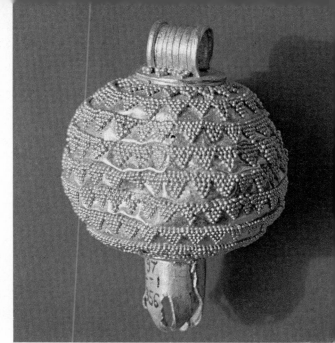

217 Gold pendant in the form of a pomegranate from Enkomi in Cyprus. The superfine granulated detail on the bold and simple shape makes this one of the finest of all known Mycenaean jewels

Ear-rings were scarcely worn except in Crete. Here a common type is a gold hoop with a large granulated pendant of conical shape (*Ill. 215*).

The twelfth century is poorly represented by jewellery except in Cyprus, where the story is rather different. In the fourteenth and thirteenth centuries BC Cypriot goldsmiths had to a certain extent copied Cretan and Mycenaean jewellery, but had more often adapted it to their own rather different requirements. The result was a hybrid style, part Cretan-Mycenaean, part native Cypriot, and part Western Asiatic, for Cyprus (as always) looked both East and West. Of the rich store of jewellery from these two centuries, the diadems (*Ill. 219*) are an Asiatic form with Mycenaean embossed decoration; the pins are purely Asiatic; the ear-rings are part Cretan, part Mycenaean, part Asiatic (*Ill. 221*); while some of the necklaces appear to be pure Mycenaean work (*Ill. 218*).

A magnificent pendant in the shape of a pomegranate with superb granulation (*Ill. 217*) is pure Mycenaean in style, and was surely made by a Mycenaean craftsman. Its date is the fourteenth century BC.

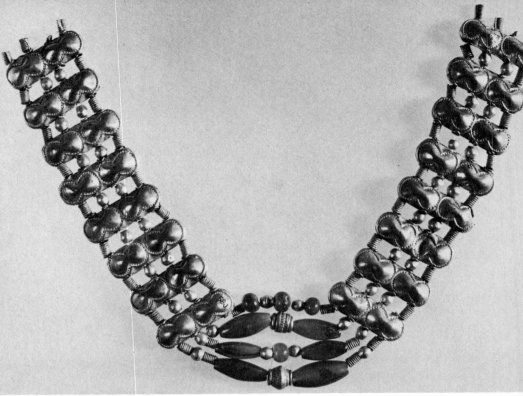

218, 219 Cypriot jewellery of the fourteenth and thirteenth centuries is partly Mycenaean, partly Western Asiatic in origin. The necklace (*above*) has carnelian spacers separating gold beads of the figure-of-eight form, but the diadems (*below*) are an Asiatic form, although the relief motifs with which they are stamped are also familiar in the Minoan-Mycenaean repertoire

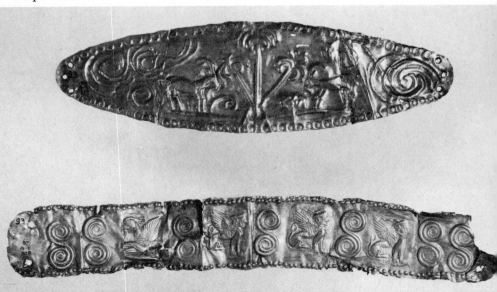

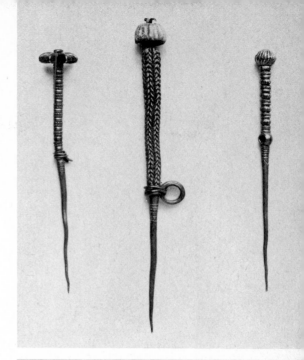

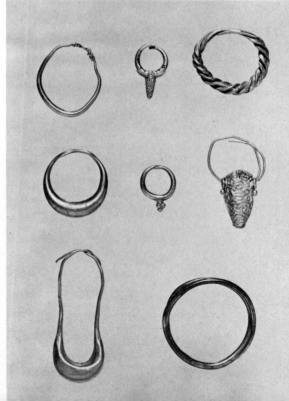

220, 221 The wide variety of influences at work in Cyprus can be seen in local dress ornaments. The pins (*above*) are a common Western Asiatic type, and ear-rings (*below*) show Cretan influence in the granulated pendants and Western Asiatic in the lunate shape. The design of the pins is not particularly functional as the ornamental head is considerably larger and heavier than the pointed shank, and the pin must, therefore, have been badly balanced. None of the ear-rings achieves a high technical standard, and even the two granulated examples are clumsily made, with the grains haphazardly placed

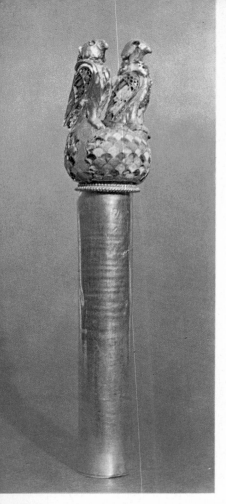

222, 223 Some of the earliest cloisonné enamelling of Mycenaean origin comes from Cyprus, where a splendid gold sceptre (*left*) was found at Curium. Of twelfth-century date, it consists of a rod surmounted by a sphere on which rest two realistically modelled hawks. Both the birds and the sphere are set with cells containing white, green and mauve enamel. In the *Clouds*, Aristophanes describes just such a sceptre as belonging to Agamemnon. The rings (*below*) also have bezels ornamented with abstract designs in true cloisonné enamelling

224–30 Six Mycenaean seals (*opposite, above*). They comprise (*left to right*) three lentoids of green jasper, agate and carnelian; a haematite cylinder, a rock-crystal lentoid and a rock-crystal amygdaloid. *Ills. 225–30* (*opposite, below*) show enlarged modern impressions of the seals of *Ill. 224*. 225, lion attacking a goat, fourteenth century BC. 226, lion attacking two deer, 1450–1400 BC. 227, three deer, fourteenth century BC. 228, nature god and animals, 1425–1400 BC. 229, horse, fourteenth century BC. 230, bird, 1450–1400 BC.

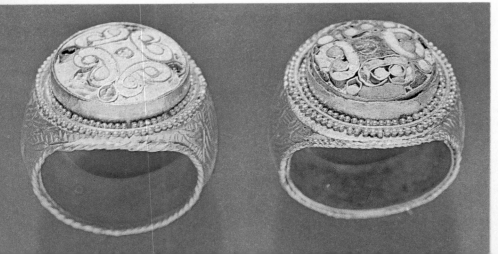

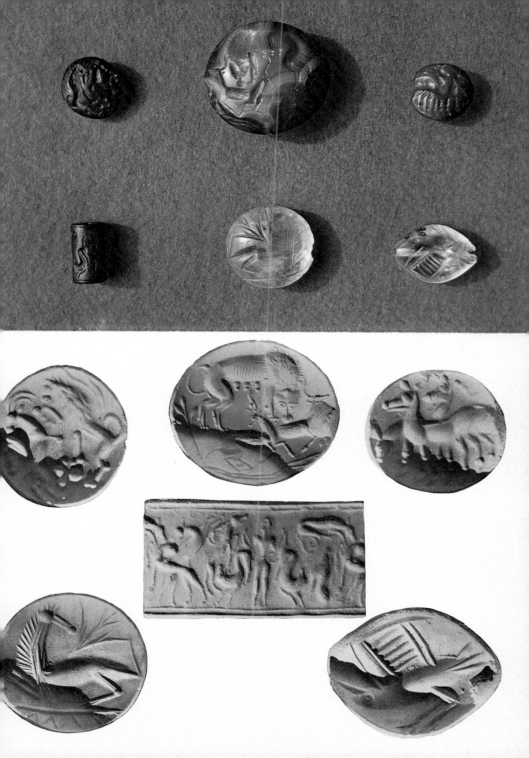

In the twelfth century BC many of the luxury articles (now rare in Mainland Greece) were probably made by refugee Mycenaean craftsmen who practised the crafts of their homeland in their adopted country, and established a tradition which was to last a century or more. Among these twelfth-century pieces is a magnificent sceptre topped by a pair of hawks (*Ill. 222*). It is decorated with the finest example in antiquity of cloisonné enamelling; that is to say, enamel set not in circular hollows, but in cells (or *cloisons*). This process, which is also represented in a set of gold rings from a contemporary Cypriot tomb (*Ill. 223*), may be a Mycenaean invention, or it may have been a discovery of Egyptian goldsmiths; there is as yet no certainty on this point. Whatever its origin, it seems to have died out quite quickly, to be rediscovered by Byzantine goldsmiths nearly two thousand years later.

SEALS

Cretan seals of the Late Minoan period fall into three chronological divisions, corresponding with the three Late Minoan phases. The great bulk of surviving material was in fact made in the first two of these phases, between 1550 and 1400 BC. Some characteristic examples, and some modern plaster impressions are shown in *Ills. 231–236*.

Late Minoan I (1550–1450 BC). Seals of this period show a logical development from those of the previous period (p. 51), from which they differ principally in a greater freedom of treatment. The hallmarks of the style, as before, are a combination of naturalism with a desire to fill the field to the best advantage. Favourite subjects are scenes of religion and the bull-ring, lions attacking their prey, and recumbent bulls and cows (*Ills. 231, 236*).

The talismanic class continued in popularity. Sacred vases are less common, their place being largely taken by creatures of the sea, beetles, branches of trees and rustic shrines. From the middle of the sixteenth century BC there was an unexplained tendency for these objects to disintegrate: handles are rendered as if wrenched from the vases to which they belonged, and limbs are similarly shown as if hacked off their owners.

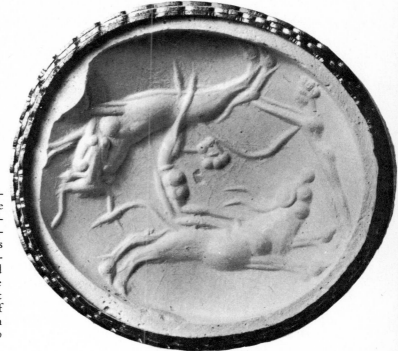

231 Modern impression of an agate lentoid seal showing Cretan bullsports. Two bulls are shown: an acrobat has just vaulted over one, while a second acrobat stands in front of the other. Cretan work of 1550–1500 BC

The choice of stones was much as before, with the addition of an attractive green porphyry from quarries near Sparta. By far the commonest shape is now the lentoid, although the flattened cylinder and the amygdaloid are still found. The latter shape, when used, is noticeably slimmer.

Late Minoan II (1450–1400 BC). This is the period of Mycenaean rule at Knossos, and we may observe a similar development in the seals as was remarked in the pottery. The subjects are much as before, with the addition of heraldic arrangements of animals. Other popular subjects are bulls and cows and scenes from the bull-sports. The bodies of the animals are frequently contorted to an extraordinary degree in order to fill the circular field of the lentoid stone. Cylinder-seals after the Babylonian fashion made a brief appearance towards

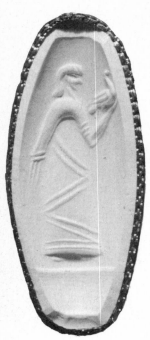
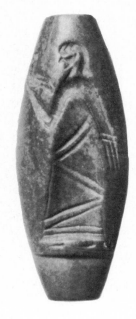

232–4 Three typical shapes of Cretan seal. The green jasper amygdaloid seal (*above*), of the fifteenth century, shows a priest wearing a long robe; a modern impression of an agate lentoid (*right*), of 1550–1500 BC, shows two pitchers, and is probably a talisman; a modern impression of a haematite amygdaloid (*below*) of the fifteenth century shows two subtly modelled lions

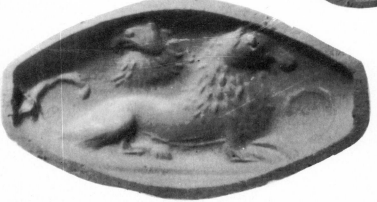

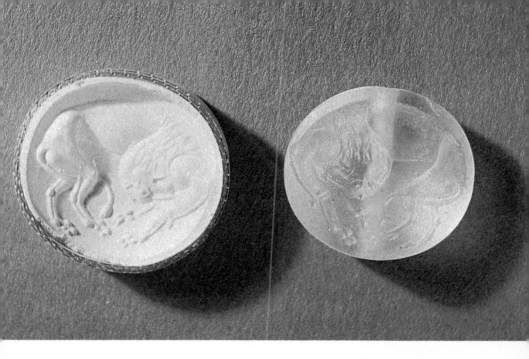

235, 236 The outstanding skill of the Cretan engraver of the late fifteenth century lay in adapting his subject to fill an extremely restricted field. The rock-crystal lentoid (*above*) and its modern impression show a lion with its body curiously contorted to the circular field. Two recumbent bulls on the agate lentoid (*below*) have been placed on a horizontal ground-line

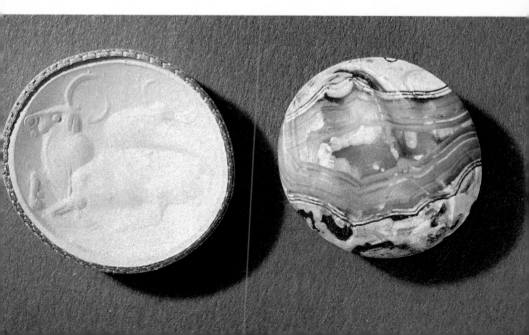

the end of the fifteenth century B C. Talismanic stones continued as before.

Late Minoan III (1400–1100 BC). After the destruction of Knossos the art of seal-engraving in Crete rapidly declined. Hard stones were neglected in favour of such easily worked materials as serpentine and glass. The lentoid was almost the only shape in use, and the motives were degraded versions of earlier subjects.

Mycenaean seals are very like the Cretan seals which inspired them, but frequently (to an experienced eye) betray their Mainland origin by a less flowing and (in the best pieces) a more monumental style. A few characteristic examples are shown together with modern plaster impressions (*Ills. 224–230*).

The dependence on Crete is particularly marked between 1550 and 1450 B C. Between 1450 and 1400 the current, to some extent, flowed the other way, and we find Mycenaean preferences in the gems from Knossos.

In the fourteenth and thirteenth centuries when Crete was in eclipse, Mainland work is frequently better than Cretan. A magnificent gold seal from a royal tomb at Pylos (*Ill. 237*) is particularly worthy of notice. It represents a griffin reclining on some form of architectural support. A date in the fifteenth century B C is suggested by the style.

Among the finest seals of the Late Bronze Age are gold signet-rings. Some could have been, and doubtless were, worn on the finger; but others have such small hoops that one can only assume them to have been worn suspended from a cord.

Earliest are the rings from the Fourth Shaft-Grave at Mycenae, dating between 1550 and 1500 B C. Their subjects are known as the Battle in the Glen (*Ill. 83*) and the Stag Hunt (*Ill. 84*). Scenes of war and the hunt are rare (though not unknown) in the Cretan repertoire, but the style and technique of these rings is without question Cretan. It has therefore been plausibly suggested that they were made by Cretan artificers to the orders of a Mycenaean master. In both rings the Cretan genius is shown in its two aspects – the realistic representation of nature and the skill to fill the space in the most elegant way.

237 A handsome gold seal from a tomb at Pylos of the fifteenth century BC. A griffin with outstretched wings is seen reclining on an architectural support like that on the Tiryns ring (*Ill. 241*)

A ring from a tomb at Knossos of 1450–1400 BC (*Ill. 239*) gives a tantalizing glimpse of Cretan religion and at the same time a singularly harmonious composition. Four women in typical Cretan dress stand in a meadow decked with lilies, as if performing a religious dance in honour of a diminutive goddess who flies down from the sky. The almost headless state of the women comes as a surprise; it was apparently a Cretan convention at this date occasionally to simplify the heads almost to the point of extinction.

In another gold ring from near Knossos of 1425–1400 BC (*Ill. 238*) a male worshipper is shown kneeling in front of a large rock. To the left is a tree, with rocks and flowers; to the right, a large bird flies down to him.

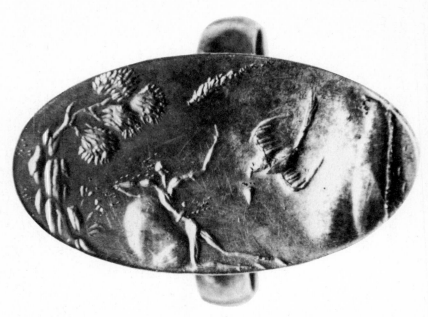

238–40 Amongst the commonest subjects for the large gold signet-rings were cult scenes. The example above shows a man kneeling in front of a rock, between a tree and a bird. A tiny deity is seen on a ring from Isopata near Knossos (*above, right*), flying down to a group of ritual dancers; the impression of movement conveyed by the composition places this ring high among Cretan works of art. Another group of worshippers is portrayed on a ring from Mycenae (*below, right*) and here the weapons carried by the deity suggest that she may be Athena herself.

A ring from Mycenae of approximately the same date shows another religious scene (*Ill. 240*). The subject matter and the style would suggest that it is Cretan work; if not, it is certainly Cretan-inspired. A goddess sits under a sacred tree, holding three poppies. Behind her is a small goddess like the one in *Ill. 239*. In front of her are three women, probably worshippers, who carry lilies, and in the upper right section a deity carrying a spear and a figure-of-eight shield is apparently flying down to earth. Other symbols in the field include the sun, the moon, the double-axe and lion's masks.

A very large ring from an ancient tomb-robber's cache at Tiryns (*Ill. 241*) gives another religious scene. A Cretan goddess sits on a

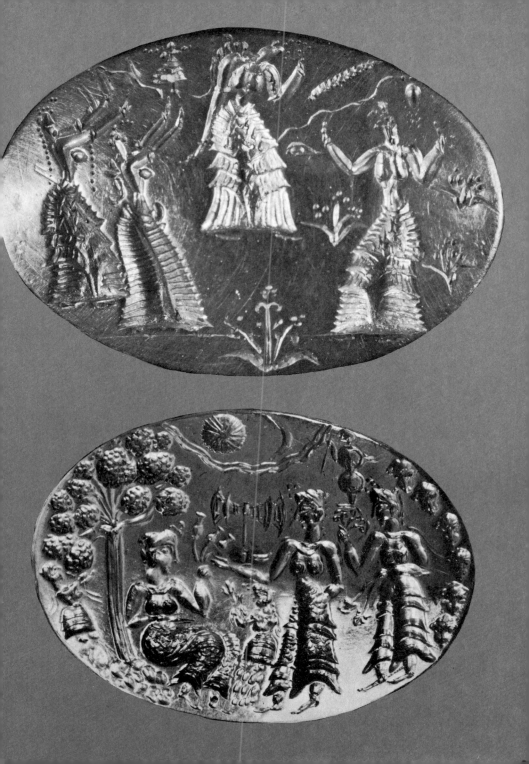

241 Large gold signet-ring from Tiryns, of the fifteenth century BC. A goddess, seated on a throne, is approached by four Cretan demons carrying libation jugs. This masterpiece is in typically Mycenaean taste, but the skill of the execution suggests that it was made by an unusually talented artist trained in the Cretan tradition

throne, and receives four Cretan demons (see p. 102) who carry pitchers to fill a cup which she holds. Although the subject is purely Cretan and the workmanship beyond praise, there is a monumental quality about the scene which bears witness to Mycenaean rather than to Cretan taste.

Gold signet-rings continued to be made in the Mycenaean Empire down to about 1150 BC.

Epilogue

In the preceding pages our background has been the rise, maturity and decay of the civilization of Greece and the Greek islands in the Bronze Age. As we have seen, the third millennium BC saw a gradual and general development throughout this area. About 2000 BC the initiative passed to Crete, where a brilliant civilization ensued, based in the first instance on close contacts with Egypt and Western Asia. After some five centuries the fruits of this civilization were made available to the whole Aegean area, and about 1450 BC the leadership passed to the Mycenaean communities of Mainland Greece. The Mycenaean Empire lasted for some two centuries from 1400 to 1200. Then followed a century-and-a-half of wars and disasters, which led to the break-up of the Mycenaean world, and our story ends about 1100 BC.

The Bronze Age was succeeded by some three centuries or more of poverty, the so-called Dark Ages. The eleventh century was marked by a pronounced decay of material civilization. The tenth and ninth centuries saw a gradual and painful recovery, and by the eighth century BC regular contacts with the East were renewed. From these contacts evolved the rich Archaic civilization of Greece, which ran from about 700 to about 480 BC, and then gave place to the Classical era.

What did the Bronze Age bequeath to Archaic and Classical Greece? Their religion, for a start; but that is outside our scope. The Homeric poems, with one foot in the Bronze Age and the other in the Dark Ages, are the chief contribution; but they too are outside the scope of this enquiry.

The Lion Gate at Mycenae and certain tholos tombs in Greece were visible to later Greeks, and it seems certain that the Doric architectural capital was derived from such Mycenaean survivals as the Treasury of Atreus. The theory that the Greek temple was derived

189

from the Mycenaean megaron is a possibility, but certainly is still far away. Moreover, the lentoid and amygdaloid shapes of seals made in Melos in the seventh century BC can only be explained as being inspired by Minoan and Mycenaean seals found in tombs on that island.

It is undoubtedly true that a fair number of technical processes and decorative motives of Mycenaean art reappear in Greece in the eighth and seventh centuries BC. These include the carving of ivory, the goldsmiths' processes of filigree and granulation, the nature deity with animals (cf. *Ill. 40*), sphinxes and griffins. But these and other processes and motives are best explained as reintroductions from the East, where they had been adopted in the days of the Mycenaean Empire and kept alive through the Dark Ages.

Perhaps the greatest contribution of the Bronze Age to Classical Greece was something less tangible, but quite possibly inherited: an attitude of mind which could borrow the formal and hieratic arts of the East and transform them into something spontaneous and cheerful; a divine discontent which led the Greek ever to develop and improve his inheritance.

The truth is that Classical Greece, which emerged after the Dark Ages, was radically different from Bronze Age Greece, just as the third great flowering of the Greek spirit, the Byzantine Age, was different again.

There is no need to excuse or to justify the art of Bronze Age Greece by an attempt to attach it to Classical art as a sort of poor relation. The major component of Greek Bronze Age culture, that of Crete, was one of the really great civilizations of antiquity. We should therefore be content to enjoy it as an achievement in its own right.

Notes

Introduction

1 'Dr Schliemann's Discoveries at Mycenae', *Edinburgh Review*, 1878. Reprinted in Newton, C.T., *Essays on Art and Archaeology* (London, 1880), 246–302.
2 Pendlebury, J.D.S., *A Handbook to the Palace of Minos, Knossos*, 2nd ed. (London, 1954), 11.

Chapter 1

1 There are at the moment two schools of thought regarding the date of the destruction of Knossos. Most archaeologists accept Evans's date of 1400, or would bring it down to about 1375, but there is a small but vociferous section, led by Professor L.R.Palmer, who would bring it down to 1200 or even 1150 BC. I am a traditionalist.
2 *Proceedings of the Prehistoric Society*, 1956, 37.

Chapter 4

1 See especially Ninkovich, D., and Heezen, B.C., 'Santorini Tephra', in *Colston Papers*, xvii (1965), 143.

Chapter 5

1 Palmer, L.R., *Mycenaeans and Minoans*, 2nd ed. (London, 1965), 113.
2 *Annual of the British School at Athens*, lviii (1963), 94; lx (1965), 212.
3 Palmer, op. cit., 135.
4 *American Journal of Archaeology*, lxxxii (1978), 35.
5 *Journal of the Warburg and Courtauld Institutes*, xv (1952), 13; xvii (1954), 1.

Map

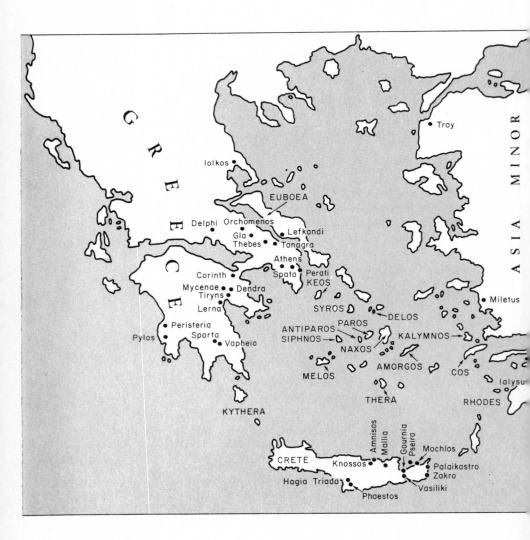

GREECE

ASIA MINOR

Troy

Iolkos

EUBOEA

Delphi Orchomenos
 Gla Lefkandi
 Thebes Tanagra
 Athens
 Corinth Spata Perati
 Mycenae Dendra KEOS
 Tiryns
 Lerna SYROS
 DELOS
 Peristeria ANTIPAROS PAROS
Pylos Sparta SIPHNOS →
 Vapheio NAXOS KALYMNOS →

 MELOS AMORGOS
 COS
 THERA Ialysus
 KYTHERA RHODES

 Amnisos
 Mallia Gournia
 Pseira Mochlos
 CRETE Knossos Palaikastro
 Zakro
 Hagia Triada Vasiliki
 Phaestos

Miletus

Seiect Bibliography

General

Desborough, V.R.D'A. *The Last Mycenaeans and their Successors* (Oxford and New York, 1964).
Evans, A.J. *The Palace of Minos at Knossos* (London, 1921–35).
Higgins, R.A. *The Archaeology of Minoan Crete* (London and New York, 1973).
Hood, Sinclair. *The Arts in Prehistoric Greece* (Harmondsworth, 1978, New York, 1979).
Hood, Sinclair. *The Minoans* (London and New York, 1971).
Hutchinson, R.W. *Prehistoric Crete* (Harmondsworth and Baltimore, 1962).
Karo, G. *Die Schachtgräber von Mykenai* (Munich, 1930).
Mackendrick, Paul. *The Greek Stones Speak* (London and New York, 1962).
Marinatos, S.N., and Hirmer, M. *Crete and Mycenae* (London, 1960).
Mylonas, G.E. *Ancient Mycenae* (London, 1957).
Pendlebury, J.D.S. *The Archaeology of Crete* (London, 1939).
Platon, N. *Crete* (London, 1966).
Taylour, Lord William. *The Mycenaeans* (London and New York, 1964).
Vermeule, Emily. *Greece in the Bronze Age* (Chicago, 1964).
Wace, A.J.B. *Mycenae* (Princeton, 1949).

Special Subjects

ARCHITECTURE Cadogan, Gerald. *Palaces of Minoan Crete* (London, 1976, reissued 1980).
 Lawrence, A.W. *Greek Architecture* (Harmondsworth and Baltimore 1957 (revised 1962)).
BRONZES Lamb, Winifred. *Greek and Roman Bronzes* (London, 1929).
IVORIES Kantor, Helen. 'Ivory Carving in the Mycenaean Period.' *Archaeology*, xiii (1960), 14ff.
JEWELLERY Higgins, R.A. *Greek and Roman Jewellery* (London, 1961).
PLATE Strong, D.E. *Greek and Roman Gold and Silver Plate* (London, 1966).
POTTERY Furumark, A. *The Mycenaean Pottery* and *The Chronology of Mycenaean Pottery* (Stockholm, 1941).

SEALS Boardman, John. *Greek Gems and Finger Rings* (London and Chicago, 1970).

STONE VASES Warren, P.M. *Minoan Stone Vases* (Cambridge, 1969).

TERRACOTTAS Higgins, R.A. *Greek Terracottas* (London, 1967).

WRITING Ventris, M., and Chadwick, J. *Documents in Mycenaean Greek* (Cambridge, 1956).

Excavations

For preliminary reports of recent excavations, see *Illustrated London News* (abbreviated *ILN*), and *Archaeological Reports* (published annually by the British School at Athens and the Society for the Promotion of Hellenic Studies). The results of British excavations are published more fully in the *Annual of the British School at Athens*; of American excavations in *Hesperia*.

Important recent excavations include:

Archanes, Royal tholos tomb: *ILN* 26:3:1966.

Keos: *Hesperia* xxxi (1962) and subsequent volumes.

Lerna: *Hesperia* xxiii (1954)–xxviii (1959).

Pylos: Palace, etc. *The Palace of Nestor at Pylos*, vols. i–iii (Princeton, 1966, 1969, 1973).
Tholos tomb, Rutsi: *ILN* 6 and 24:4:1957.
Tholos tombs, Peristeria: *ILN* 4:12:1965.

Tanagra: Vermeule, E. *Journal of Hellenic Studies*, lxxxv (1965), 123. *Archaeological Reports* from 1969.

Thera: Marinatos, S. *Excavations at Thera*, vols. i–vii (Athens, 1968–76).

Zakro: Platon, N. *Zakros, the Discovery of a Lost Palace of Ancient Crete* (New York, 1971).

Acknowledgments

My thanks are due to the following for advice on archaeological matters and for help with photographs: Dr S. Alexiou, Dr H.W. Catling, Mr P.A. Clayton, Mr D.E.L. Haynes, Mr M.S.F. Hood, The late Rev. V.E.G. Kenna (on whose unrivalled knowledge of Cretan seals I have drawn heavily), the late Prof. S. Marinatos, Prof. N. Platon (who has generously put at my disposal a number of photographs from his excavations at Zakro), Mr. M.R. Popham, the late Prof. D.E. Strong, Dr F. Stubbings, Dr and Mrs C.C. Vermeule, Mrs Helen Wace, Dr Anne Ward, and Prof. P.M. Warren.

List of Illustrations

NMA: National Museum, Athens. AMH: The Archaeological Museum, Heraklion. All pictures not otherwise credited are from Thames and Hudson's Archives

17 Jar with light-on-dark palm-tree decoration, 1700–1550, from Knossos. AMH. Height 57 cm. Photo: Peter Clayton.

18 Terracotta female figurine, 2000–1700, from Petsofa. AMH. Height 14·3 cm. By courtesy of Dr C. Zervos.

19 Terracotta male figurine, 2000–1700, from Petsofa. AMH. Height 17·5 cm. By courtesy of Dr C. Zervos.

20 Terracotta model of a deer, 2000–1700, from Porti. AMH. Height 19·5 cm.

21 Faience and ivory plaques, the Town Mosaics, 1800–1700, from Knossos. AMH.

22 Faience Snake Goddess, c. 1600, from Knossos. AMH. Height 34·5 cm.

23 Ivory and gold Snake Goddess, c. 1600, unknown provenance. Boston Museum of Fine Arts. Height 16 cm. Boston Museum photo.

24 Faience cow with calf, c. 1600, from Knossos. AMH. Width 19 cm.

25 Ivory acrobat, c. 1600, from Knossos. AMH. 24·5 cm. to finger-tips.

26 Two marble jars, 2500–2000, from Palaikastro and Mochlos. British Museum (no. 1907.1–19.227 and no. 1921.5–15.24). Height 7 cm. and 4·2 cm. Photo: the author.

27 Breccia bird's-nest vase, 2500–2000, from Mochlos. British Museum (no. 1921.5–15.25). Height 5·5 cm. Photo: the author.

28 Serpentine blossom bowl, 2000–1400, unknown provenance. British Museum (no. 1914.34–21.1). Diameter 5·6 cm. Photo: Peter Clayton.

29 Schist pyxis lid with reclining dog in relief, 2500–2200, from Zakro. AMH. Diameter c. 11 cm. Photo by courtesy of Professor N. Platon.

30 Silver cup, 1900–1800, from Gournia. AMH. Height 8 cm.

31 Silver vessels, 1950–1900, from Tod in Egypt. The Louvre.

32 Spouted silver 'teapot', c. 1800, from Byblos. National Museum, Beirut. Photo by courtesy of the Director-General, Service des Antiquités.

33, 34 Gold cup, with repoussé spiral decoration, 1700–1500, from Aegina. British Museum. Diameter 9·7 cm. Photo: the author.

35 Gold pommel from sword-hilt with figure of an acrobat, 1800–1700, from Mallia. AMH. Diameter 7 cm.

36 Gold diadem 2300–2100, from Mochlos. Hagios Nikolaos Museum. Length 29·2 cm. After T. Phanourakis (*Annual of the British School at Athens*, lxx, 1975, 103, fig. 3).

37 Gold pendant, 2300–2100, from Sphoungaras. AMH. Height 8·7 cm. Museum photo.

38 Gold band with two eyes outlined in repoussé dots, 2300–2100, from Mochlos. AMH. Photo: Peter Clayton.

39 Gold pendant with appliqué and granulated ornament, two bees, 1700–1550, from Mallia. AMH. Height 4·6 cm. Photo: Peter Clayton.

40 Gold pendant, Master of Animals, 1700–1550, from Aegina. British Museum (no. 762). Height 6 cm. Photo: the author.

41 Gold flower-headed pin, 2300–2100, probably from Mochlos. Metropolitan Museum of Art, New York; bequest of Richard B. Seager, 1926. Height 3 cm. Metropolitan Museum photo.

42 Spray of gold leaves, 2500–2200, from Mochlos. Metropolitan Museum of Art, New York; bequest of Richard B. Seager, 1926. Height 5 cm. Metropolitan Museum photo.

43 Granulated gold lion, 2000–1700, from Koumasa. AMH. Length 1·1 cm.

44 Gold bead with appliqué spiral decoration, 2000–1700, from Kalathiana. AMH. Length 1 cm.

45 Gold pectoral with profile heads with traces of inlay, 1700–1550, from Aegina. British Museum (no. 761). Length 10·8 cm. Photo: the author.

46 Stone and gold beads and inlaid rings, 1700–1550, from Aegina. British Museum. Photo: Peter Clayton.

47 Gold ring with plain convex bezel, type existing 1700–1100. British Museum. Drawing by Lucinda Rodd.

48 Cretan seals and modern impressions, Middle Minoan period. From left to right: Impression from an agate flattened cylinder, bull drinking at a cistern, c. 1600 (no. 202). Length 2·1 cm by 1·7 cm. Amethyst scarab, 1900–1700 (no. 126). Length 1·5 cm. Impression from a carnelian amygdaloid of the talismanic class, ritual vessel and branches, 1700–1600. Length 2 cm. Carnelian signet, 1800–1700 (no. 121). Height 1·4 cm., diameter 1·5 cm. All in the Ashmolean Museum. Ashmolean Museum photos.

49 Impressions from a three-sided steatite prism seal. Top to bottom: A toothed swastika. A sun symbol with hooked rays. Three ritual vessels, c. 2000. Width of each face 1·3 cm. Drawing by Lucinda Rodd, after Kenna.

50 Gold signet-ring with intaglio design of two goats mating, 1700–1550, from Crete. British Museum (no. 14). Diameter of bezel 1·7 cm. Photo: Peter Clayton.

51 Cycladic pot with incised herringbone pattern, 2800–2500, from Antiparos. British Museum (no.

A 301). Height 18 cm. British Museum photo, by courtesy of the Trustees of the British Museum.

52 Cycladic footed vase with incised spiral decoration, 2500–2200, from Syros. NMA. Height 20·5 cm.

53 Detail of a ship from a Cycladic 'frying-pan', 2500–2200, from Syros. NMA. Photo: Peter Clayton.

54 Cycladic 'frying-pan', 2500–2200, from Syros. NMA. Height 34 cm. Photo: Peter Clayton.

55 Cosmetic-box with linear decoration in lustrous black paint, 2500–2200. NMA. Height 5·5 cm.

56 Animal (perhaps a bear or a hedge-hog) drinking from a bowl, 2500–2200, from Syros. NMA. Height 10·8 cm.

57 Cycladic duck-vase (oil-flask), 2200–2000, unknown provenance. British Museum (no. A 330). Height 15 cm. British Museum photo, by courtesy of the Trustees of the British Museum.

58 Cycladic multiple-vase, perhaps for offerings, c. 2000, from Melos. British Museum (no. A 344). Height 32 cm. British Museum photo, by courtesy of the Trustees of the British Museum.

59 Cycladic beak-spouted jug with linear decoration, 2000–1850, unknown provenance. British Museum (no. A 341). Height 28 cm. British

Museum photo, by courtesy of the Trustees of the British Museum.

60 Cycladic beak-spouted jug with curvilinear decoration, 1850–1700, probably from Melos. British Museum (no. A 342). Height 40 cm. British Museum photo, by courtesy of the Trustees of the British Museum.

61 Cycladic beak-spouted jug painted with grotesque birds, 1700–1550, from Knossos. Ashmolean Museum. Height 52 cm. Ashmolean Museum photo.

62 Cycladic idol, c. 2500, from Greece. British Museum (no. A 17). Height 50 cm. British Museum photo, by courtesy of the Trustees of the British Museum.

63 Cycladic fiddle idol, c. 2500, from Antiparos. British Museum (no. A 6). Height 12 cm. British Museum photo, by courtesy of the Trustees of the British Museum.

64 Seated figure of a harpist, c. 2500, from Keros. NMA. Height 22·5 cm. Photo: Peter Clayton.

65 Standing figure of a pipe-player, c. 2500, from Keros. NMA. Height 20 cm. Photo: Peter Clayton.

66 Three Cycladic marble vases, c. 2500. British Museum. Height of tallest, 10 cm. Photo: Peter Clayton.

67 Gold bowl, 2500–2200, perhaps from Euboea. Benaki Museum,

Athens. Height 9 cm. Photo by courtesy of the Benaki Museum.

68 Shallow silver bowl, 2500–2200, from Amorgos. Ashmolean Museum. Diameter 9 cm. Ashmolean Museum photo.

69 Silver, bronze and bone pins, 2500–2200, from Syros. NMA. Drawing by Lucinda Rodd after Higgins.

70 Pottery 'sauceboat', 2500–2200, from Lerna. Argos Museum. Height c. 20 cm. By courtesy of the American School of Classical Studies at Athens.

71 Two-handled tankard, 2200–2000, from Lerna. Argos Museum. Height 11·7 cm. By courtesy of the American School of Classical Studies at Athens.

72 Large storage-jar, 2200–2000, from Orchomenos. NMA. Height 66 cm.

73 Minyan goblet, 2000–1500, from Mycenae. British Museum (no. A 284). Height 19 cm. British Museum photo, by courtesy of the Trustees of the British Museum.

74 Minyan kantharos, 2000–1500, from Lerna. Argos Museum. Height to top of handles, 10 cm. Photo by courtesy of the American School of Classical Studies at Athens.

75 Matt-painted kantharos, 2000–1550, from Lerna. Argos Museum. Height to top of handles, 12 cm. Photo by courtesy of the American School of Classical Studies at Athens.

76 Matt-painted storage-jar, 2000–1550, from Lerna. Argos Museum. Height 63 cm. Photo by courtesy of the American School of Classical Studies at Athens.

77 Gold 'sauceboat', 2500–2200, from Arcadia. The Louvre. Height 10 cm.

78 Early Helladic jewellery, 2500–2200, from Thyreatis, Berlin Museum. Photo: Staatliche Museen zu Berlin.

79 a–f Clay seal-impressions, 2300–2200, from Lerna. Argos Museum. Drawing by Piet de Jong, by courtesy of the American School of Classical Studies at Athens.

79 g Seal-impression, 2300–2200, from Lerna. Argos Museum. Photo by courtesy of the American School of Classical Studies at Athens.

80 Grave-Circle A at Mycenae, looking north-west. Photo: Peter Clayton.

81 Reconstruction of Grave-Circle A at Mycenae. Drawing by P. P. Platt, after Piet de Jong.

82 Gold kantharos, 1550–1500, from Shaft-Grave IV at Mycenae. NMA. Height (without handles) 9·2 cm.

83 Seal-ring with intaglio 'the Battle in the Glen', 1550–1500, from Shaft-Grave IV, Mycenae. NMA. Width

3·5 cm. Photo: Deutsches Archäologisches Institut, Athens.

84 Seal-ring with intaglio of a hunting-scene, 1550–1500, from Shaft-Grave IV at Mycenae. NMA. Width 3 cm. Photo: Deutsches Archäologisches Institut, Athens.

85 Gold-plated box, 1550–1500, from Shaft-Grave V at Mycenae. NMA. Height 8·5 cm. Photo: Konstantine Konstantopoulos.

86 The Throne Room at Knossos, 1450. The frescoes are modern restorations. Photo: Peter Clayton.

87 Reconstructed view of the Citadel at Mycenae. Painting by Alton S. Tobey in the Mycenae Guide, by courtesy of Mrs A. J. B. Wace.

88 Entrance Court of the palace at Pylos. Reconstruction by Piet de Jong, by courtesy of Professor C. W. Blegen and the Department of Classics, University of Cincinnati.

89 Plan of the palace at Pylos, by courtesy of Professor C. W. Blegen and the Department of Classics, University of Cincinnati.

90 Megaron of the palace at Pylos, with central hearth surrounded by columns. Reconstruction by Piet de Jong, by courtesy of Professor C. W. Blegen and the Department of Classics, University of Cincinnati.

91 Remains of the megaron of the palace at Pylos, showing the hearth and the bases of surrounding columns. Photo by courtesy of Professor C. W. Blegen and the Department of Classics, University of Cincinnati.

92 Corbel-vaulted galleries inside the walls at Tiryns. Photo: Peter Clayton.

93 Isometric plan of the Treasury of Atreus at Mycenae, 1300–1250. After Hood.

94 Façade of the Treasury of Atreus (the columns are drawn in). Photo by courtesy of the Trustees of the British Museum.

95 Corbel-vaulting of the chamber of the Treasury of Atreus. Photo: Peter Clayton.

96 Reconstruction of the façade of the Treasury of Atreus. The doorway is 5·4 m. high. Drawing by Mabel Miller, after Wace and Williams, by courtesy of the Trustees of the British Museum.

97 Cast of green marble column-capital from the Treasury of Atreus, 1300–1250. British Museum. Photo by courtesy of the Trustees of the British Museum.

98 Part of the shaft of one of the green marble columns from the Treasury of Atreus, 1300–1250. British Museum photo, by courtesy of the Trustees of the British Museum.

99 Limestone stele with a warrior in a chariot, 1550–1500, from Grave-

Circle A at Mycenae. NMA. Height
1·33 m. Photo: Peter Clayton.

100 Limestone relief, heraldically op-
posed lions, 1250, from the Lion
Gate at Mycenae.

101 Painted plaster head (of sphinx?),
1300–1200, from Mycenae. NMA.
Height 16·8 cm. Photo: Peter
Clayton.

102 The Priest-King fresco, 1550–1450,
from Knossos. Largely restored,
but the crown, the torso and most
of the left leg are original. AMH.
Photo: Peter Clayton.

103 The Parisienne fresco, 1550–1450,
from Knossos. AMH. Photo by
courtesy of Mrs Anne Ward.

104 Fresco of a dancing lady, 1550–
1450, from Knossos. AMH.

105 Fresco of a cluster of lilies, 1550–
1450, from a villa at Amnisos.
AMH. Photo: Peter Clayton.

106 Painted limestone sarcophagus
from Hagia Triada, c. 1400,
showing the sacrifice of a bull, and
a priestess before a shrine. AMH.
Length 1·37 m. Photo: Josephine
Powell.

107 Painted limestone sarcophagus
from Hagia Triada, c. 1400, show-
ing a procession bearing votive
gifts to the dead man. AMH.
Length 1·37 m. Photo: Josephine
Powell.

108 Fresco of flying fish, 1550–1450,
from Phylakopi in Melos. Original
in NMA, restoration photo-
graphed by Peter Clayton.

109 Fresco of a procession of women
bearing votive gifts, 1400–1350,
from the palace at Thebes. Ori-
ginal in Thebes Museum, restora-
tion photographed by Peter
Clayton.

110 Fresco of richly dressed priestess
holding a brazier, 1600–1500, from
Thera. Original in NMA. Photo:
Hannibal, Greece.

111 Fresco of the Theran landscape,
1600–1500, from Thera. Original
in NMA. Photo: Hannibal, Greece.

112 Large jar painted with bulls' heads
and double-axes, 1550–1500, from
Pseira. AMH. Height 77 cm.

113 Large jar with all-over spiral
design (Pattern Style), 1550–1500,
from Pseira. AMH. Height 98 cm.

114 Ewer painted with sea-creatures
(Marine Style), 1500–1450, from
Egypt. Musée Borély at Marseilles.
Height 25 cm. Photo: Jacobsthal.

115 Jug painted with reeds (Floral
Style), 1550–1500, from Phaestos.
AMH. Height 29 cm.

116 Rhyton painted with sea-creatures
(Marine Style), 1500–1450, from
Zakro. AMH. Height 33 cm.
Photo: Josephine Powell.

117 Flat 'pilgrim flask' with octopus design (Marine Style), 1500–1450, from Palaikastro. AMH. Height 28 cm. Photo: Josephine Powell.

118 Pattern Style stirrup-vase, 1500–1450, from Zakro. AMH. Photo by courtesy of Professor N. Platon.

119 Large jar with Mainland version of Marine Style decoration, 1500–1400, from Kakovatos. NMA. Height 78 cm.

120 Palace Style jar with stylized lilies, 1450–1400, from Knossos. AMH. Height 70 cm.

121 'Ephyrean' goblet, 1550–1400, from Mycenae. Nauplia Museum. Height 38 cm. Drawing by Piet de Jong.

122 View of the magazines at Knossos, with large storage-jars (pithoi) still *in situ*, 1450–1400. Photo: Peter Clayton.

123 Large pithos with applied rope decoration, 1450–1400, from Knossos. British Museum (no. A 739). Height 1·15 m. British Museum photo, by courtesy of the Trustees of the British Museum.

124 Stemmed cup (kylix), 1400–1300, from Ialysus. British Museum (no. A 868). Height 15·5 cm. British Museum photo, by courtesy of the Trustees of the British Museum.

125 One-handled tankard, 1400–1300, from Mycenae. Nauplia Museum.

Height *c.* 16 cm. Drawing by Piet de Jong.

126 Jug, 1425–1400, from Ialysus. British Museum (no. A 877). Height 25·5 cm. British Museum photo, by courtesy of the Trustees of the British Museum.

127 Two storage-jars (stirrup-jar on the left), 1400–1300, from Aegina. Ashmolean Museum. Height of both 20 cm. Ashmolean Museum photo.

128 Three-handled alabastron, 1400–1300, from Mycenae. British Museum (no. A 781). Diameter 14 cm. British Museum photo, by courtesy of the Trustees of the British Museum.

129 Large jar with octopus design, 1400–1300, from Ialysus. British Museum (no. 1959. 11–4.1). Height 40 cm. Photo: the author.

130 Stemmed cup (kylix), 1300–1200, from Kalymnos. British Museum (no. A 1008). Height 19 cm. Photo: Peter Clayton.

131 Tin-plated goblet, *c.* 1400, from Ialysus. British Museum (no. A 861). Height 12 cm. British Museum photo, by courtesy of the Trustees of the British Museum.

132 Crater painted with a procession of chariots, 1400–1300, from Maroni. British Museum (no. 1925. 11–1.3). Height 42 cm. British Museum

photo, by courtesy of the Trustees of the British Museum.

133 Crater painted with a figure (Zeus?) with scales before a chariot, 1400–1300, from Enkomi. Cyprus Museum. Height 37·5 cm. Photo by courtesy of Dr V. Karageorghis.

134 Bowl painted with confronted sphinxes, 1300–1200, from Enkomi. British Museum (C 397). Height 25 cm. British Museum photo, by courtesy of the Trustees of the British Museum.

135 Bowl painted with a bull and a bird, 1300–1200, from Enkomi. British Museum (no. C 416). Height 27 cm. Photo: the author.

136 Jar with light-on-dark design of swans, 1400–1300, from Maroni. British Museum (no. C 332). Height 40 cm. British Museum photo, by courtesy of the Trustees of the British Museum.

137 Three-footed tankard, 1200–1050, from Miletus. Izmir Museum. Height 21 cm. Photo by courtesy of Professor G. Kleiner.

138 Close Style bowl painted with dark-on-light swans, 1200–1050, from Mycenae. Nauplia Museum. Height 7 cm.

139 Jar painted with birds and fish, 1400–1300, from Phaestos. AMH. Height 28·5 cm. Photo: Josephine Powell.

140 Fringed Style motives, 1100–1050, from Karphi. After Desborough.

141 Submycenaean stirrup-jar, 1100–1050, from Cerameicus at Athens. Cerameicus Museum. Height 15·3 cm. Photo: Deutsches Archäologisches Institut, Athens.

142 Stirrup-jar, Octopus Style, 1100–1050, from Attica. National Museum, Copenhagen. Height 24·3 cm. Photo: National Museum, Copenhagen.

143 The Warrior Vase, 1200–1150, from Mycenae. NMA. Height 41 cm. Photo: Peter Clayton.

144 Alabastron painted with two griffins feeding their young, c. 1150, from Lefkandi. Chalcis Museum. Height 12 cm. Photo British School of Archaeology at Athens, by courtesy of M. Popham.

145 Chest larnax, 1400–1350, from Vasilika Anogeia. AMH. Length 1·23 m. Photo: Peter Clayton.

146 Painted chest larnax, c. 1200, perhaps from Tanagra. Badische Landesmuseum, Karlsruhe. Height 40 cm. Photo by courtesy of the Badische Landesmuseum.

147 Bath-shaped larnax, 1400–1350, from Pachyammos. AMH. Height 48 cm. Photo: Peter Clayton.

148 Terracotta rhyton in the shape of a bull, 1500–1450, from Pseira. AMH. Length 25·5 cm.

149 Terracotta standing female figurine ('psi' type), 1300–1200, probably from Athens. British Museum (no. B 5). Height 11·5 cm. British Museum photo, by courtesy of the Trustees of the British Museum.

150 Terracotta figurine ('tau' type), 1400–1200, from Athens. British Museum (no. B 7). Height 9·5 cm. British Museum photo, by courtesy of the Trustees of the British Museum.

151 Terracotta figurine ('phi' type), 1400–1300, perhaps from Melos. British Museum (no. B 12). Height 8 cm. British Museum photo, by courtesy of the Trustees of the British Museum.

152 Terracotta 'household goddess' with poppy-head crown, 1300–1200, from Gazi. AMH. Height 77·5 cm.

153 Terracotta figurine of a mule carrying wine-jars, with painted detail, 1200–1100, from Phaestos. AMH. Height 17 cm.

154 Terracotta bull with painted detail, 1200–1100, from Phaestos. AMH. Height 37 cm.

155 Terracotta chariot group, 1400–1200, from Ialysus. British Museum (no. B 2). Height 8 cm. British Museum photo, by courtesy of the Trustees of the British Museum.

156 Terracotta female figurine, 1500–1400, from Keos. Keos Museum.

Height 98·8 cm. Photo by courtesy of the Department of Classics of the University of Cincinnati.

157 Argonaut shell made of faience, 1500–1450, from Zakro. AMH. Photo by courtesy of Professor N. Platon.

158 Ivory plaque with relief of an alighting bird, 1500–1450, from Palaikastro. AMH. Height 7 cm. Photo: Peter Clayton.

159 Ivory group of two goddesses and a divine child, 1400–1200, from Mycenae. NMA. Height 7 cm.

160 Ivory cosmetic-box (pyxis) with scenes of hunting griffins, 1400–1300, from the Agora at Athens. Stoa of Attalus Museum. Height 16 cm. Photo by courtesy of the American School of Classical Studies at Athens.

161 Extension of the design on the ivory pyxis (*Ill. 160*). Drawing by courtesy of the American School of Classical Studies at Athens.

162 Ivory relief of two confronted sphinxes at an altar, 1300–1200, from Mycenae. NMA. Height 8 cm. Photo by courtesy of Dr F. H. Stubbings.

163 Ivory relief of a recumbent sphinx, 1300–1200, from Spata. NMA. Width 5·5 cm.

164 Ivory relief of a warrior armed with figure-of-eight shield and

boars' tusk helmet, 1400–1200, from Delos. Delos Museum. Height 13 cm. Photo: École Française d'Athènes.

165 Ivory mirror-handle, lion attacking bull, 1200–1100, from Enkomi. British Museum (no. 97. 4–1. 872). Height 20 cm. British Museum photo, by courtesy of the Trustees of the British Museum.

166 Reverse of ivory mirror-handle (*Ill. 165*), warrior killing a griffin. British Museum photo, by courtesy of the Trustees of the British Museum.

167 Bronze figurine of female worshipper, *c.* 1500, unknown provenance. British Museum (no. Height 18·4 cm. Photo: Peter Clayton. From a cast.

168 Bronze figurine of a male worshipper, *c.* 1500, unknown provenance. British Museum (no. 1918. 1–1. 114). Height 22 cm. British Museum photo, by courtesy of the Trustees of the British Museum.

169 Reconstruction of inlaid bronze dagger showing a lion-hunt. Length 37 cm. Photo: Peter Clayton.

170 Three bronze dagger-blades inlaid with gold, silver and niello: *above*, leopards hunting wild-duck; *centre*, a lion-hunt; *below*, three lions running, 1550–1500, from Shaft-Graves IV and V at Mycenae. NMA. Length 16·3, 23·8 and 21·4 cm.

171 Detail of bronze dagger with inlaid dolphin, 1500–1400, from the Argive Heraeum. NMA.

172 Dagger with gold hilt and inlaid blade showing three hunting leopards, 1500–1400, from Rutsi near Pylos. NMA. Length 32 cm. Photo: Peter Clayton.

173 Inlaid silver knife, *c.* 1800, from Byblos. National Museum, Beirut. Length 28·4 cm. Photo by courtesy of the Director-General, Service des Antiquités.

174 Engraved gold double-axes, 1550–1450, from Arkalochori. AMH. Width about 8 cm. Photo: Peter Clayton.

175 One-handled gold goblet, 1550–1500, from Shaft-Grave IV at Mycenae. NMA. Height without handle, 12·6 cm.

176 Gold cup with embossed spiral pattern and ribbon handle, 1550–1500, from Shaft-Grave V at Mycenae. NMA. Height without handle, 11 cm. Photo: Josephine Powell.

177 Bronze cup with ivy-leaf ornaments, *c.* 1550, from Mochlos. NMH. Height 6·5 cm. Drawing after Evans.

178 Gold cup embossed with scene of the capture of a wild bull in a net,

1500–1450, from Vapheio. NMA. Diameter 10·8 cm.

179 Reverse of gold cup (*Ill. 178*) showing a wild bull escaping from its captors.

180 Gold cup with scene of wild bull being captured by means of a decoy cow and tethered, 1500–1450, from Vapheio. NMA. Diameter 10·8 cm. Photo: Peter Clayton.

181 Gold 'tea-cup' with spiral design, 1500–1450, from Knossos. AMH. Height 3·7 cm. Photo by courtesy of Sinclair Hood.

182, 183 Bottom and side view of a gold 'tea-cup' embossed with marine scene, *c.* 1400, from Dendra. Diameter 17·3 cm.

184 Silver jug with arcade pattern over horizontal fluting, 1550–1500, from Shaft-Grave V at Mycenae. NMA. Height 34·5 cm.

185 Bronze jug with arcade pattern, 1550–1500, from Knossos. AMH. Height 34·5. Drawing after Evans.

186 Electrum goblet inlaid with gold and niello, 1550–1500, from Shaft-Grave IV at Mycenae. NMA. Height 15·5 cm.

187 Wall-painting of offerings of Cretan wares, from the tomb of Senmut, *c.* 1500, at Thebes, Egypt. Drawing by courtesy of the Oriental Institute of the University of Chicago.

188 Silver cup with wishbone handle inlaid with gold and niello bulls' heads, *c.* 1400, from Enkomi. Cyprus Museum. Diameter 15·7 cm. Photo by courtesy of Dr V. Karageorghis.

189 Silver cup inlaid with male heads, 1300–1200, from Mycenae. NMA. Diameter 16·5 cm. Photo: Josephine Powell.

190 Gold mask, 1550–1500, from Shaft-Grave V at Mycenae. NMA. Height 26 cm. Photo: Peter Clayton.

191 Upper part of a serpentine rhyton, showing an agricultural festival, the Harvester Vase, 1500–1450, from Hagia Triada. AMH. Diameter 11·5 cm. Photo: Josephine Powell.

192 Serpentine cup with relief of aristocrat and soldier, the Chieftain Cup, 1500–1450, from Hagia Triada. AMH. Diameter 9·9 cm. Photo: Josephine Powell.

193 Serpentine rhyton (neck missing) showing wild goats and a mountain-top shrine, 1500–1450, from Zakro. AMH. Height 24 cm. By courtesy of Professor N. Platon.

194 Obsidian chalice, 1500–1450, from Zakro. AMH. Height 30·5 cm. By courtesy of Professor N. Platon.

195 Marble chalice with horizontal fluting, 1500–1450, from Zakro

AMH. Height 31 cm. By courtesy of Professor N. Platon.

196 Marble chalice, quatrefoil section, 1500–1450, from Zakro. AMH. Height 31 cm. By courtesy of Professor N. Platon.

197 Marble jar with high handles, 1500–1450, from Zakro. AMH. Height to top of handles 40·5 cm. By courtesy of Professor N. Platon.

198 Porphyry bridge-spouted jar, 1500–1450, from Zakro. AMH. Height 17 cm. By courtesy of Professor N. Platon.

199 Fluted porphyry jar with bronze handles, 1500–1450, from Zakro. AMH. Height 12·5 cm. By courtesy of Professor N. Platon.

200 Fluted red marble rhyton with beaded collar, 1500–1450, from Zakro. AMH. Height 43·5 cm. By courtesy of Professor N. Platon.

201 Rock-crystal unguent-vase in the form of a duck, 1550–1500, from Grave-Circle B at Mycenae. NMA. Length 13·2 cm.

202 Rhyton in the form of a bull's head, serpentine with shell inlay, 1500–1450, from Knossos. The horns are restored. AMH. Height without horns 20·6 cm.

203 Segmented serpentine rhyton, 1300–1200, from Mycenae. NMA. Height 19 cm. Drawing by Piet de Jong.

204 Gold ear-ring, 1550–1500, from Shaft-Grave III at Mycenae. NMA. Diameter 7·5 cm. Photo: Deutsches Archäologisches Institut, Athens.

205 Gold relief-beads in the form of stylized ivy-leaves, c. 1400, from Mycenae. NMA. About twice life-size. Photo: Ronald Sheridan.

206 Granulated gold relief-beads in the form of paired argonauts, c. 1400, from Mycenae. NMA. About twice life-size. Photo: Ronald Sheridan.

207 Massive pin with silver shank and gold turned-back head, 1550–1500, from Shaft-Grave III at Mycenae. NMA. Head 6·7 cm, shank 21·5 cm. Photo: Ronald Sheridan.

208 Gold cut-out of a nude goddess with doves, 1550–1500, from Shaft-Grave III at Mycenae. NMA. Height 6 cm. Photo: Ronald Sheridan.

209 Gold cut-out of an octopus, 1550–1500, from Shaft-Grave IV at Mycenae. NMA. Height 6 cm. Photo: Ronald Sheridan.

210 Gold cut-out of a butterfly, 1550–1500, from Shaft-Grave IV at Mycenae. NMA. Height 2·6 cm. Photo: Ronald Sheridan.

211 Gold diadem with attachments, 1550–1500, from Shaft-Grave III at Mycenae. NMA. Width 65 cm.

212 Gold necklace of spiral beads, *c.* 1400, from Mycenae. NMA. About life-size. Photo: Ronald Sheridan.

213 Gold relief-beads, rosette with pendant curl, *c.* 1400, from Mycenae, NMA. About life-size. Photo: Ronald Sheridan.

214 Gold relief-beads, some with traces of enamelling, *c.* 1400, from Volo. About life-size. NMA. Photo: the author.

215 Gold ear-ring with granulated conical pendant, 1400–1200, from Mavro Spelio near Knossos. AMH. Height 3·4 cm.

216 Stone and glass beads, 1400–1100, from Ialysus. British Museum. About life-size. Photo: Peter Clayton.

217 Granulated gold pendant in the form of a pomegranate, 1400–1300, from Enkomi. British Museum (no. 623). Height 2 cm. Photo: the author.

218 Gold necklace of beads in the form of figure-of-eight shields, 1400–1200, from Enkomi. British Museum (no. 580). Each bead 3·5 cm. high. British Museum photo, by courtesy of the Trustees of the British Museum.

219 Cypriot gold diadems with designs in relief, 1400–1200, from Enkomi. British Museum (nos. 194, 84). Length 13·8 cm and 17 cm. British Museum photo, by courtesy of the Trustees of the British Museum.

220 Cypriot gold pins with ornamental heads, 1400–1200, from Enkomi. British Museum (nos. 552, 550, 556). Length of longest 13·2 cm. British Museum photo, by courtesy of the Trustees of the British Museum.

221 Cypriot ear-rings of various shapes, 1400–1100, from Enkomi. British Museum. Height of largest 4·5 cm. British Museum photo, by courtesy of the Trustees of the British Museum.

222 Gold and enamelled sceptre, 1200–1100, from Curium. Cyprus Museum. Height 16·5 cm. Photo by courtesy of Dr V. Karageorghis.

223 Two gold rings with cloisonné enamelling, 1200–1100, from Kouklia. Cyprus Museum. Diameter 2·5 cm. Photo by courtesy of Dr V. Karageorghis.

224 Mycenaean seals. Left to right: Green jasper lentoid, lion attacking a goat (no. 1934. 11–20.12), 1400–1300. Diameter 1·8 cm. Agate lentoid, lion attacking two deer (no. 48), 1450–1400. Diameter 3·5 cm. Carnelian lentoid, three deer (no. 54), 1400–1300. Diameter 1·7 cm. Haematite cylinder, nature god and animals (no. 1945. 10–13. 133), 1425–1400. Length 2 cm. Rock-crystal lentoid, horse (no.

64), 1400–1300. Diameter 2·5 cm. Rock-crystal amygdaloid, bird (no. 1959. 3–31. 3), 1450–1400. Length 2·5 cm. All in the British Museum. Photo: Peter Clayton.

225–30 Modern impressions of the seals in *Ill. 224*. Although the arrangement is slightly different, the order (left to right, top to bottom) is the same.

231 Modern impression from a lentoid seal, bull-leaping scene, 1550–1500, from Crete. Ashmolean Museum (no. 246). Diameter 1·7 cm. Ashmolean Museum photo.

232 Green jasper amygdaloid seal, a priest in a long robe, 1500–1400, from Crete. Ashmolean Museum (no. 293). Length 3·4 cm. Ashmolean Museum photo.

233 Modern impression from an agate lentoid seal of the talismanic class, two ritual vessels, 1550–1500, from Crete. Ashmolean Museum (no. 262). Diameter 1·7 cm. Ashmolean Museum photo.

234 Modern impression from a haematite amygdaloid seal, two recumbent lions, 1500–1400, from Crete. Ashmolean Museum (no. 329). Length 2·4 cm. Ashmolean Museum photo.

235 Rock-crystal lentoid seal and modern impression, lion contorted to fit the field, 1450–1400, from Crete. Ashmolean Museum (no. 315). Diameter 2·5 cm. Ashmolean Museum photo.

236 Agate lentoid seal and modern impression, two recumbent bulls, 1450–1400, from Crete. Ashmolean Museum (no. 311). Diameter 2·4 cm. Ashmolean Museum photo.

237 Gold seal showing a griffin, 1500–1400, from Pylos. NMA. Width 3·5 cm.

238 Gold signet-ring showing a man worshipping, 1425–1400, from Sellopoullo near Knossos. AMH. Width 2 cm. Photo M.R. Popham, courtesy British School at Athens.

239 Gold signet-ring showing group of dancing women, 1500–1400, from Isopata near Knossos. AMH. Width 2·6 cm. Photo: Josephine Powell.

240 Gold signet-ring showing a group of worshipping women, 1500–1400, from Mycenae. NMA. Width 3·4 cm. Photo: Deutsches Archäologisches Institut, Athens.

241 Gold signet-ring showing a procession of demons bringing votive gifts to a goddess, 1500–1400, from Tiryns. NMA. Width 5·6 cm.

Map: Main Cretan and Mycenaean sites. Drawn by Lucinda Rodd.

Index

Numbers in italics refer to illustrations